Drawing Perspective & Space

Basic Principles of Drawing in Perspective

by Markus S. Agerer

Imprint

Markus S. Agerer

Drawing Perspective & Space
Basic Principles of Drawing in Perspective

ISBN-13: 978-1540361639

Original Texts: Markus S. Agerer
Illustrations: Markus S. Agerer
Cover Design: Markus S. Agerer

Copyright: © 2015 Markus S. Agerer

Bürgermeister-Haidacher-Straße 1
82140 Olching
Deutschland

email: markus-agerer@web.de
web: www.markus-agerer.de

Printed in Germany by Amazon Distribution GmbH, Leipzig

This book, sections thereof as well as the pictorial material – if not otherwise noted – are protected by copyright. It may not be used or exploited in any manner divergent from the law without authorization from the creator.

The author/illustrator has produced all contents with the utmost care; nevertheless, liability of any kind can not be assumed for errors and the direct or indirect consequences thereof.

Contents

1 Introduction – Representation of Space and Perspective ..1
 1.1 History of Perspective Representation ..2

2 Representation of Depth and Space ..4
 2.1 Proper Composition of an Image ..4
 2.2 Overlapping of Upright Planes ..5
 2.3 Repetition of Objects at Varying Distances ..6
 2.4 Achieving a Depth Effect by Reducing the Level of Detail7
 2.5 Aerial Perspective ..8
 2.6 Perspective Foreshortening ...8
 2.7 Vanishing Point Perspective ..10

3 Vanishing Point Perspective – the Basics ...11
 3.1 General Information about Vanishing Point Perspective ..11
 3.2 The Eye – Rays of Light Become Images ..12
 3.3 How Perspective is Portrayed on the Canvas ...14
 3.4 Construction of Vanishing Point Perspective ...16
 3.5 Types of Perspective ...20

4 Central Perspective with one Vanishing Point ..23
 4.1 Exercise – Central Perspective with one Vanishing Point ..24
 4.2 Drawing a Pathway ...26
 4.3 Drawing a Curved Pathway ..26
 4.4 Drawing a Pathway with an Incline ..28
 4.5 Drawing a Pathway with a Downward Slope ...29
 4.6 Drawing a Curved Pathway with an Incline ...31
 4.7 Drawing a Cube (Box with equal Edge-Lengths) ...34
 4.8 Representation of Repetitive, Equal-Sized Elements ...38
 4.9 Drawing a House ...42
 4.10 Exercise – a House with Side View ..45
 4.11 Exercise – Houses in the Mountains ..46

5 Diagonal Perspective .. 49
5.1 Drawing a Box in Diagonal Perspective ... 49
5.2 Drawing a Cube that Has Been Shifted by 45° .. 52
5.3 Drawing a Cube That Has Been Shifted by 30° ... 57
5.4 Representing Repetitive, Equal-Sized Elements .. 61
5.5 Drawing Diagonal Upright Planes .. 65
5.6 Drawing a Staircase ... 70
6 Three-Point Perspective ... 78
6.1 Three-Point Perspective Step by Step .. 80
6.2 Three-point Perspective with Top View ... 83
6.3 Exercise: Drawing a Cityscape ... 84
7 Circles, Cylinders and Arcs ... 94
7.1 Drawing a Circle and/or Ellipse in Perspective ... 94
7.2 Drawing a Cylinder .. 96
7.3 Drawing an Archway ... 99
7.4 Drawing an Archway from the Side .. 103
8 Shadows in Perspective .. 110
8.1 Drawing Shadows without Perspective ... 110
8.2 Shadows in Perspective Representation .. 115
9 Representation that is True to Proportion .. 128
9.1 Elements of Perspective Drawing that is True to Proportion 128
9.2 Individual Lines ... 130
9.3 Drawing Any Desired (Random) Four-Sided Figure 133
9.4 Drawing Any Desired (Random) Form in Perspective 139
9.5 Drawing a Box in Perspective .. 143
9.6 Determining the Height of an Object ... 148
9.7 True-to-Proportion Representation in Diagonal Perspective 154
9.8 Perspective Representation of a Complex Object ... 159
10 A Supplementary Observation: Perspective According to Dürer 164
11 Sources .. 167

1 Introduction – Representation of Space and Perspective

This book is dedicated in its entirety to the topic "Drawing in Perspective". Primarily, it involves so-called vanishing-point perspective. By making use of vanishing-point perspective, it is possible to realistically display objects, landscapes and architecture. A persuasive illusion of reality is thus created on paper.

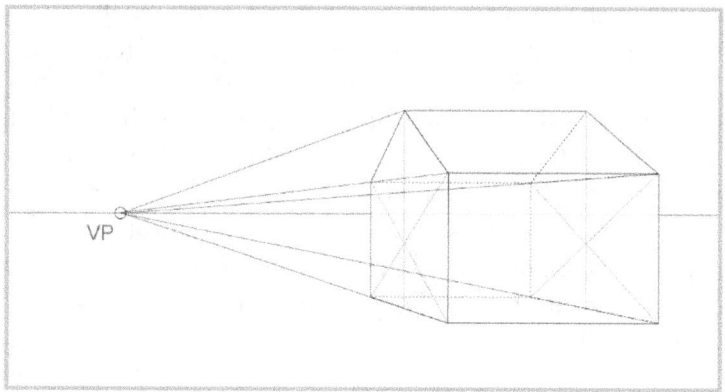

Example of representation in central perspective

By using the methods described in this book you can learn to create, on your own and without a template, realistic drawings of large objects. All you need for this is paper, a pencil, a ruler and the theoretical knowledge that you can acquire with the aid of this book.

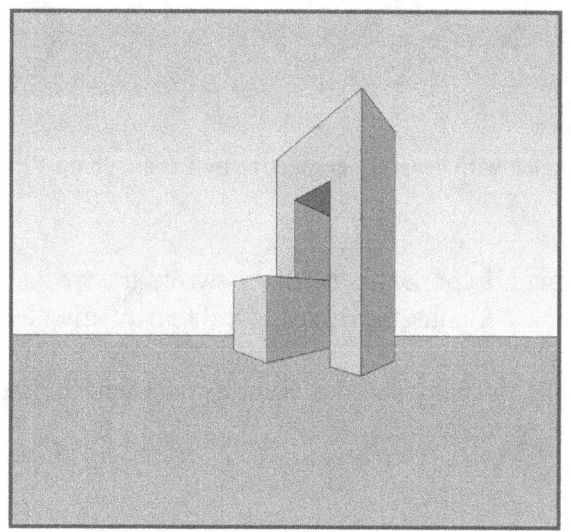

Example for perspective representation of an object

1.1 History of Perspective Representation

The first artistic explorations in perspective representation can be traced back to the early history of mankind. In the cave paintings from as early as 30,000 years ago, one can find representations of spatial motifs. Even though these images had not yet mastered the technique of vanishing-point perspective, they give witness to the first attempts at spatial illustration.

In wall frescoes of ancient Rome as well, one can see paintings with an advanced reproduction of perspective. The artists of this time were already working with various techniques in graphic construction. The images were thus intended to convey the illusion of a real room, but this knowledge was not further developed in successive centuries until the end of the Middle Ages. It was not until the Renaissance that the technique of central perspective was (re-) discovered. The artists responsible for this innovation were Filippo Brunelleschi, Giotto as well as the previously mentioned Leon Batista Alberti.

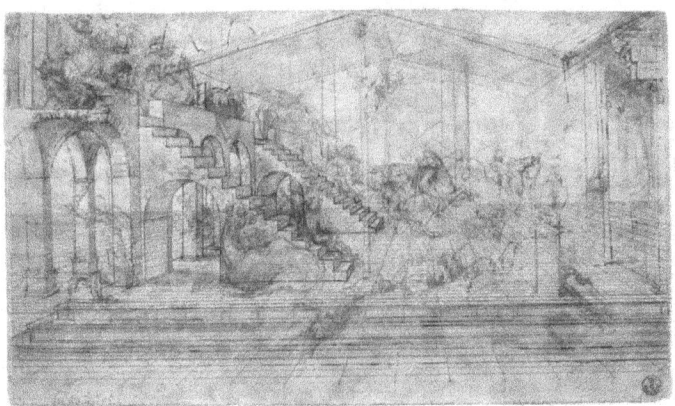

Sketch with central perspective by Leonardo da Vinci

The Italian artist and polymath Leon Battista Alberti wrote the treatise "De Pictura" (The Art of Painting) in 1436. The book contains the first theoretical treatment of perspective in the New Era.
One can find representations in many famous Renaissance paintings that were designed on the basis of so-called central perspective.

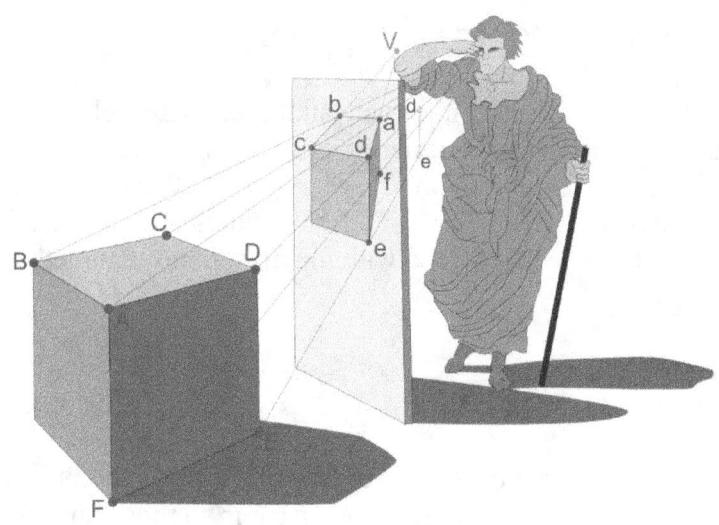

Illustration based on perspective visualization and drawing (after a drawing by Leon Battista Alberti)

About one hundred years after Alberti (1525), Albrecht Dürer published his book <u>A manual of measurement of lines, areas, and solids by means of compass and ruler</u> ("Underweysung der messung mit dem zirckel un richtscheyt"), in which he described mathematical-geometrical procedures for perspective design techniques. We will focus on one of his methods at the very end of the book.

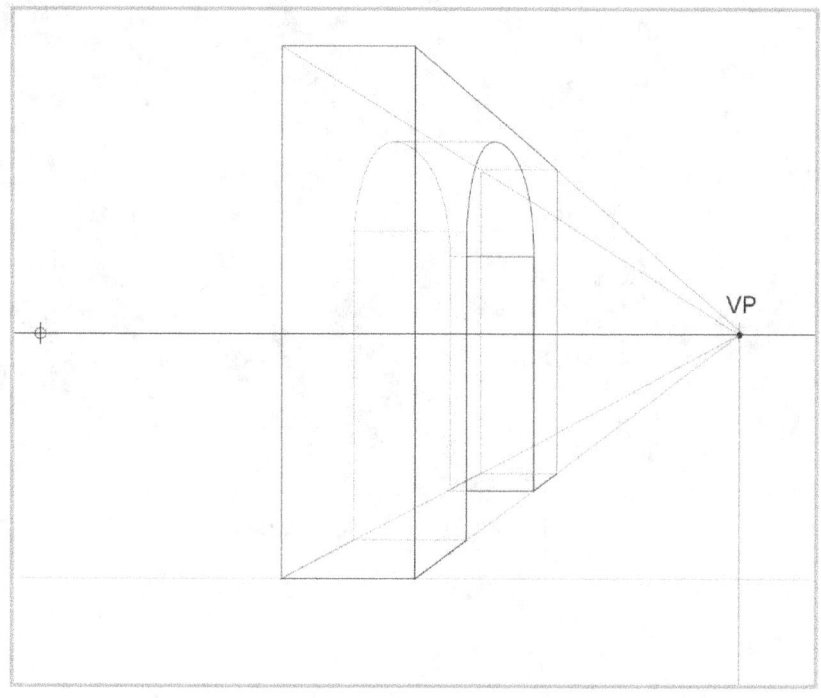

Example of vanishing-point perspective

2 Representation of Depth and Space

Representation of spatial depth is an important and challenging element in design. If one is capable of achieving the effect of three dimensions in a painting, a considerable contribution is made thereby towards a realistic impression. In order to allow this sense of space to emerge upon a two-dimensional drawing surface, diverse graphic aids are frequently deployed. In the following pages you will become acquainted with the most important methods.

2.1 Proper Composition of an Image

A simple principle for achievement of the effect of space and depth is to fulfill the expectations of the observer. This means that we represent the space in the manner that he is accustomed to and anticipates according to his own experience. Specifically: those objects that lie on the ground, i.e. in the lower area of the drawing, are located in the foreground, and those objects that are in the upper section are more likely located in the background. Thus we make it easier for the observer of the drawing to get his bearings within the image, and the impression of a three-dimensional landscape is more readily conveyed in this manner.

You can see an example of this technique in the following section (2.2 Overlapping of upright planes).

Still life a perspective illustration

2.2 Overlapping of Upright Planes

The effect of spatial representation is optically reinforced when the image is constructed in several upright planes. These planes can contain trees, a house, a car etc. The planes are laid out at varying distances and overlap one another. Due to the fact that the planes overlay one another, it is immediately obvious to the observer that the various objects in the image are located at different distances.

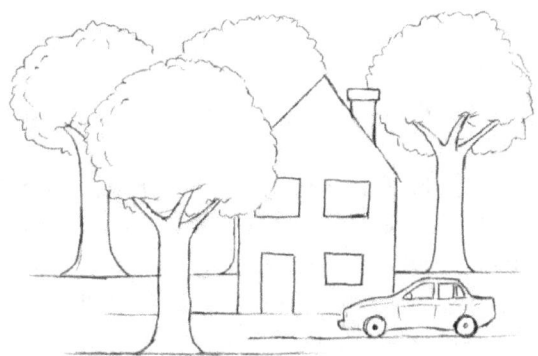

Example for the overlapping of planes in a landscape sketch

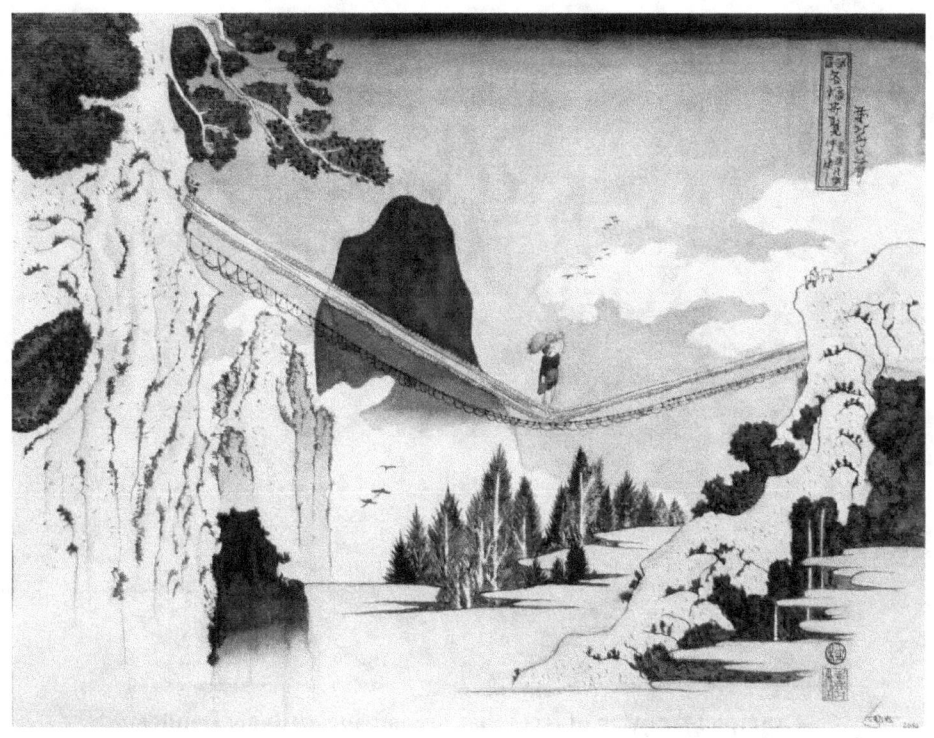

Copy of a Japanese colored woodcut with planes effect

5

In the copy of the Japanese colored woodcut (Ukiyo-e), we have a picture entitled <u>Farmer on a Suspension Bridge on the Border between the Provinces Hida and Etchu</u> by the artist Katsushika Hokusai (1760 - 1849).
We see a good example in this image of how perspective effects were applied in other cultures as well.

It is, of course, not necessary to undertake such an obvious arrangement of planes as can be seen in the previous drawing. One usually makes an effort to conceal this technique in such a manner that it does not stand out and appears natural.

2.3 Repetition of Objects at Varying Distances

The spatial effect in a drawing can be further increased through application of a variation on an object's perspective. Specifically, this refers to repetition of equal objects.
The effect of depth emerges as a result of representing the objects – depending on their distance – in varying sizes. Thus a person, for example, can be drawn somewhat taller and a second person noticeably smaller. It is evident to the brain of the observer that these two individuals must be of approximately the same height, and he automatically assumes that one person is standing in the foreground and the other in the background. The impression of depth emerges thereby.

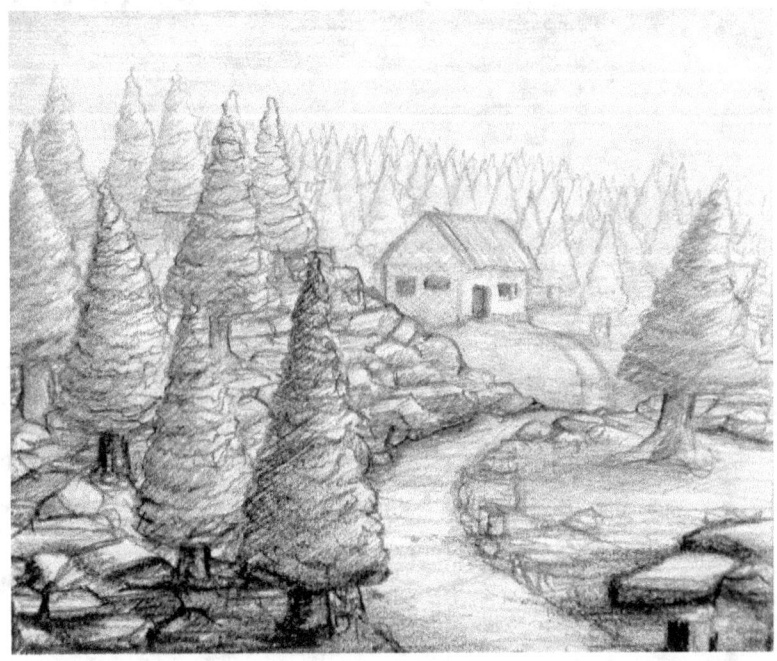

Example: Drawing of trees that become increasingly smaller

Furthermore, with the aid of vanishing-point perspective it is relatively simple to draw the different sizes in appropriate correlation to the distance.

The effect should also be carried out in steps that are not too big. Specifically, this means that the downsizing of the objects in the background should proceed uniformly. Depiction of size differences that are too extreme comes across rather confusing for the observer, and the logical interrelationship is lost.

2.4 Achieving a Depth Effect by Reducing the Level of Detail

The methods described above can be perfected further by making the level of detail in the objects correspond to their distance away from the observer.
It is possible to recognize many details in an object that is close. Conversely, if something is located farther away, one can no longer discern these details. In drawing, we thus include fewer and fewer particulars, the farther away the object is located.
This method can also be recognized in the following landscape sketch.

Cityscape with detail reduction in the background

2.5 Aerial Perspective

Aerial perspective is used in drawings and paintings in order to produce an impression of depth. In reality, this involves an atmospheric effect. Light is deflected by air molecules, haze and dust. This causes distant objects to acquire a light blue tinge, while also appearing lighter in color and lower in contrast. Due to this blue tinge, one often times refers to a "blueing" effect and/or tonal phase.

Since we don't use color in a pencil drawing, this effect can only be produced by making the distant objects paler and reducing the contrast.

Example of aerial perspective

2.6 Perspective Foreshortening

Perspective foreshortening is an effect that becomes particularly distinct when we view, from straight ahead, an object that stretches out into the distance. For example, we look at an outstretched arm or a branch directly from the front.

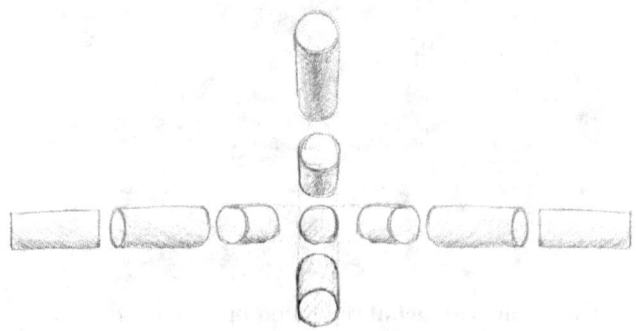

Perspective foreshortening of a cylinder from various points of view

The drawing below is a further good example of perspective foreshortening. Here we see a man stretching out his arms to both sides. Our point of view as observers of the scene has been selected in such a manner that we are standing almost in a line with the stretched out arms. We can thus only guess at the length of the arms. This makes it quite difficult for us as illustrators to realistically draw the geometry of the arms including the clothing.

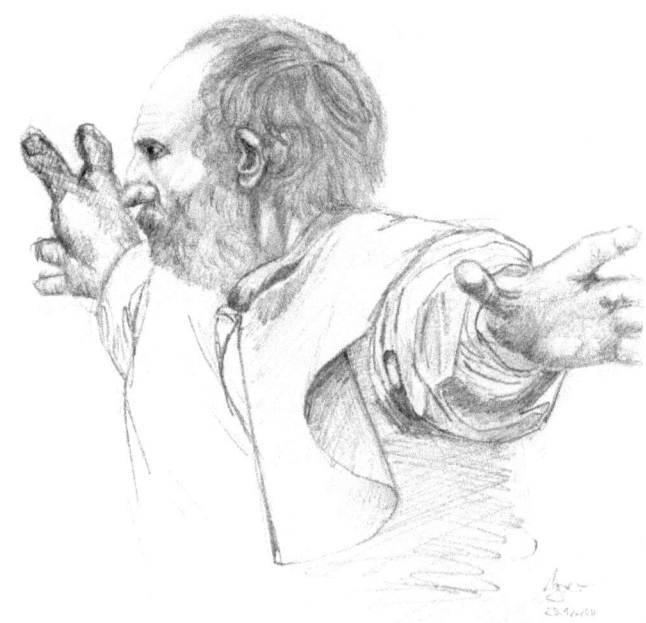

Example of perspective foreshortening

The following painting served as a model: <u>The Lord's Supper in Emmaus</u> by Caravaggio

The graphic problem arises out of the geometrical form that the arms and sleeves assume from this perspective. The geometry in this context is simply quite abnormal when it has to be drawn. The reason: What we need to draw here contradicts our pre-conception that arms, hands and fingers are long and thin. From our point of view however, these body parts rather assume the form of a circle.

Furthermore, a lot of "information" is compressed into very little space in this foreshortening of perspective. In our example here the wrinkles in the sleeve are compressed into the small surface area that we can see.

The foreshortening of perspective is also an effect that can be readily portrayed by using the technique of vanishing point perspective.

2.7 Vanishing Point Perspective

The last method of spatial representation to be introduced here is vanishing point perspective. The procedure here is much less characterized by feeling and intuition than the previous methods. Vanishing point perspective is first and foremost a technical method. But more about that in the remainder of the book!

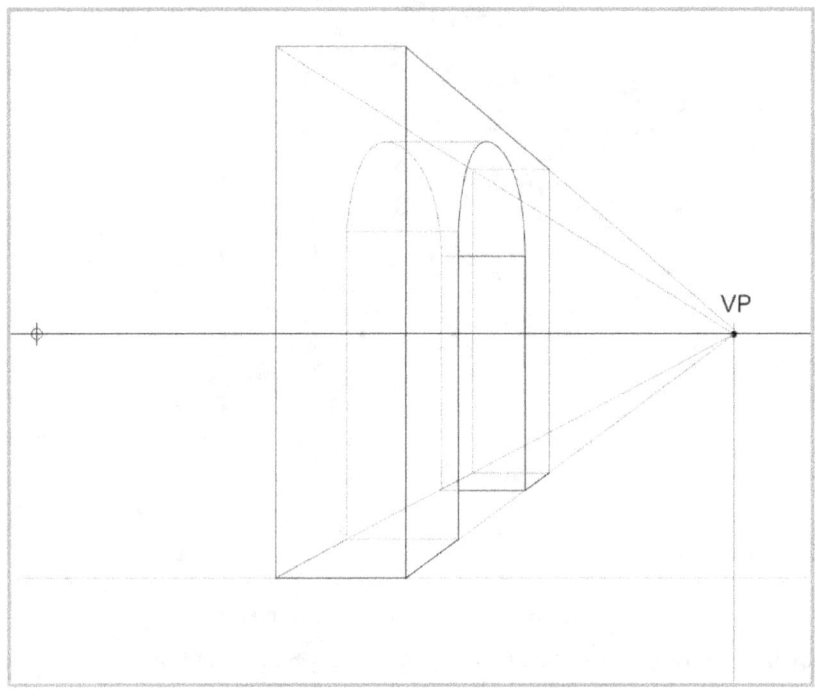

Example of representation of a portal in perspective

3 Vanishing Point Perspective – the Basics

3.1 General Information about Vanishing Point Perspective

Perspective

The term perspective refers to the spatial circumstances of objects in space. Perspective is always dependent on the standpoint of the viewer and describes the relative distances of objects in comparison to the viewer.
Perspective only changes when either the location of the objects or that of the observer changes. This means that the perspective does NOT change when only the observed section of the picture is changed (e.g. in a zoom-in using a camera).

Vanishing Point Perspective

Vanishing point perspective presents a graphic method with which we can represent three-dimensional objects on a two-dimensional surface with the use of perspective. This involves a construction procedure that is both technical and artistic. The objective here is to create the illusion of a three-dimensional space, even though the drawing, i.e. the surface of the canvas, is only two-dimensional.

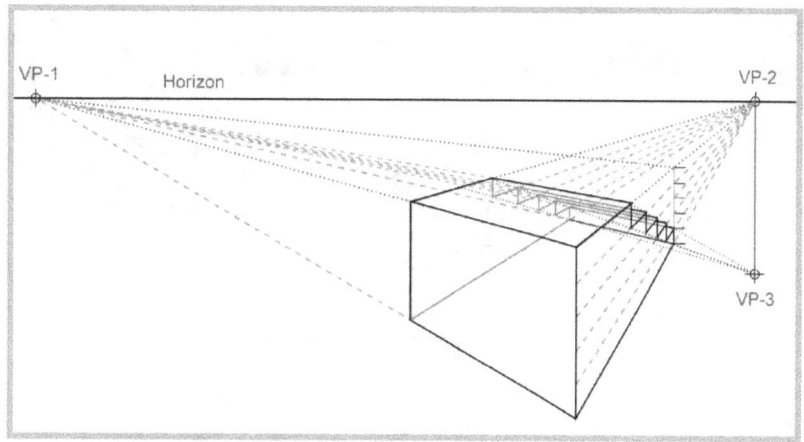

Example for the construction of an object in vanishing point perspective

3.2 The Eye – Rays of Light Become Images

If one wants to better understand sight in perspective, it is helpful to know how our eyes and sight function.

We are only able to perceive our environment with the aid of light, which is emitted by the sun and reflected off of objects. Reflected light travels through the pupil into the eye and is then projected onto the back of the retina – this image is actually an inverted mirror image. From there this information is directed via the optical nerves into our brain.
In order to understand the process of sight in reference to perspective, it is first of all important to know that perspective appears on our retina – in that place where the world, as we see it, is displayed.

Perception of objects in perspective is primarily characterized by the fact that the smaller we perceive objects to be, the farther they are away from us. This miniaturization occurs as a result of rays of light entering our eye at a lower angle when an object is farther away. This effect is presented simplistically in the illustration below in order to make this (quite complicated) phenomenon a bit more understandable.

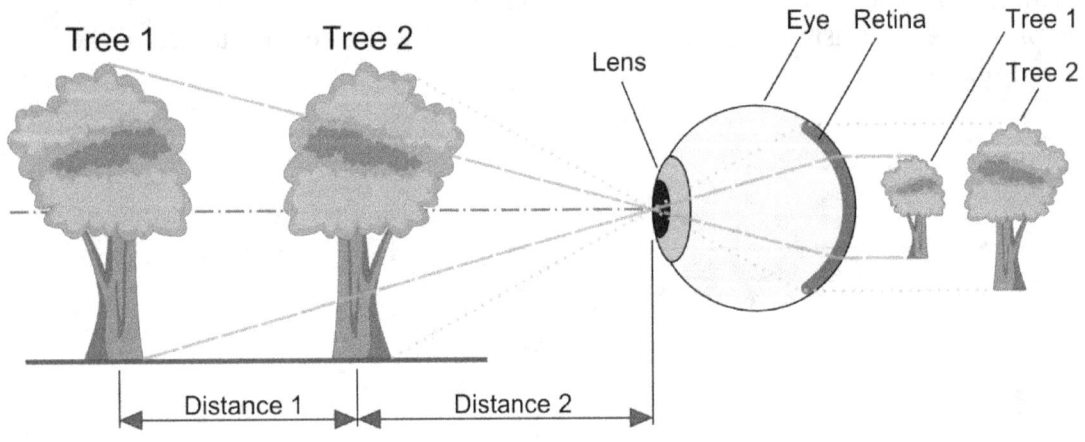

Generation of perspective in our eye

Another effect of perspective is the fact that we see more objects at a distance than we do within our immediate surroundings. This phenomenon basically has the same background as the previously mentioned effect of miniaturization. In the following illustration you can see how our field of vision (also known as visual field or field of view) expands in the distance.

A checkerboard pattern is displayed in the following figure. Here you can recognize immediately, and understand as well, why we perceive more objects at a distance. As we can see from the drawing, there are many more squares in the background area of the field of vision than in the foreground. This means that the numerous objects at a distance in our picture have to compress themselves; in other words, it could not be otherwise to the extent that these objects are perceived to be smaller.

The method one uses, furthermore, to draw such a checkerboard pattern in perspective is described in more detail in a subsequent chapter of this book.

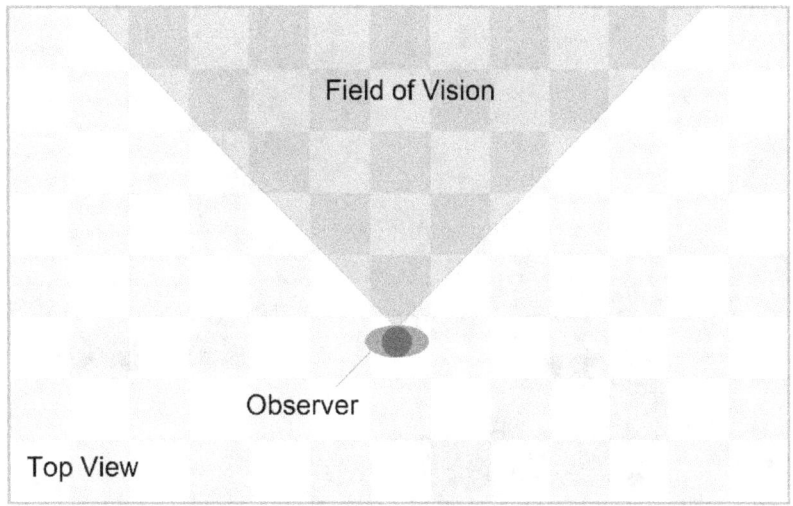

Expansion of an observer's visual field in the distance

If one takes only the left eye into consideration, then the field of vision extends from about 90° on the left side and up to 60° to the nose. Downwards, it achieves an opening angle of about 70°, while upwards the angle is about 60°.
But in the case for human beings, one can perceive in the wide scale only a cone of undistorted vision of 90°, i.e. 45° to the left and 45° to the right. Objects that are located outside this field are optically distorted.

Furthermore:
Precondition for perspective sight is the fact that rays of light always proceed in an absolutely straight line. While constructing a drawing in perspective, we interpret the rays of light in the form of reference lines (i.e. construction lines). With the aid of these reference lines, we can achieve the illusion of a spatial illustration on a flat sheet of paper. In the process we always illustrate the point of view from an individual eye, in other words, with no stereoscopic or three-dimensional sight.

3.3 How Perspective is Portrayed on the Canvas

In the previous chapter, we saw how our eyes function and how perspective is generated in the retina. And now we would like to find out how an image in perspective is portrayed onto the canvas.

In order to understand the procedure better, you can regard the following two drawings.

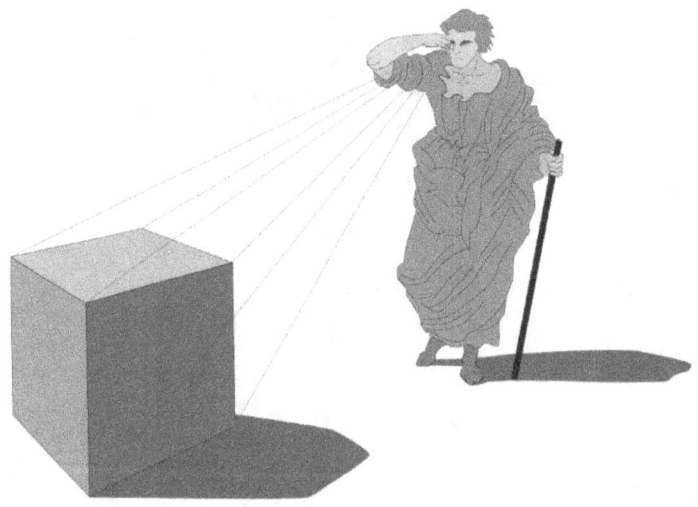

Illustration – taken from Leon Battista Alberti

In this image one can see an individual who is standing at the so-called construction- or drawing-plane while observing an object. As already described in the previous chapter, rays of light are reflected from the object. These rays of light enter into the eye of the observer and produce here a depiction of reality. These rays of light can also be understood, in reverse, as lines of sight.

Now we should imagine an upright plane located between the observer and the object – as in the following image. We refer to this plane as the picture plane. You can imagine it as your drawing sheet or canvas, upon which you want to draw or paint the picture.

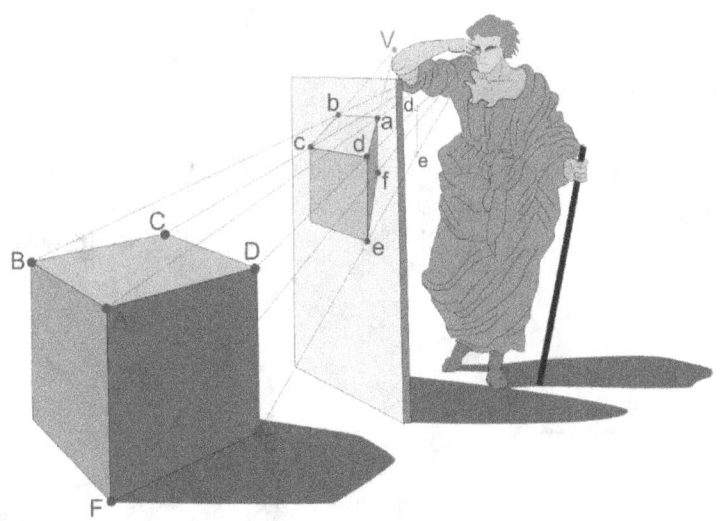

Illustration – taken from Leon Battista Alberti

And now one can symbolically imagine that the observer is emitting lines of sight with which he is scanning the object. Each line of sight burns a hole into the picture plane whereby the object is displayed point by point on the picture plane. The result is that precisely the same perspective that the observer has perceived emerges on the picture plane. A three-dimensional scene is thus transformed into a two-dimensional drawing.

When we draw in perspective, we execute this procedure with the aid of various graphic design techniques. You will become acquainted with these methods in the following chapters.

3.4 Construction of Vanishing Point Perspective

At the beginning of this chapter we will have a look at the individual elements of vanishing point perspective. The simplest form of perspective representation requires a horizon, a vanishing point, vanishing lines and, of course, an object that we would like to draw spatially.

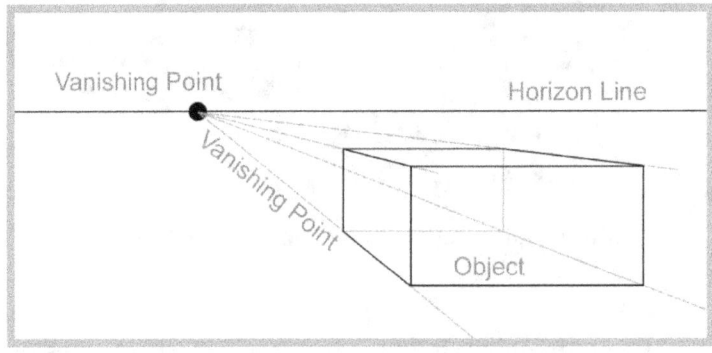

The most important elements in vanishing point perspective

3.4.1 The most important terms

The Horizon

The horizon is the separation line between the ground and the sky. The technically correct description, however, would be "the line at which the view from below and the top view are separated". This means that one looks down (top view) at everything that is located below the horizon line – one is thus looking at the upper face of the object. Conversely, everything that is located above the horizon line is viewed upwards (view from below) – it is thus seen from below.

Even though the Earth is a sphere, the horizon is always perceived as a horizontal line. Obviously, mountains, hills, canyons and such interrupt the horizon line – in order to execute a drawing in perspective, we are forced to just imagine the horizon here.

It is furthermore important that the horizon is always placed at eye level with the observer! The horizon is the most important element in a drawing with vanishing point perspective, and is therefore drawn first.

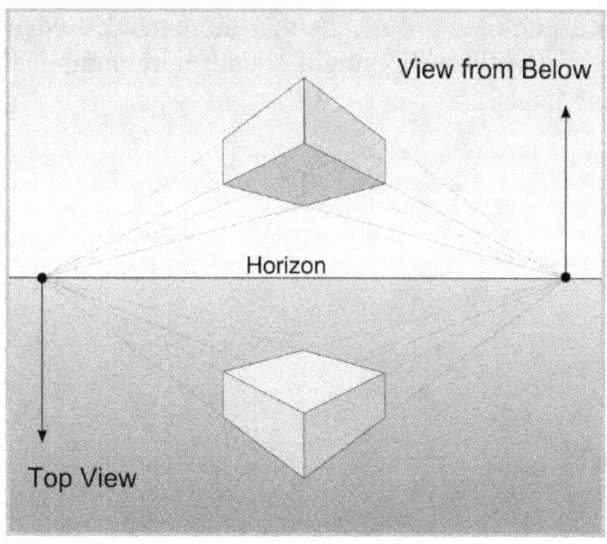

Top view and view from below

<u>Vanishing Point and Vanishing Line</u>

After the horizon line, the vanishing point is the second most important element in a drawing in perspective. With vanishing point perspective, all lines vanish into (i.e. are aligned in) one or several points. These points are called vanishing points. The aligned lines are also called vanishing lines and are frequently extended out to the vanishing point to aid construction of the drawing.

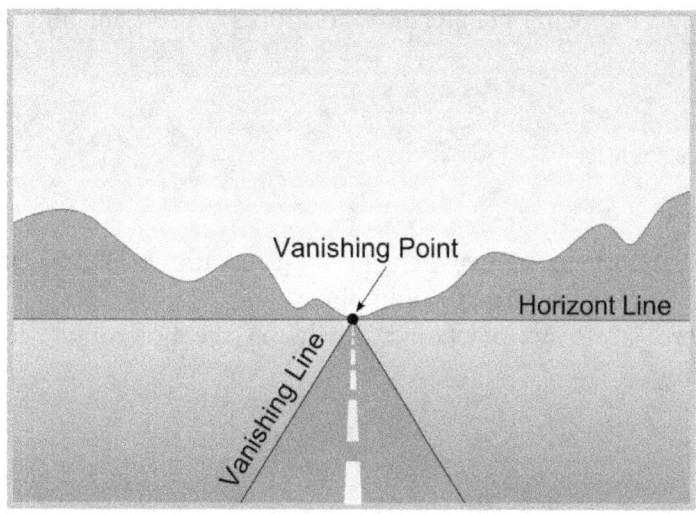

Perspective representation of a simple landscape

That lines are aligned to a point simply means that the extended edges of objects are brought together into a point. In written form this might sound more complicated than it really is. Just take a look at the following image.

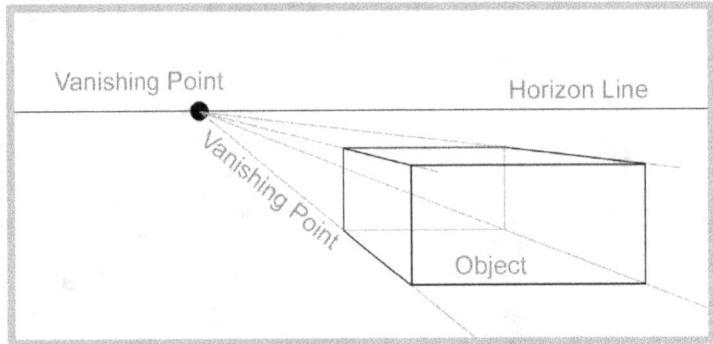

The most important elements in vanishing point perspective

A few important rules for vanishing points and vanishing lines:

- Depending on the spatial position and the form of an object, an individual vanishing point can suffice for representation, or several vanishing points are required.

- Vanishing points that are referenced underground are always located on the horizon line.

- Lines that run parallel to one another vanish into a common vanishing point.

You can discover in the following chapter how to properly use vanishing points and vanishing lines.

The Picture Plane

The picture plane is the surface upon which the image is drawn. Here, the observer's lines of sight are projected, so to speak, onto an upright plane.
The picture plane here is always placed vertically on the horizontal floor, upon which the observer is also standing.

Floor Line / Track

The floor line (also called track) is the intersection line between the picture plane and the floor's surface. Our drawing is created above the floor line.

The most important elements of perspective are illustrated and named once again in the following diagram.

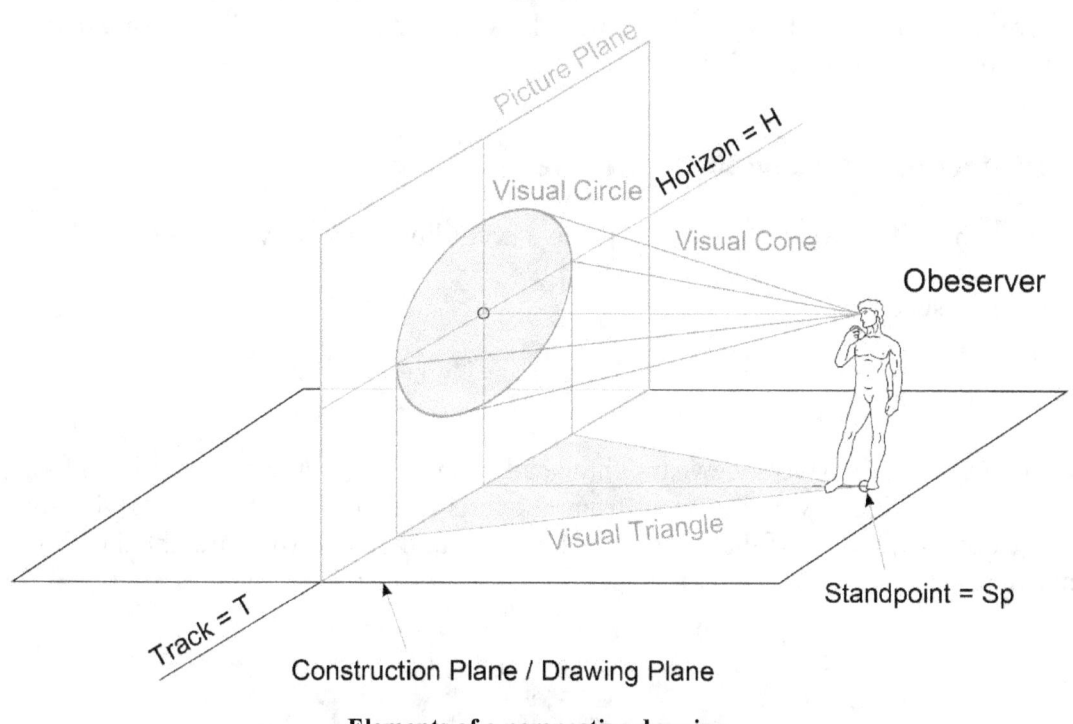

Elements of a perspective drawing

3.5 Types of Perspective

At this point I'd like to offer a small overview of the various types of vanishing point perspective, so that you are prepared for the following chapter. Accordingly, one distinguishes representation in perspective as follows:

3.5.1 Distinctions based on the type of view

We distinguish the following types of perspective according to the view:

- Normal perspective
- Bird's-eye view
- Worm's-eye view

In many cases we don't have a view straight ahead at an object, but from underneath looking up, or from above looking down. The view from above is designated as bird's-eye view and from below as worm's-eye view. If the observer is looking at an object from straight ahead, we call it normal perspective.

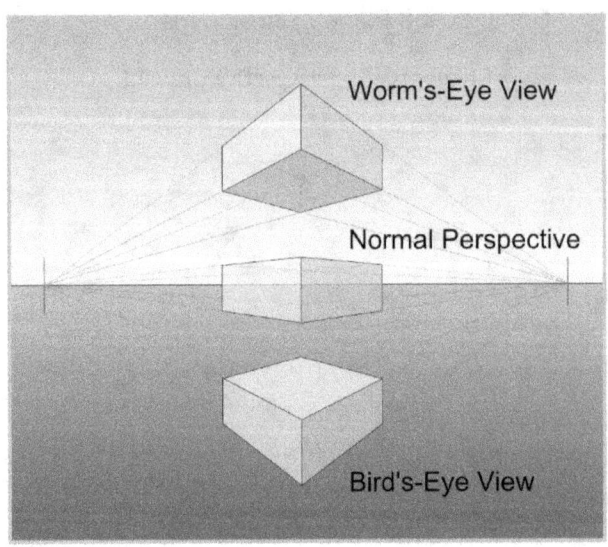

Three types of view – worm's-eye view, normal perspective and bird's-eye view

3.5.2 Distinctions based on the application of vanishing points

Central Perspective

For central perspective with a (primary-) vanishing point, the objects to be displayed are situated with their front surface parallel to the picture plane. As observers, we are thus looking straight on at the frontal face (end face) of the objects. Here we only need one vanishing point for the basic situation.

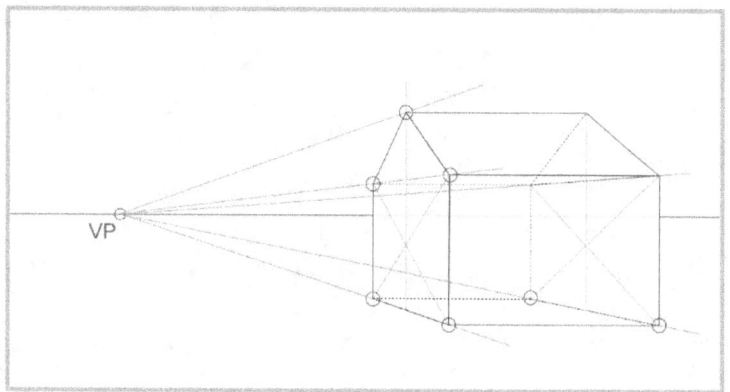

House in central perspective with one vanishing point

Diagonal Perspective

Diagonal perspective represents objects that are positioned at an angle (obliquely) to the observer. For this we need at least two vanishing points.

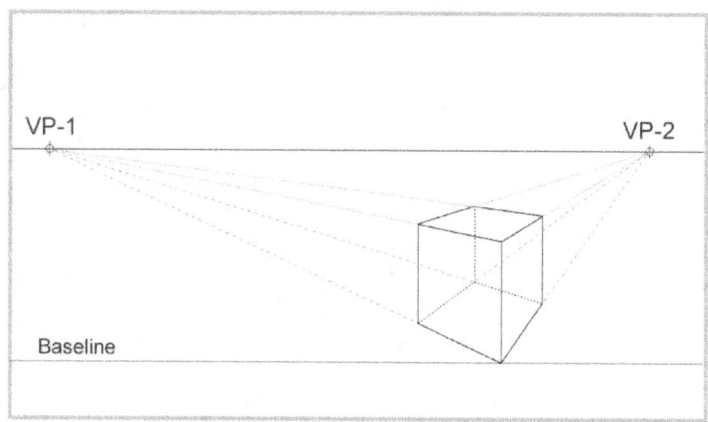

Box in diagonal perspective

Three-point Perspective

With the aid of three-point perspective, one can convey the impression of looking upwards or downwards. As implied in the name, at least three vanishing points are used for this technique.

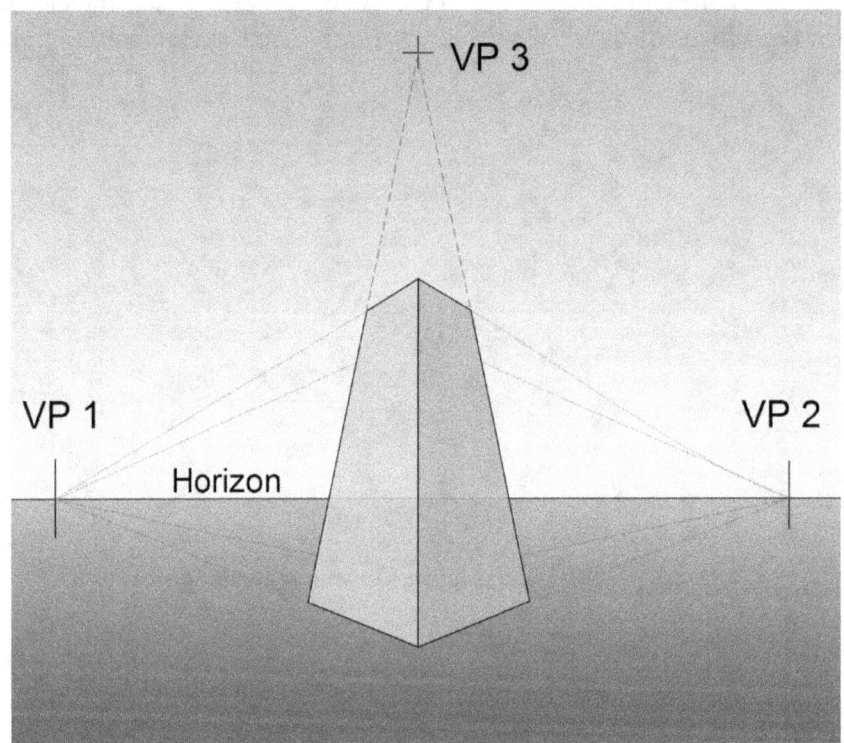

An example of three-point perspective

4 Central Perspective with one Vanishing Point

For central perspective with a (main-)vanishing point, the objects to be displayed are situated with their front surface parallel to the picture plane. We as observers are thus looking straight at the frontal face of the objects.
It can be said that the vanishing point is the point at which the observer's visual axis meets the horizon.

This type of perspective is certainly the simplest form. Only lines that lead back into the depth of space disappear into a vanishing point. Vertical lines are always vertical. Horizontal lines that run parallel to the horizon remain horizontal and do not align/disappear. The entire frontal face is thus not distorted through perspective.

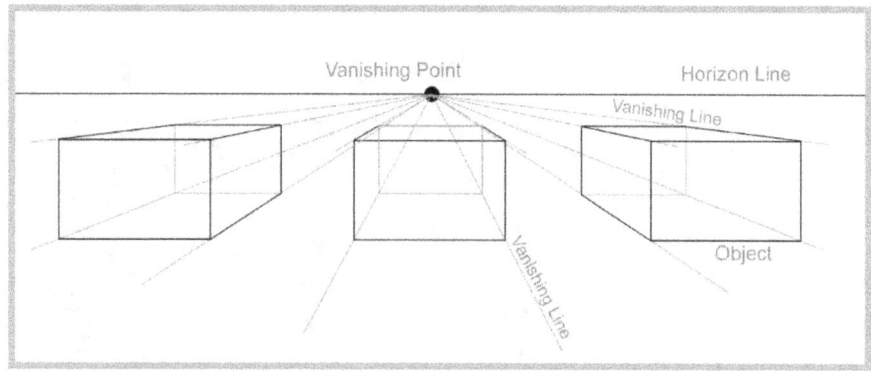

Three cubes in central perspective with one vanishing point

Central perspective with one vanishing point, however, can only be used when the represented objects fulfill the following requirements:

- The objects to be displayed have to stand vertically on the base plane.

- The objects have to stand with one surface head-on to the observer, i.e. the front is parallel to the picture plane.

4.1 Exercise – Central Perspective with one Vanishing Point

And now we would like to translate, with a small exercise, the theoretical principles from the previous chapter into practice. A box with one vanishing point should be drawn in central perspective.
As you proceed, you can view the picture series step by step. A clarification of the individual steps will follow the drawings.

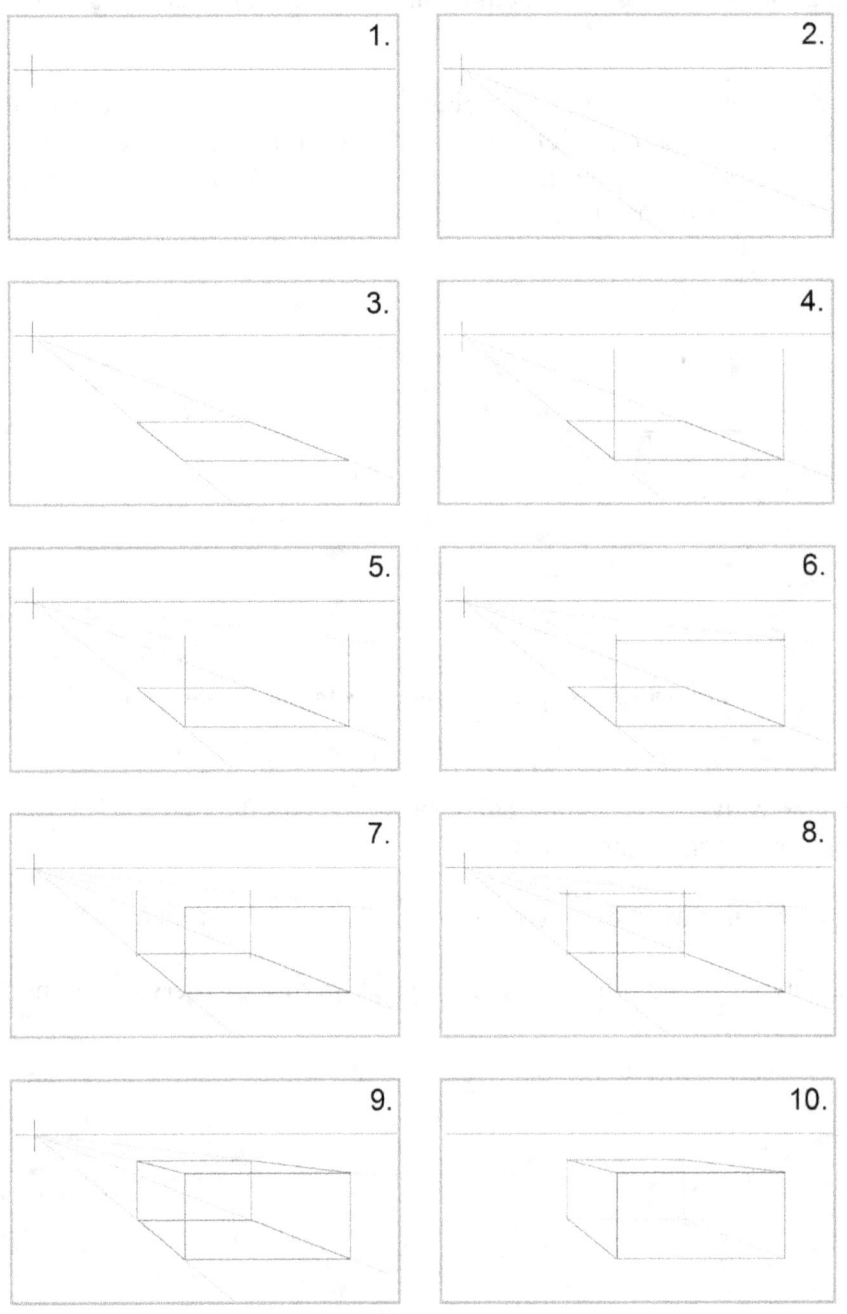

1. As you can see in the first image (upper left), we begin with the horizon line. It is drawn at any desired position. In this step we can also determine the vanishing point at the same time.

2. Now you can draw two vanishing lines that will determine the width of the box. These vanishing lines emerge out of the vanishing point and run in a direction towards the observer.

3. The base of the box is defined by two horizontal lines that intersect with the two vanishing lines.

4. At the corner points of this square, two vertical lines are drawn upwards. These lines represent the edges of the frontal face of the box.

5. Two more vanishing lines are then drawn which intersect with the two vertical lines. The height of the box is determined in this step. The two vertical edges of the box must be intersected at the same height. Step 5 can be executed together with step 6, so that it is a bit easier.

6. In this step, a horizontal line is extended out from one of the two points of intersection – this refers to the two points of intersection between the vertical lines and the new vanishing lines. This line represents the front upper-edge of the box.

Moreover, the point of intersection for the second vanishing line, which we have already drawn in Step 5, would appear due to the horizontal line. Thus one could also proceed in such a manner that one draws only one vanishing line at first, then the horizontal upper edge of the box and, finally, the second vanishing line.

7. In the seventh step, two further vertical lines are drawn on the two back corner points of the floor area.

8. The new points of intersection can once again be connected to each other by a horizontal line.

9. And now you only have to represent the upper face of the box by drawing in the upper vanishing lines.

10. If you now remove the extraneous construction elements (vanishing point and vanishing lines), you'll get the completed box drawing in perspective. The hidden edges are represented in light grey in the drawing.

4.2 Drawing a Pathway

Drawing a pathway is even easier than drawing a box. For the simplest version, you only need a horizon, one vanishing point and two vanishing lines. It can also get a bit more complicated, as you will see in the following examples.

In the image below, you can see the simplest version with a road that runs straight as an arrow in the direction of the horizon. From a creative design point of view, it is advisable to avoid this form of representation, because the observer's gaze is conveyed straight ahead and out of the image. Routes and/or roads that progress in a serpentine line are considerably better for the creative design, since they are much more interesting for the viewer. And we can still work with vanishing points in this context.

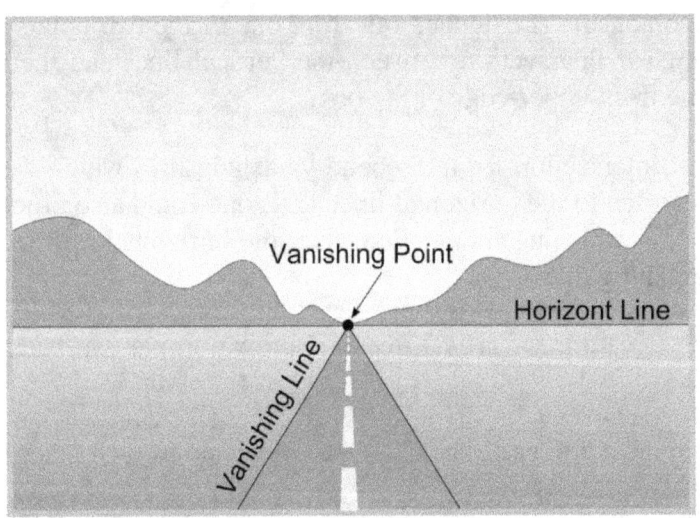

Perspective representation of a simple landscape

4.3 Drawing a Curved Pathway

The preferable version from a design point of view is a pathway that curves back and forth. The observer is motivated to follow the course of the path with his eyes. The image also appears much more natural and not so static.

In a drawing with perspective, one can create a curved road design by using several vanishing points. In order to achieve the points of intersection for the opposing road section, we draw a horizontal line at the desired location, as represented in the diagram below.

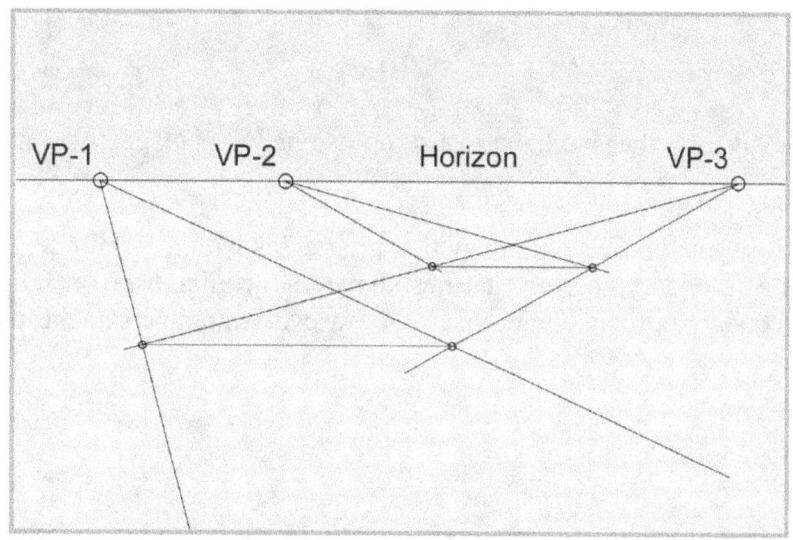

Construction of a curved pathway

In order to optically improve the drawing, we need to round out the corners. It is necessary here to work with a bit of artistic intuition.

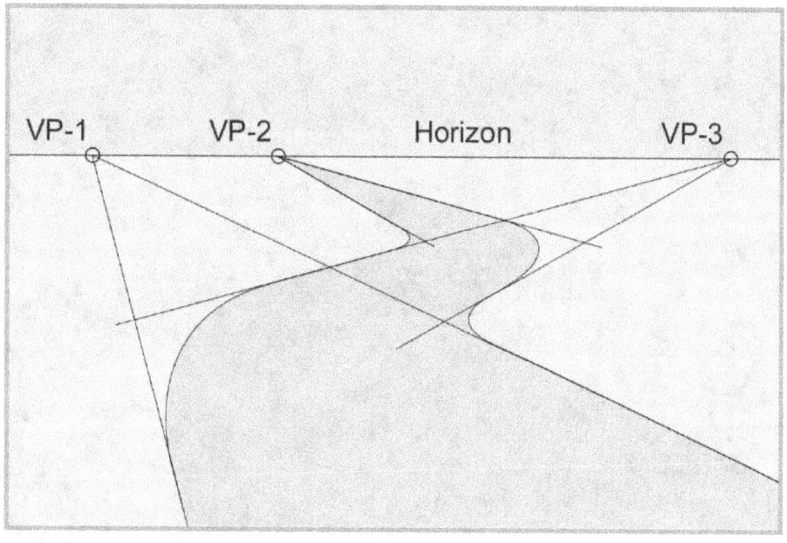

4.4 Drawing a Pathway with an Incline

Here is another small trick that we have to use occasionally – perspective representation of an incline.

In the example below you can see a pathway that progresses with a certain degree of incline. For this we only need a secondary horizon that lies above the genuine horizon. The vanishing point now lies on the secondary horizon. Otherwise we draw everything the same as usual.

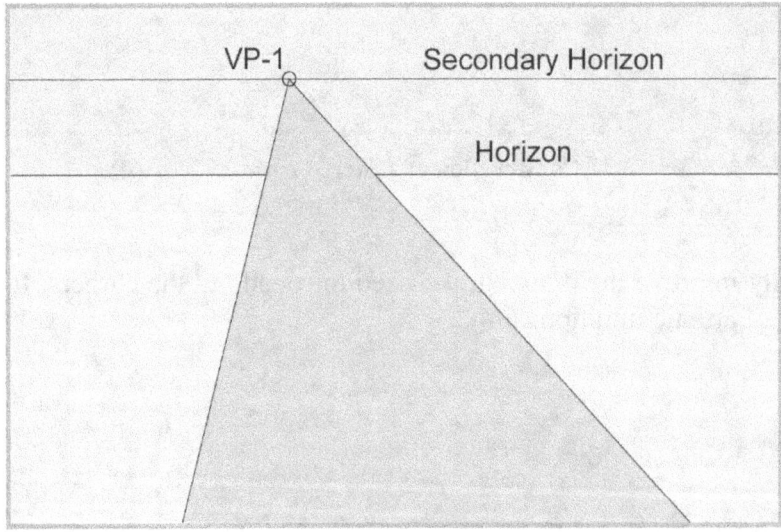

4.5 Drawing a Pathway with a Downward Slope

The opposite of the previous example is a pathway with a downward slope. A pathway with a downward slope is a bit more difficult to draw, as you will see shortly.

Again we need a secondary horizon, which lies underneath the genuine horizon this time.

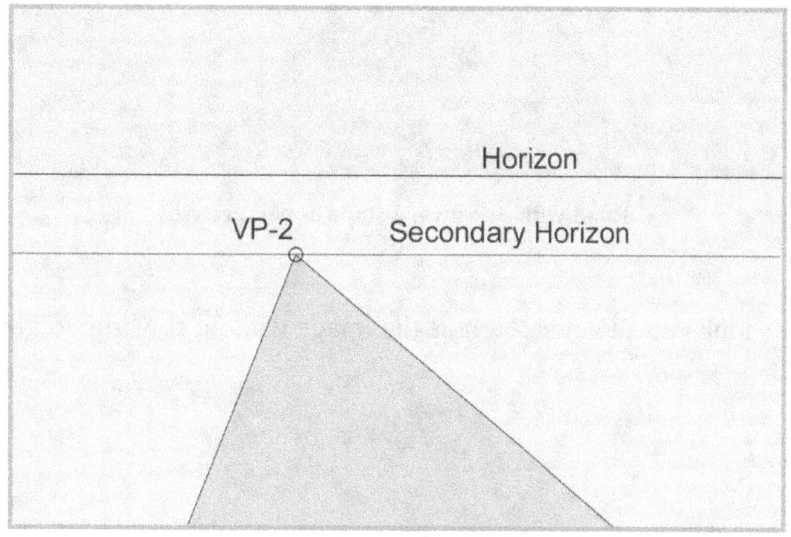

Road with downward slope in perspective

The drawing still looks a bit confusing, since the pathway is not able, ultimately, to simply run into the ground like this. In order to render the representation more plausible, we have to include some more geometry.

So, we want to imagine here that the pathway ends at a certain point and concludes in a wall. We can compare this set-up with an entryway into an underground garage that has a closed door.
For the representation, we have to draw the same pathway without a downward slope. The vanishing point VP1 lies directly over the VP2 on the genuine horizon. In that place where the concluding wall stands, we draw two vertical lines that combine the two vanishing points of VP1 and VP2 together.

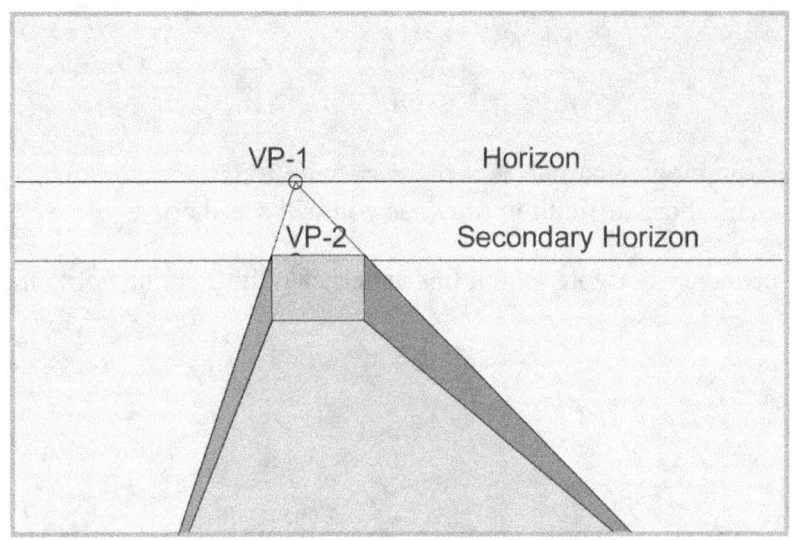

Road with downward slope in perspective

And now the set-up looks much better. Here is the image without construction lines:

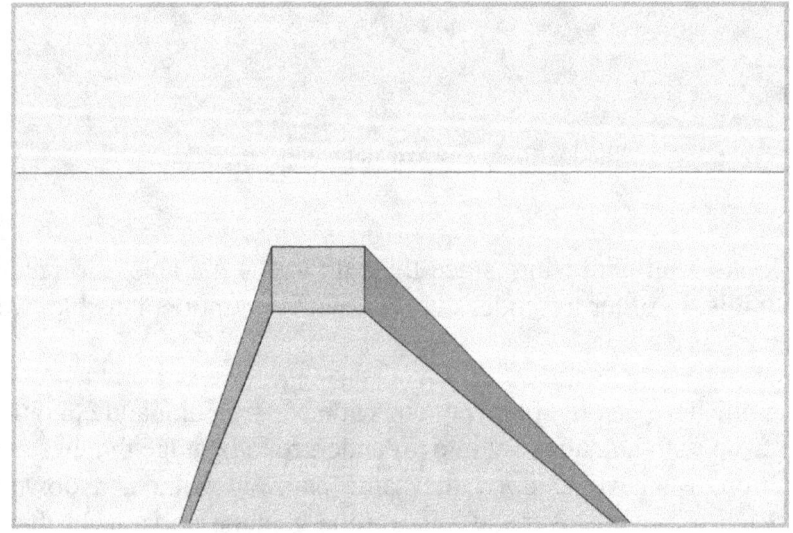

Road with downward slope in perspective

Of course, this image is just an example. Depending on the situation, entirely different representations can be achieved.

4.6 Drawing a Curved Pathway with an Incline

And now another exercise in which we combine two of the previous lessons with one another:

1. A pathway with an incline.
2. A curved pathway.

First of all, draw a curved pathway with the aid of two or more vanishing points.

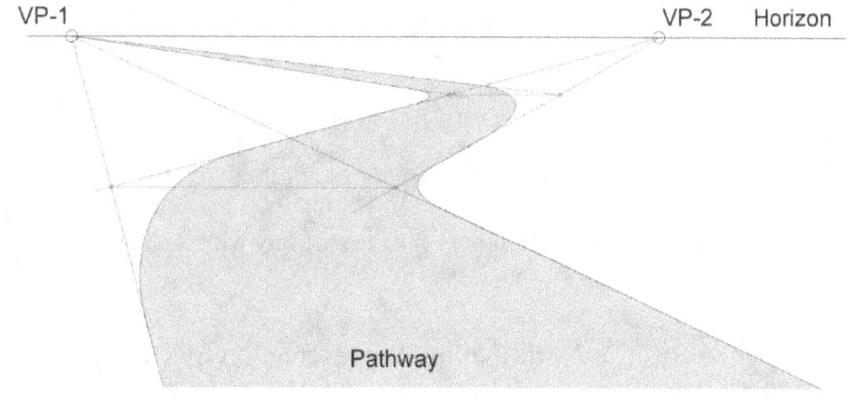

Curved pathway with two vanishing points

And now we have a construction that looks more complicated than it actually is. We proceed in the same manner as in the previous examples.

Simply draw a second horizon that lies above the normal horizon. Transfer the vanishing points (VP1 and VP2) to the second horizon (VP3 and VP4). And now begin with the front section of the pathway that you represent as a path with incline. The points of intersection of the curves (of the pathway without incline) can be transferred with the aid of vertical lines to the new vanishing lines. The respective vanishing lines of the corresponding vanishing points now run to these points of intersection.

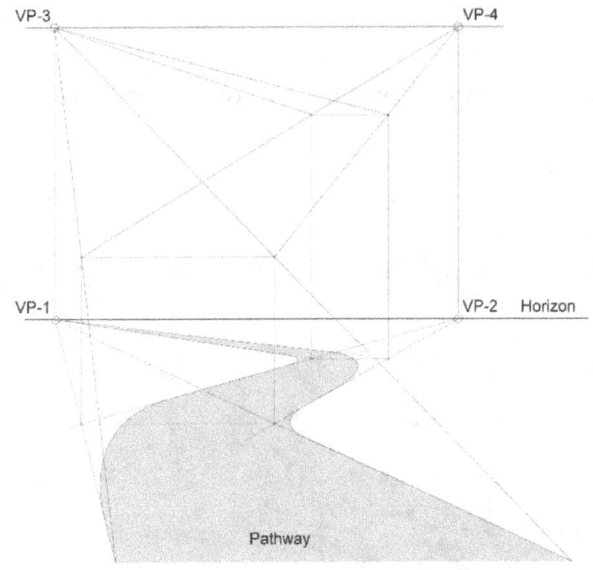

Auxiliary construction lines for the pathway with incline

And now we can draw the pathway with incline. Representation of the curves is ideally carried out freehand and by feel.

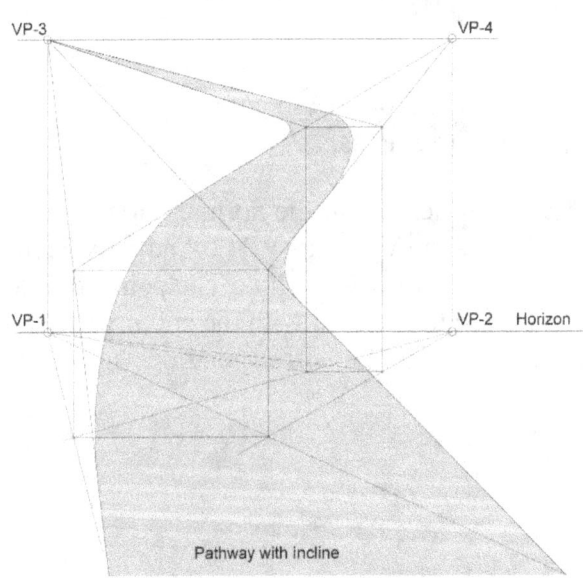

Curved pathway with incline

The drawing looks like this without the construction lines:

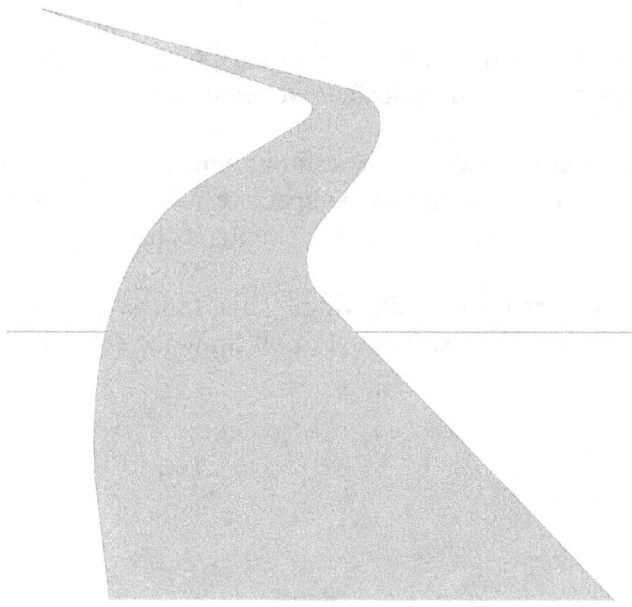

Curved pathway with incline

4.7 Drawing a Cube (Box with equal Edge-Lengths)

Drawing a box in central perspective with a vanishing point is not difficult. And now you will get an assignment that is a bit more complicated: we want to draw a cube.

In geometry we define a cube as a rectangular solid in which all edges have the same length. The difficulty that one runs into concerning this perspective representation involves the problem of initially not knowing how far (deep) the solid object extends back into space.

Let's just begin with the perspective drawing. This time we want to proceed somewhat differently compared to before. That is, we first of all draw the complete frontal face of the cube on the base line.

Then we define a vanishing point and extend vanishing lines to the four corner points.

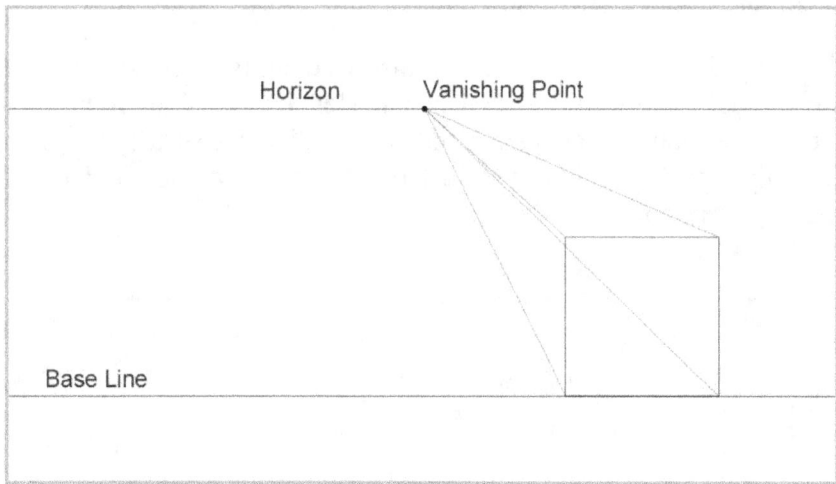

At this point, the problem becomes obvious. How far back in space is the back edge of the cube?

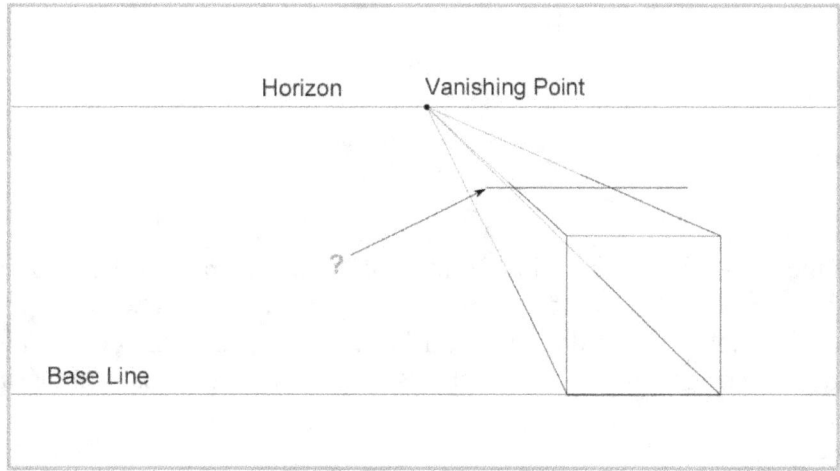

In order to solve this problem, we need two additional vanishing points: the vanishing points of the diagonals.

These vanishing points are given this name because we are able to determine with their help the diagonal lines for the upper face and lower face of the cube.

As you can see in the image below, it is possible to determine the vanishing points by means of the eye point. This point gives the distance from the observer's eye to the drawing, from which the illusion of perspective seems to be perfect.

The 90° angle corresponds to our field of vision (also frequently referred to as sight cone or sight triangle), in which visual distortion does not occur. Hence, if an individual as observer is at a certain distance from the picture that corresponds to the distance of the 'vanishing point – eye', then the two vanishing points are located just on the edge of the field of vision, in which distortion of objects does not occur.

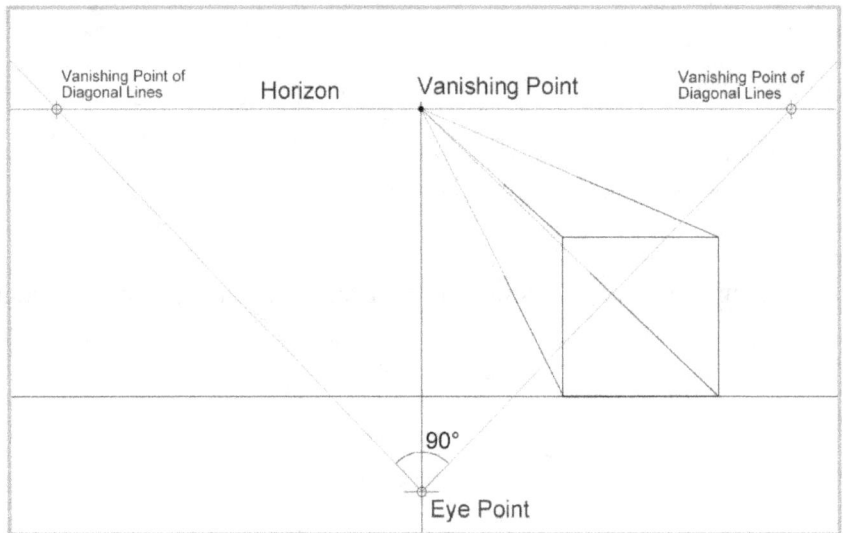

With the aid of these additional vanishing points, we can now draw in the diagonal lines on the upper face of the cube. At that point at which a diagonal intersects with the respective upper vanishing line of the cube, we can draw the rear horizontal edge of the cube. This sounds much more complicated in written form than it really is in practice. Just take a look at the following drawing.

The depth of the cube is thus defined. In principle, it would be sufficient here, of course, if we only drew one diagonal line.

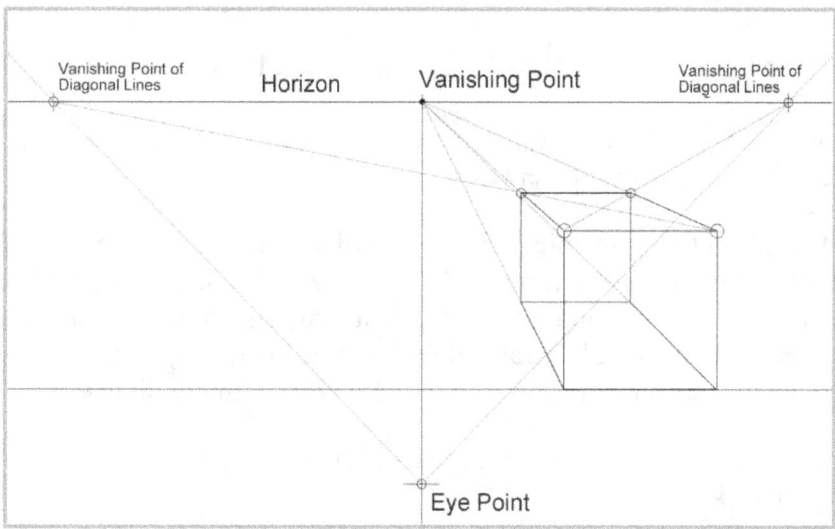

And here is how the cube looks without the aid of reference lines and construction lines:

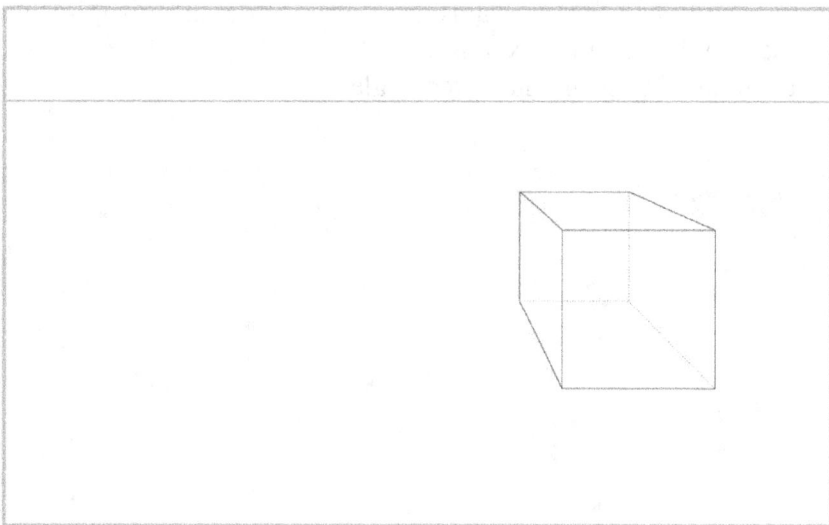

4.8 Representation of Repetitive, Equal-Sized Elements

And now we come to another favorite topic regarding perspective drawings: representation in perspective of repetitive, equal-sized elements.

It sounds complicated, but in principle it simply involves the drawing of a chessboard pattern, cobblestones in the street, or similar forms. With this method, one would just have to divide the ground into equal-sized squares and use them as a starting point for further elements – for instance for columns that are equally arranged with various patterns, or a boulevard with trees in equal distance from one another. The possibilities here are extremely diverse.

How you can draw such a pattern in perspective is something that can best be learned in the following step-by-step exercise.

Exercise – a Chessboard in Central Perspective

Begin by simply drawing a square in top view. The square can be placed in the middle of the picture as shown in the drawing below. Representation with perspective is accomplished with one primary vanishing point and the two vanishing points of the diagonals with which you have just become acquainted in the previous exercise.
(Remember: we want to draw a square, not a rectangle.)

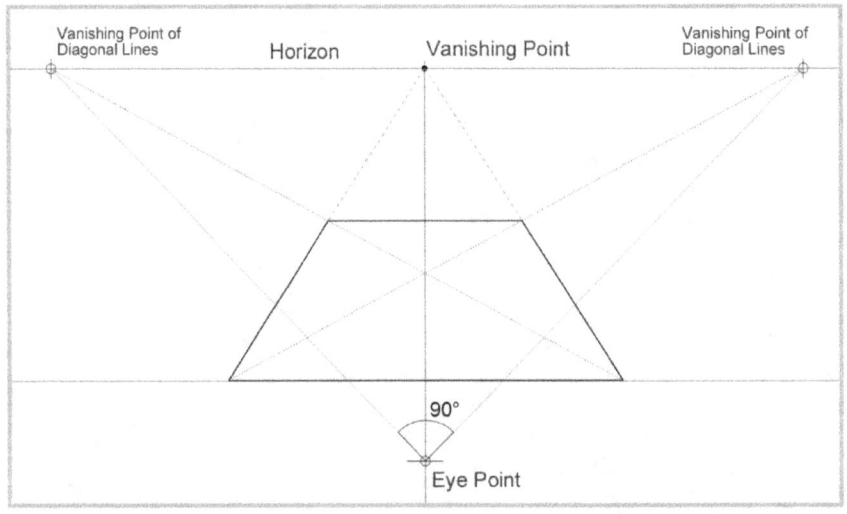

Now the front edge of the square is divided into eight lengths (a) of equal size.

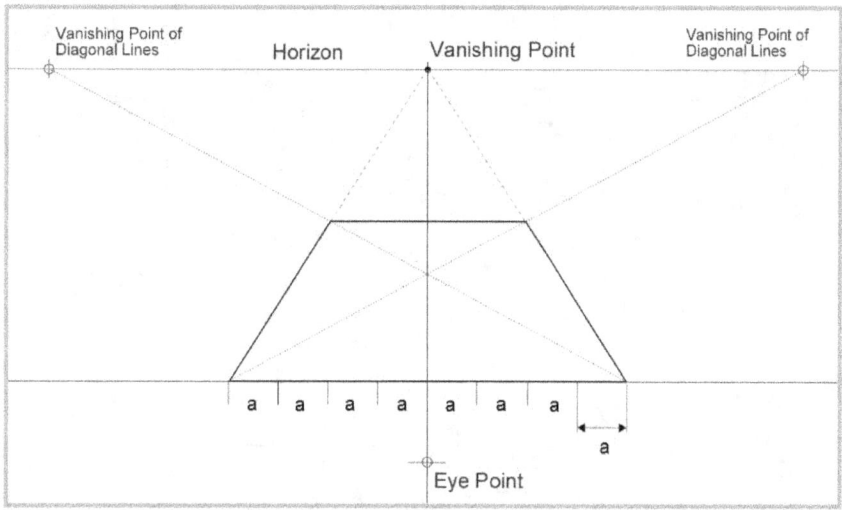

With the aid of this subdivision and the vanishing point, you can now extend lines into the background. This was the simpler part of the exercise.

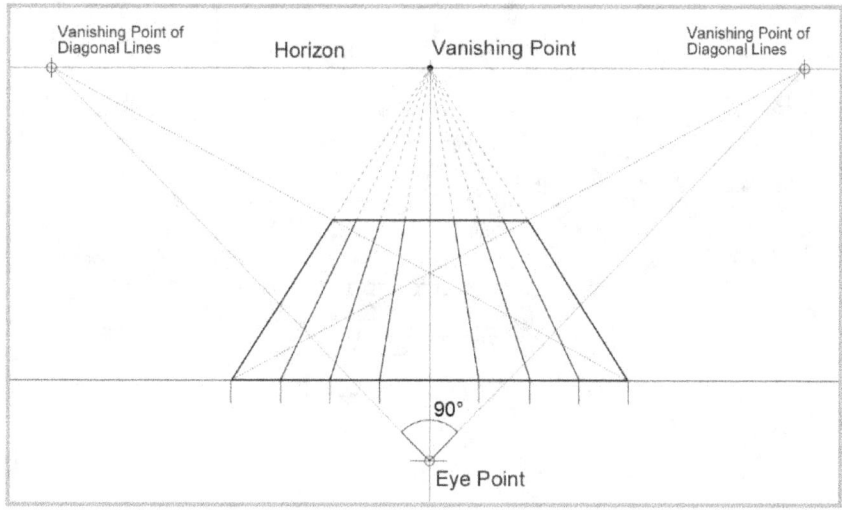

As in the previous example, representation of the horizontal lines into the background depth is more difficult. At this point the two diagonal lines of the square are once again deployed:
We mark the points at which diagonal lines and depth lines intersect.

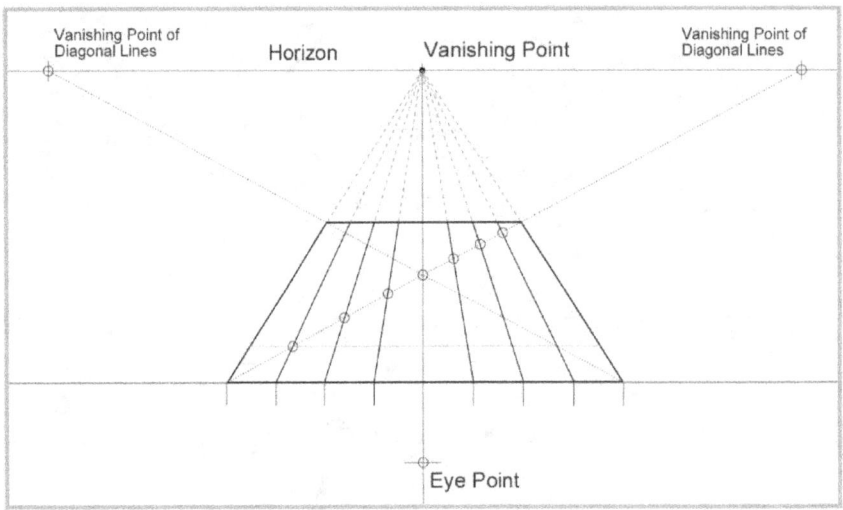

You can draw horizontal lines at these points of intersection – and, voila, the chessboard is finished!

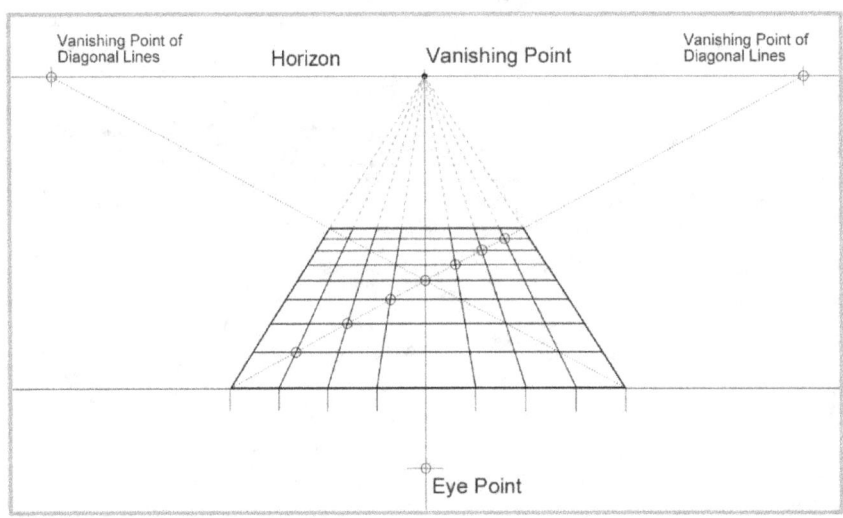

By using color in the design, the line drawing becomes a genuine chessboard.

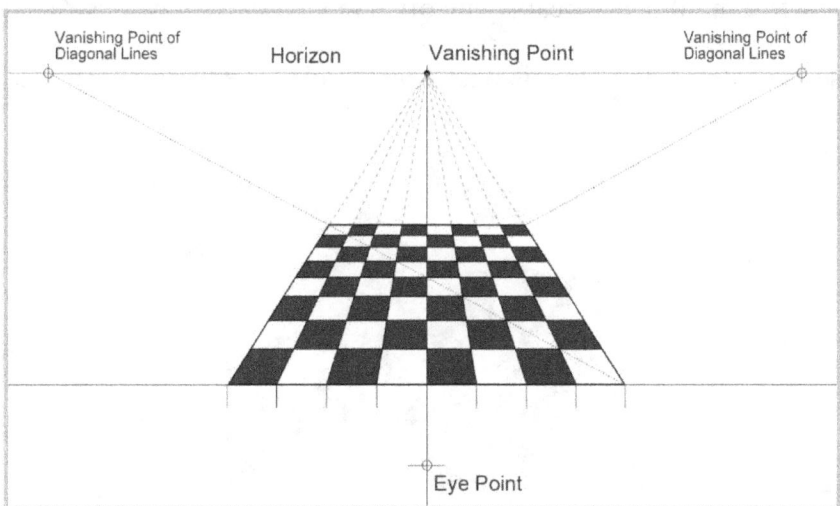

Once you have erased the construction lines and vanishing points, the image is finished.

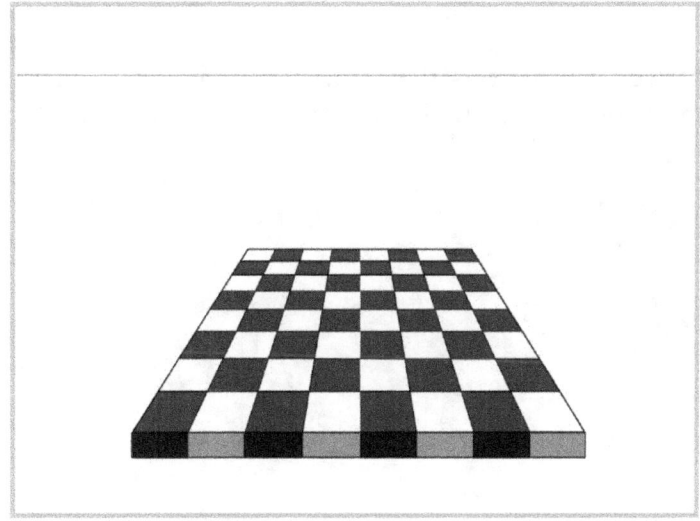

As previously mentioned, by making use of this technique you can also represent other kinds of objects that are arranged in a uniform pattern. Examples of this are trees, vineyards, street cobblestones, etc.
With a chessboard-like subdivision, we can also prepare a base grid for any desired drawing. This sometimes simplifies our work, even if we don't strictly adhere to the subdivision of the square.

4.9 Drawing a House

And now we come to a motif that appears quite often in landscape drawings – a house.

Drawing a house in central perspective is relatively simple. The basic object is a box – we have thus far practiced this enough.

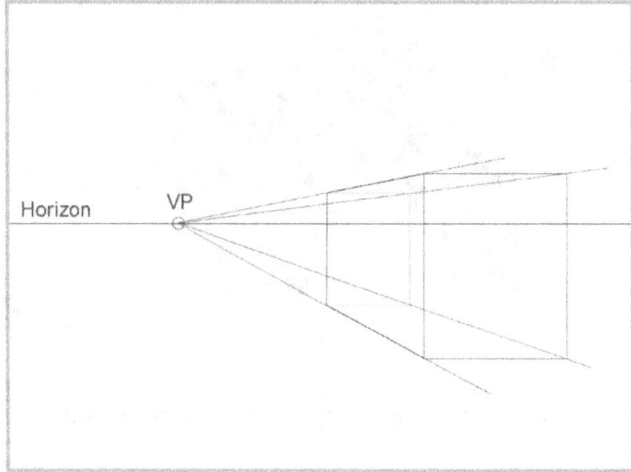

The thing that is however new here is the roof. A roof is an oblique plane that is, with a vanishing point in central perspective, still quite easy to depict.

Draw the diagonal lines of the end faces of the house, in order to determine the center point of these faces. Then a vertical line is drawn through each of the two center points.

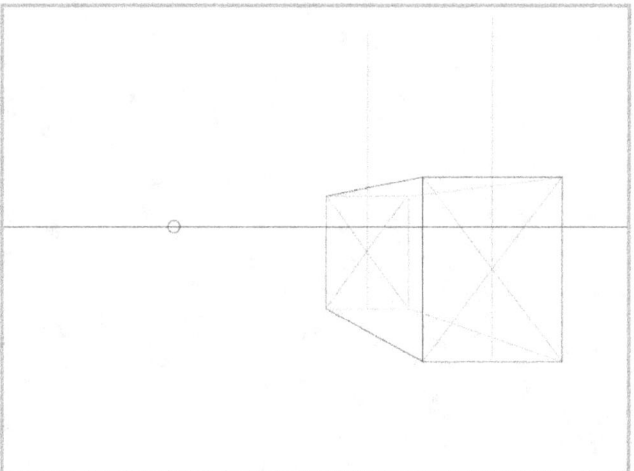

A vanishing line that intersects the two vertical lines forms the roof ridge (upper ridge of the roof).

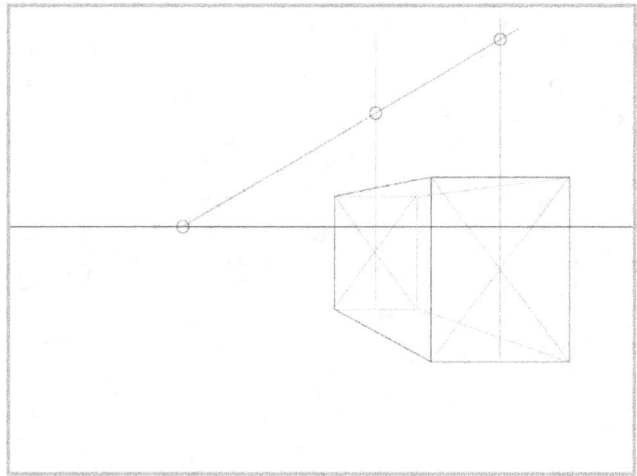

And now you can draw the roof gable with the aid of the two intersection points.

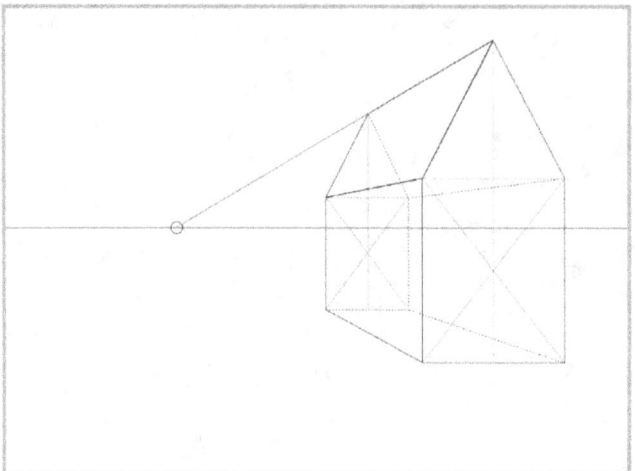

And now the house is finished.

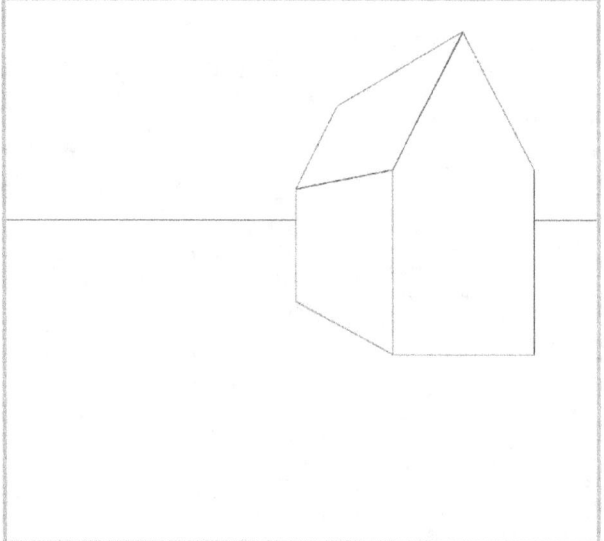

And with a bit of shading in the design, the picture looks like this:

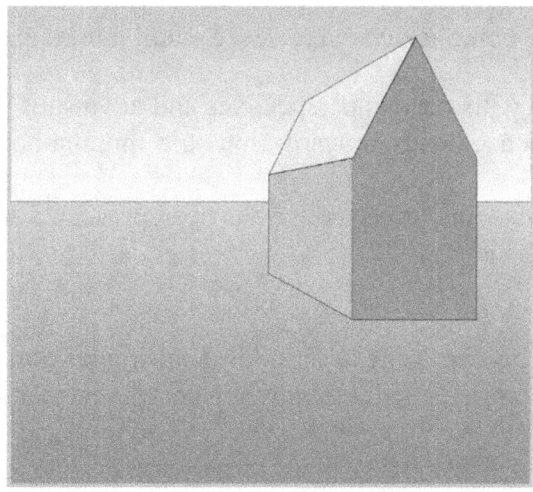

4.10 Exercise – a House with Side View

Now try to draw, on your own, a house with a side view. You can see in the drawing below what the final result will look like.

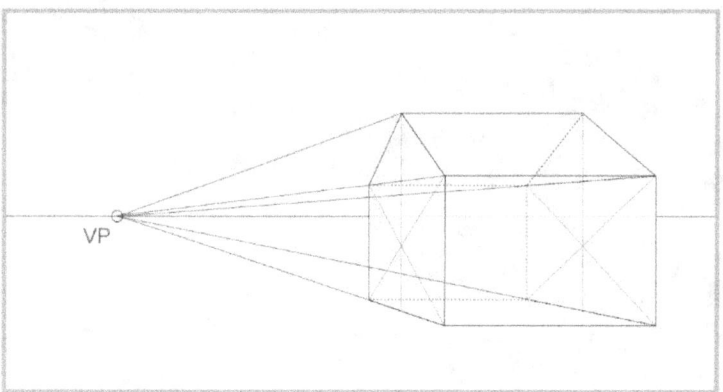

4.11 Exercise – Houses in the Mountains

And now you can try a more complicated exercise – a small landscape picture.

Simply draw several houses with various perspectives and at various altitudes. A road progresses between the houses and then extends upwards into the mountainous landscape. A few cliffs complete the picture.
The knowledge required to execute this exercise has been presented in the previous example and exercises. Thus it is not so difficult.

And one more small tip:
While drawing the cliffs, you can achieve an additional impression of depth by working with aerial perspective – the objects become increasingly paler, the farther away they are situated.

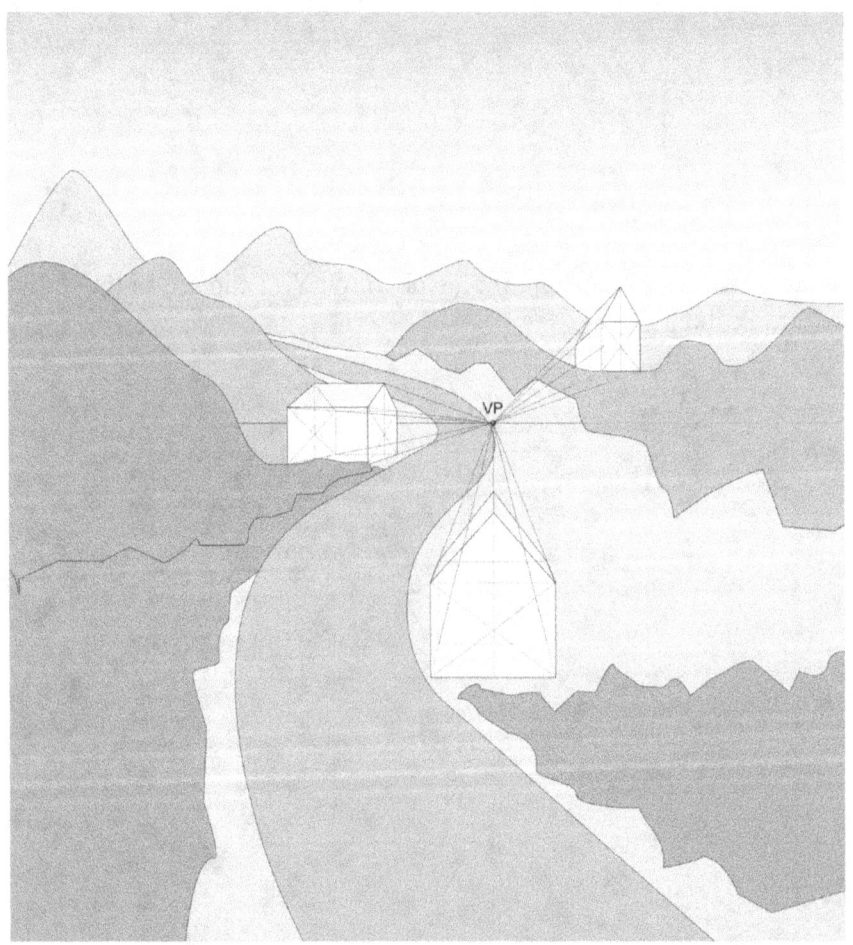

Cliff landscape with houses in various perspectives

In the previous picture, you can see the drawing with the vanishing lines for the houses. For the representation below, the reference lines for the road are additionally included.

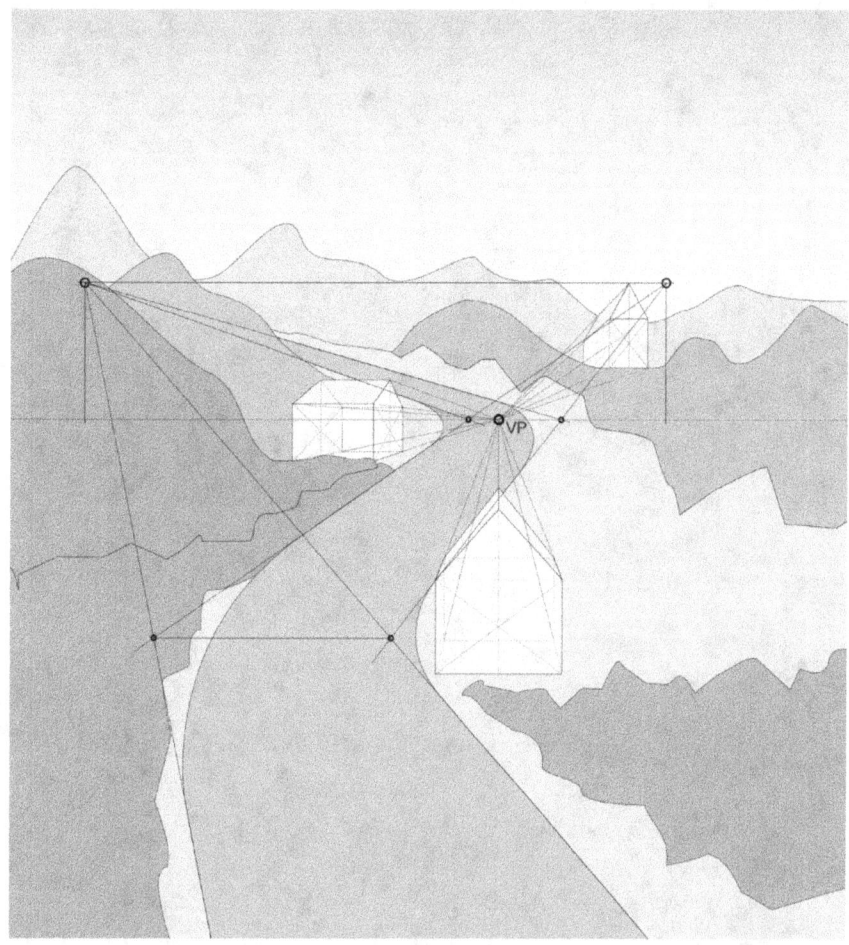

If we remove all of the reference lines, the drawing turns out like this in the following illustration. Make sure in this case that the horizon as well is removed, since this lies behind the mountains. Your own drawing can, of course, look entirely different. Draw the houses, roads and mountains in a style that is pleasing to you.

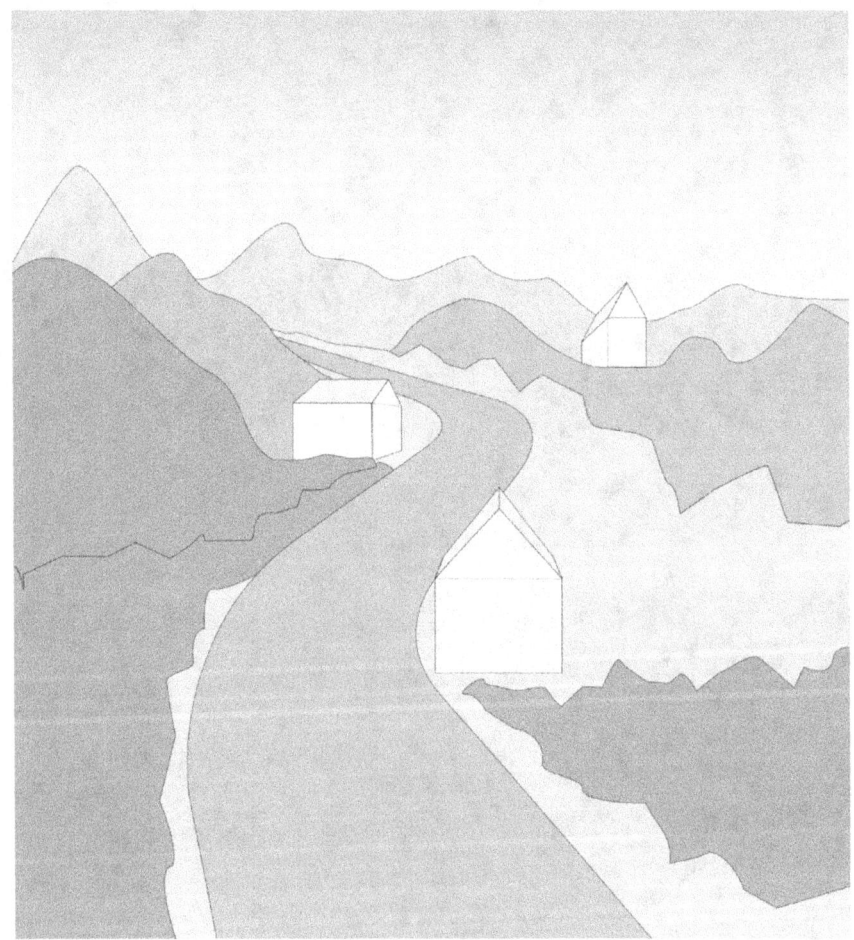

5 Diagonal Perspective

In this chapter you will learn how you can draw objects in diagonal perspective (also called oblique perspective or two-point perspective). The central perspective covered in the previous chapter, included the limitation that one could only represent objects in perspective from the front.

Diagonal perspective, conversely, presents objects that are positioned at an angle (oblique) to the observer – as portrayed in the picture below. You will learn how to deploy this technique in the following exercise.

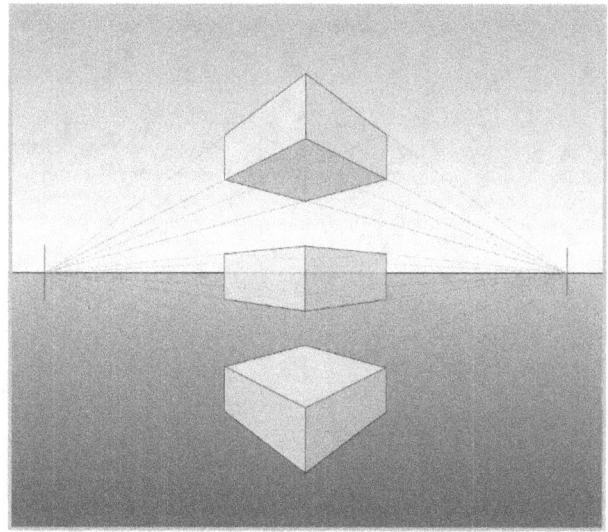

Objects in diagonal perspective

5.1 Drawing a Box in Diagonal Perspective

In the following exercise, we would like to try to draw a simple box in diagonal perspective. This object represents one of the simplest motifs for this technique.

You can find the step-by-step development of the box on the following page. A clarification of the pictures then follows.

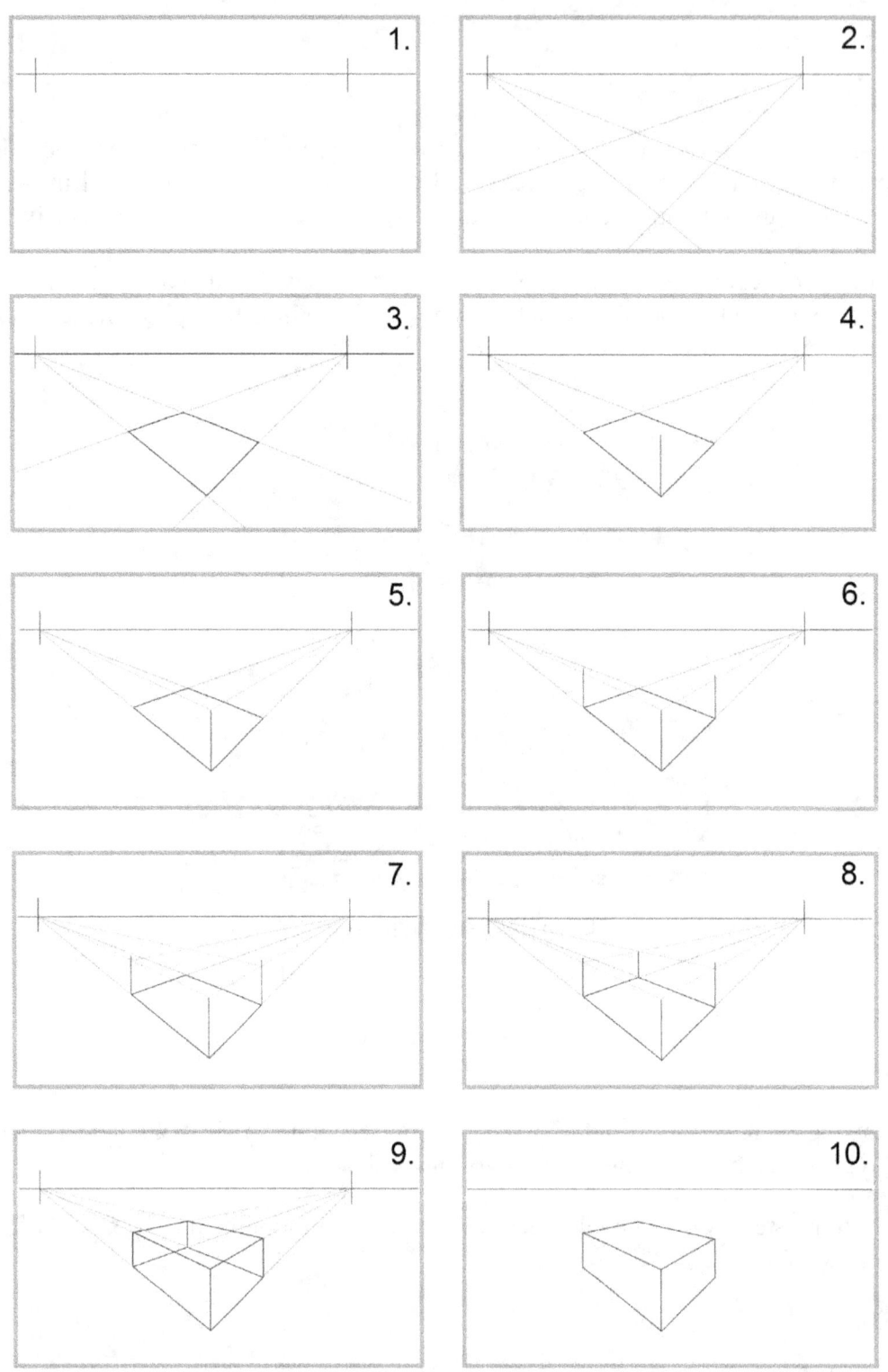

1. For diagonal perspective we need two vanishing points (similar to the two vanishing points of the diagonals). Therefore, we first of all draw the horizon and mark two vanishing points – one left and one right.

2. Starting from the two vanishing points, we now extend two vanishing lines each which define the lower surface of the box.

3. The lower surface of the box can now be drawn in.

4. Next we come to the front edge of the box. The height of the box is then defined by this edge.

5. And now we extend two vanishing lines – respectively from the left and right vanishing point – to the upper point of the edge.

6. With the aid of these vanishing lines, we can now extend the two side edges up vertically. These two lines are automatically shorter than the front edge, as it is required according to the guidelines for perspective representation.

7. We can now draw two more vanishing lines up to the points at which these two side edges intersect the upper vanishing lines.

8. The two new vanishing lines define the height of the back vertical edge of the box.

9. Thus the form of the upper surface of the box is also defined.

10. If we remove all reference lines and the hidden edges, the drawing of a box in perspective is now complete.

5.2 Drawing a Cube that Has Been Shifted by 45°

In the previous exercise you learned how to draw any desired box in diagonal perspective with two vanishing points. Now the lesson gets a bit more specific – in this exercise, a cube (a box with equal-length edges) will be illustrated in a 45° angle.

We have already covered the challenges involved with cubes in the section on central perspective. Here we needed additional vanishing points in order to be able to construct the perspective. For two-point perspective as well, we need a few additional aids. In this example, the box should not only possess a defined edge length, but should also be placed in a specific angle to the observer. Let's get started.

First of all draw the most important elements on the paper. This includes the two vanishing points, the horizon and – very important for this exercise – the sight triangle with the eye point. The sight triangle here is also reflected upwards from the horizon.

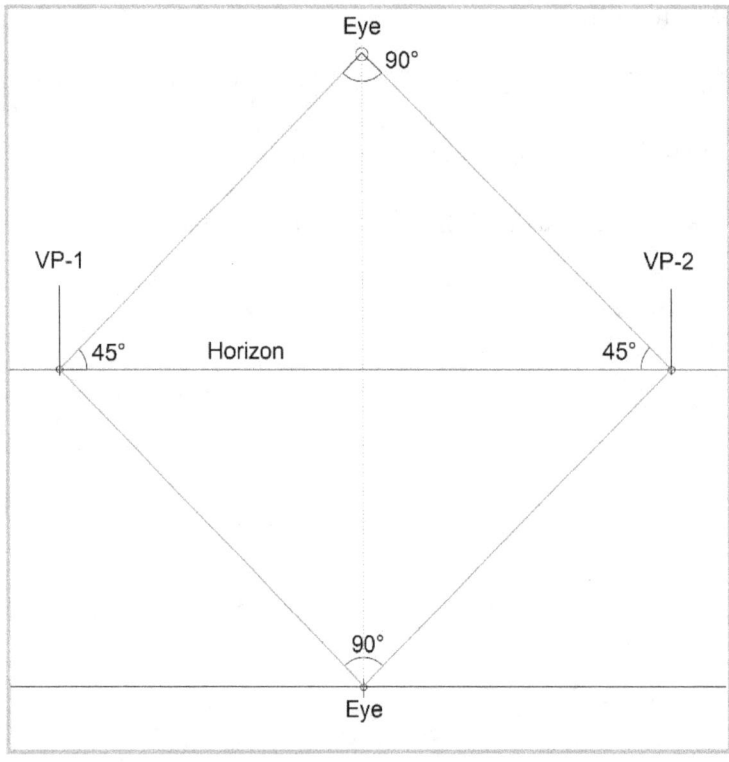

You need a drawing compass for the next step.

Place the point of the compass precisely on vanishing point 1 and draw an arc from the upper eye point to the horizon. Repeat this for vanishing point 2. This will result in two reference points on the horizon line.
Your drawing should now look like the image below.

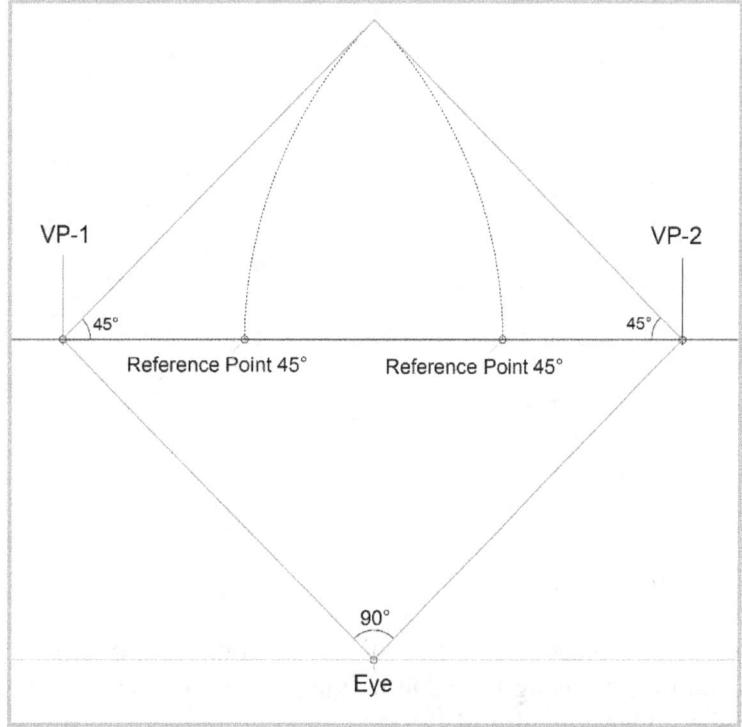

So now you can begin drawing the cube. The procedure in the beginning is similar to that for the box. You'll draw the front vertical edge of the cube and extend vanishing lines for the side edges down to the lower and up to the upper endpoint of the vertical lines.

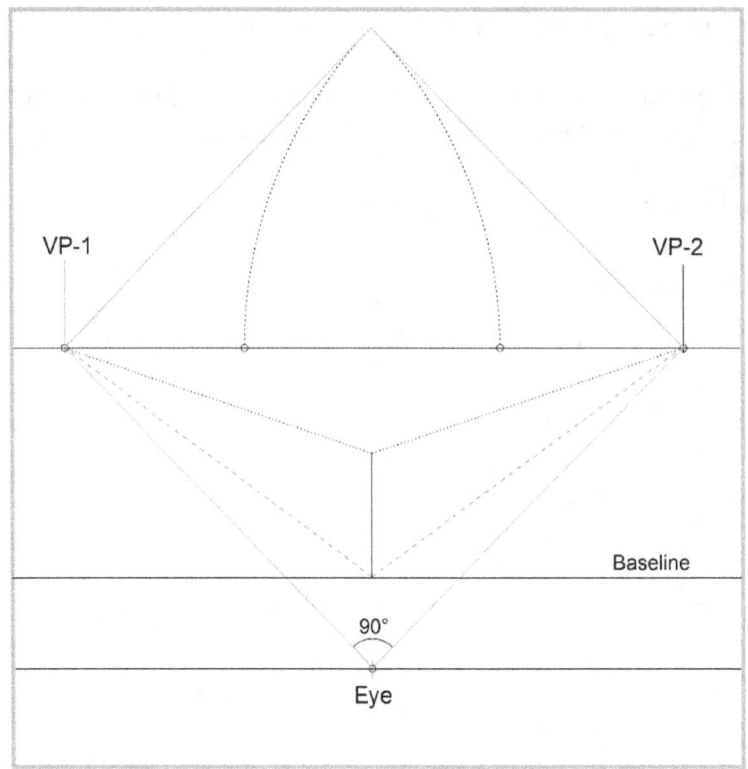

And now something else that is new:

Take the compass again and place the point at the lower endpoint of the verticals (edge of the cube). Now draw a semi-circle using the edge height of the cube as the radius. The semi-circle should extend from the upper endpoint of the vertical edge to the base line – out to the left and right side respectively.

The two points where the semi-circle intersects with the base line once again represent two construction elements. Starting at the two intersection points, we now have to extend a line from each up to the 45° reference points on the horizon, so that the two lines cross.
Take a look at the following image, to help you visualize the procedure.

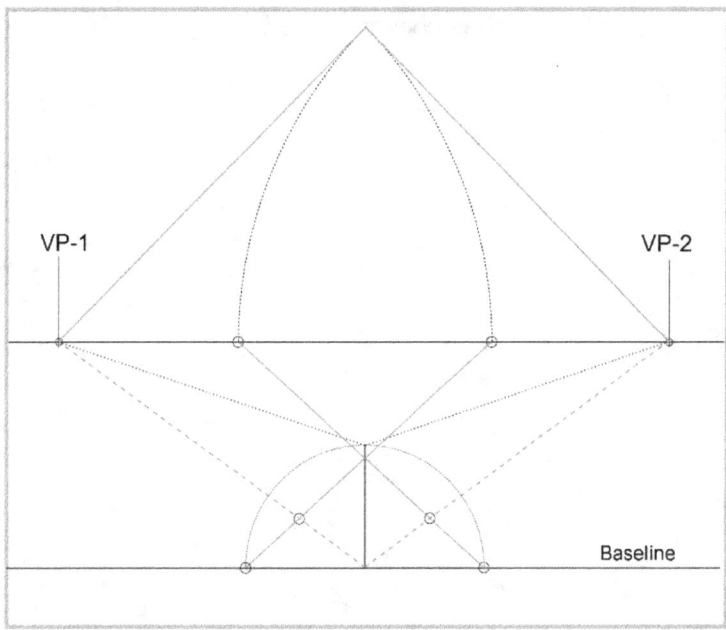

As you can see in the image above, the two new reference lines intersect with the lower vanishing points of the cube. Precisely at these intersection points, you can now draw the two outer cube edges upwards until they intersect with the upper vanishing lines.

We can now draw four more vanishing lines down to the intersections that have emerged. The geometry of the cube has in principle been already established in this step.

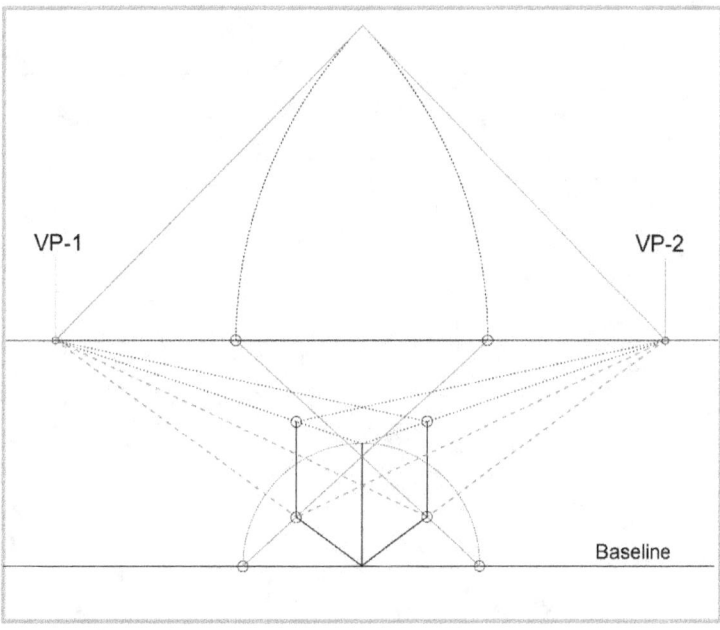

Now you can draw all of the edges of the cube, as in the image below.

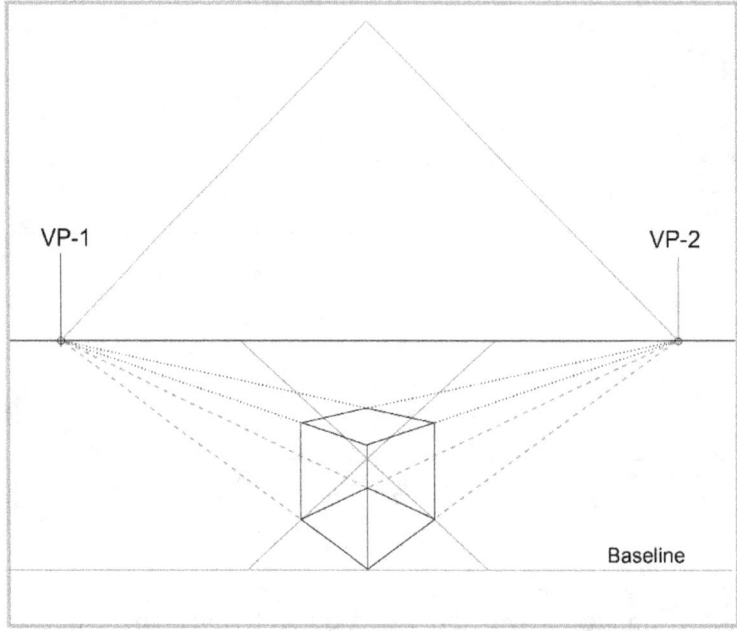

Once the reference lines and points have been removed, the completed drawing of the cube is visible.

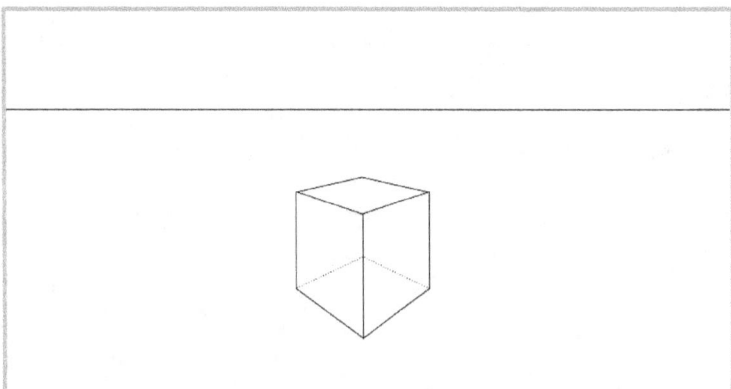

5.3 Drawing a Cube That Has Been Shifted by 30°

Not every object is shifted by exactly 45° to the observer, so we will now try to draw a cube with a different angle. We'll try 30°. The procedure is similar and overlaps in a few details.

We'll begin the exercise with a representation of the most important construction elements. The crucial difference when compared to the previous exercise is that this time the sight triangle is drawn with a 30° (or 60°) angle to the horizon. For best results, use a geometric triangle.

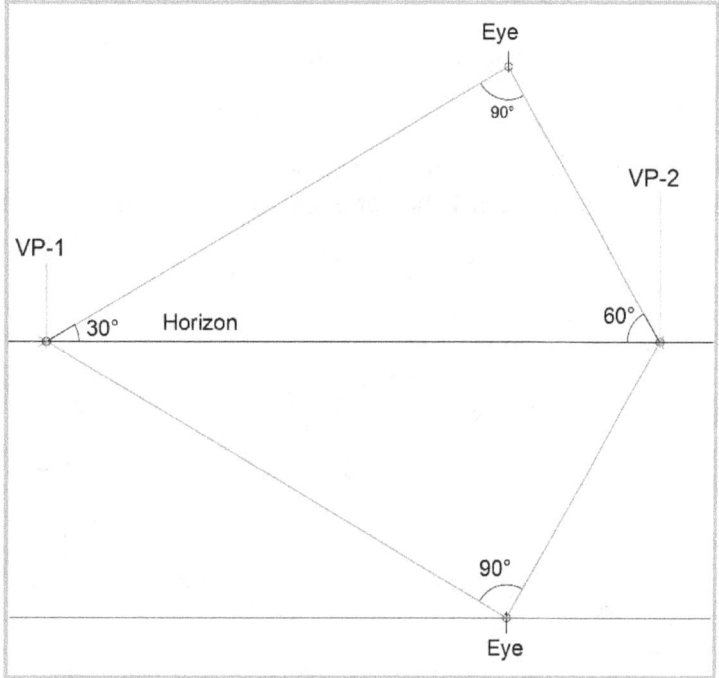

For the next step you'll need a compass again.

Place the point of the compass precisely on the vanishing point 1 and draw an arc from the upper eye point down to the horizon. Repeat this for vanishing point 2. You will thus acquire the 30° and 60° reference points on the horizon line.

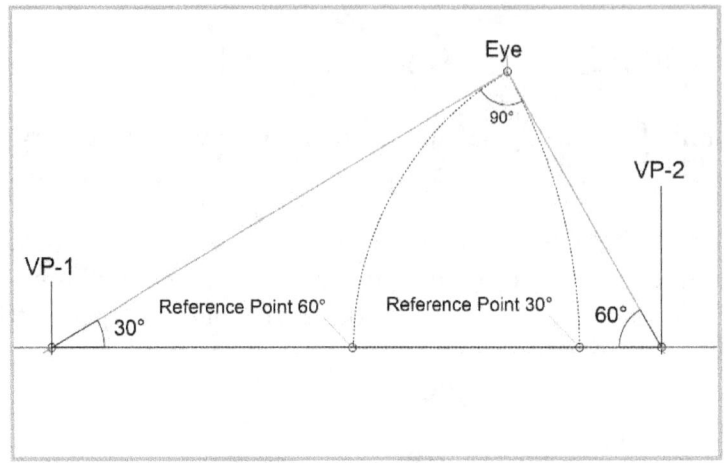

Now draw a base line, upon which the front corner point of the cube is to be located. And now you can represent the front edge and draw the vanishing lines for the upper and lower edges.

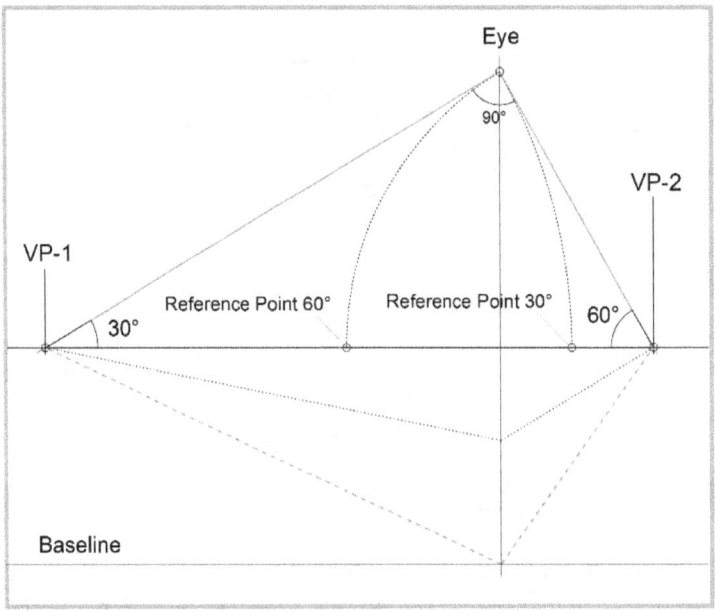

In this step you have to draw a semi-circle with the compass. The center of the circle is the point at which the cube touches the base line. The points at which the semi-circle touches the base line aid in the formation of two reference lines. These reference lines emerge – as in the previous example – through the connection of the semi-circle end-point with the 30° and 60° reference point.

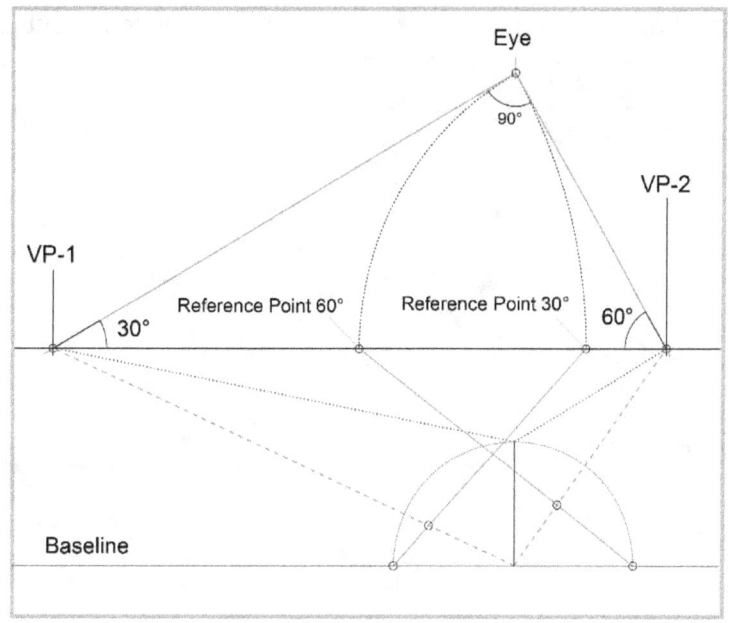

With the aid of these two new reference lines, two new points of intersection emerge on the lower vanishing lines, from which you can now extend upwards the two side edges of the cube.

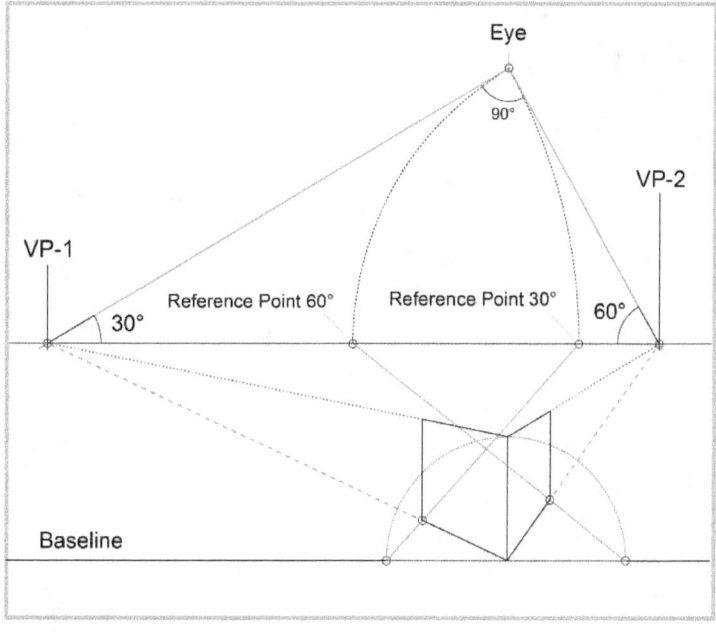

With the aid of the remaining vanishing lines, you can now complete the cube.

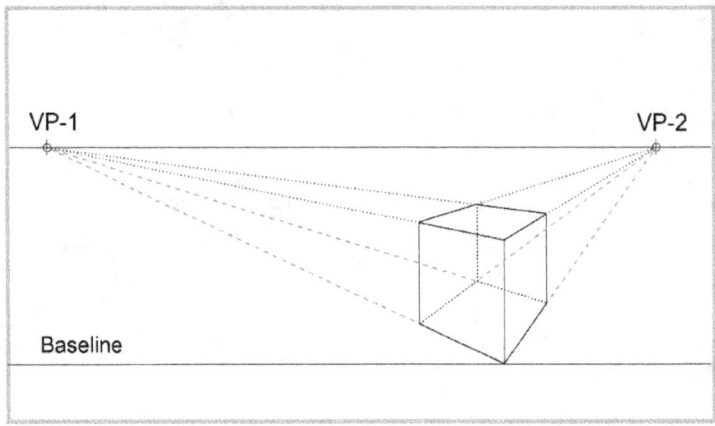

The final result is shown here without reference lines:

5.4 Representing Repetitive, Equal-Sized Elements

You have already learned from the exercise with the chessboard how to represent elements that repeat themselves in a pattern with central perspective. Now we want to try the same thing with diagonal perspective using two vanishing points.

Exercise – Drawing a Chessboard in Two-Point Perspective

Begin the exercise by drawing the horizon, the vanishing points, the sight triangle, the eye point and the base line. The chessboard is displayed in an angle shifted 30° to the observer. You have just learned in the previous exercise how we can implement the 30° shift.

So that we can illustrate the fields of the chessboard, we now have to divide the base line into 16 sub-sections of equal size – 8 to the left of the eye point and 8 to the right.

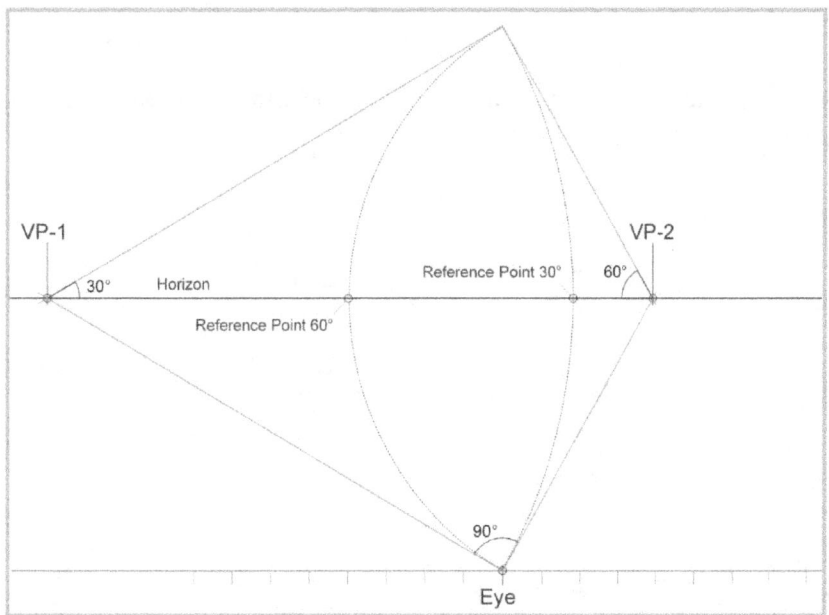

And now – starting from the left reference point (60°) – extend 8 reference lines to the points inserted in the base line, which are located to the right of the eye point. Do the same with the right reference point (30°) and the reference points to the left of the eye point.

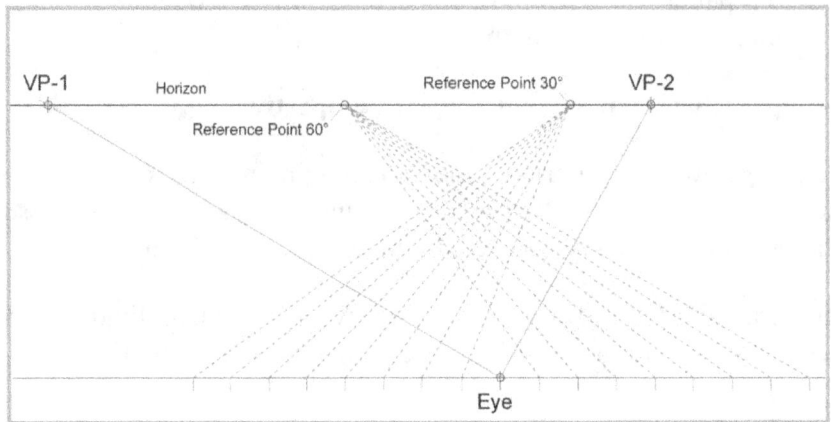

Reference lines above the vanishing lines can now be erased in order to make the overall structure more concise.

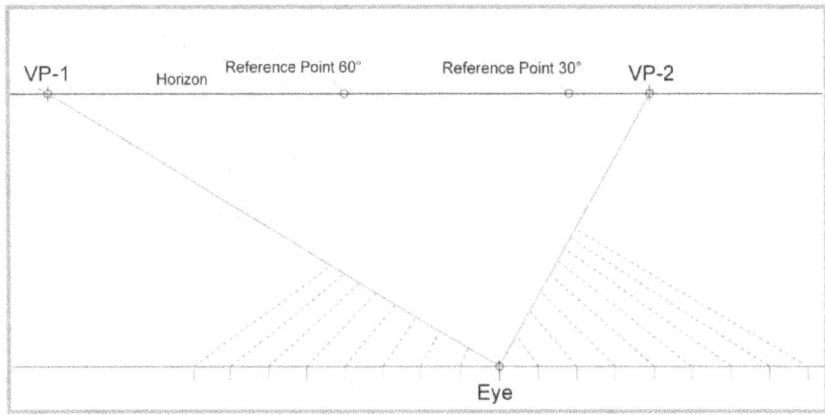

The points at which the construction lines intersect with the two (initially drawn) vanishing lines now have to be connected with the vanishing points, as has been illustrated in the diagram below. Now a grid made of vanishing lines has emerged, from which the chessboard pattern can be recognized.

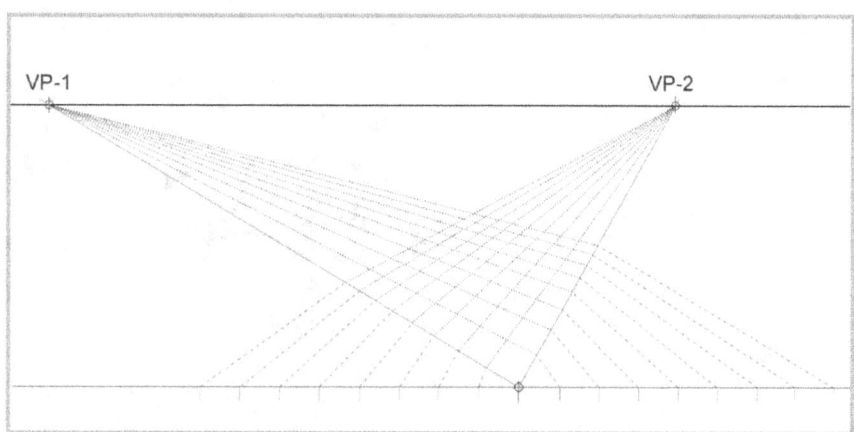

Now all of the non-essential reference lines and vanishing lines can be erased. The chessboard is what remains.

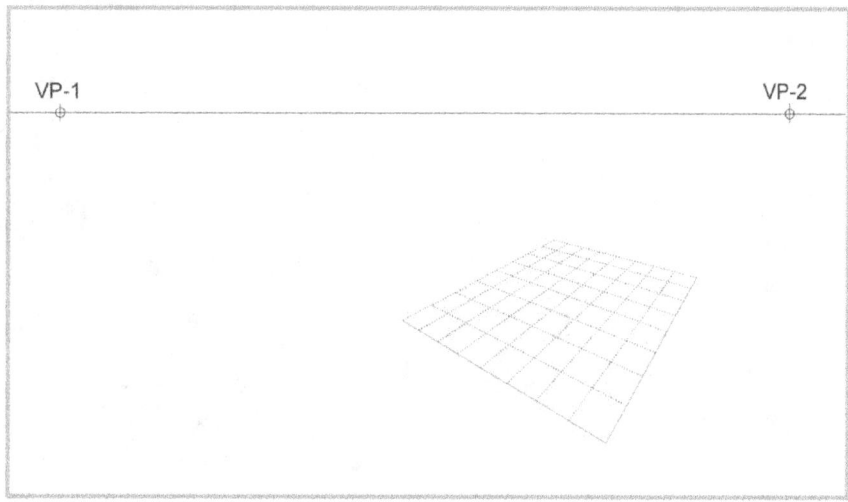

A bit more detail work, and your chessboard looks like the one in the following drawing.

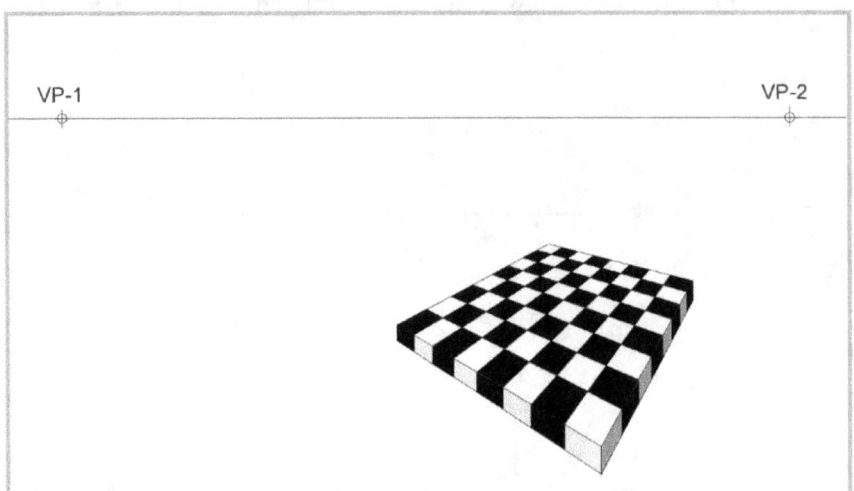

5.5 Drawing Diagonal Upright Planes

Up to this point, everything that we have drawn in diagonal (oblique) perspective was flat. This means that all of the surfaces were vertical or parallel to the floor. But what do we do if we want to draw a surface that lies diagonal to the base plane?
We want to take a closer look at this situation on the basis of the following example.

Exercise – Drawing a House in Diagonal Perspective

Now we return to a highly practice-oriented exercise – a house.

The new learning objective here is representation of diagonal planes. In the previous example with the house, the diagonal plane is of course the roof; but otherwise everything here functions as usual.
You can, of course, translate the presentation technique for diagonal surfaces in a 2-vanishing-point perspective to any other possible situation – not only when you draw a house.

So the initial situation here is a box, as you can see in the illustration below. You have already learned in previous exercises how to draw the box in perspective.

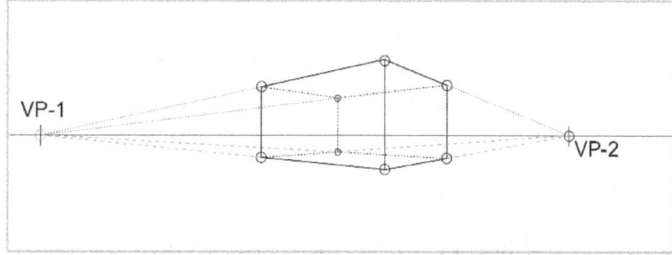

In order to draw the roof, the center point of the upper horizontal edge of the box has to be ascertained first. This must be carried out for both the front and back end-faces of the house.

In order to determine the center point, we draw the surface diagonals of the two end-faces. Just take a look at the following image.
What you have achieved through this step is the respective center point within the two end-faces

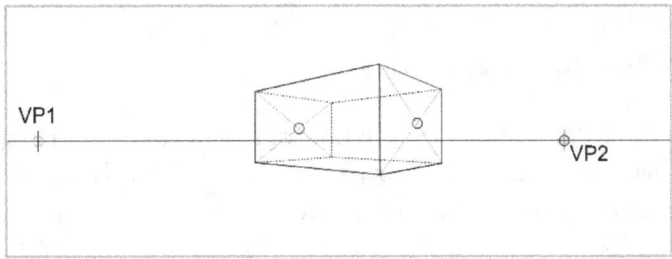

We then draw one line each, vertical to the horizon line, up through the two surface center points. The point, at which the lines intersect with the two upper edges of the box, is where the center point of the respective edge is located.

You should also extend these vertical lines a bit further up – we will need them for the following step.

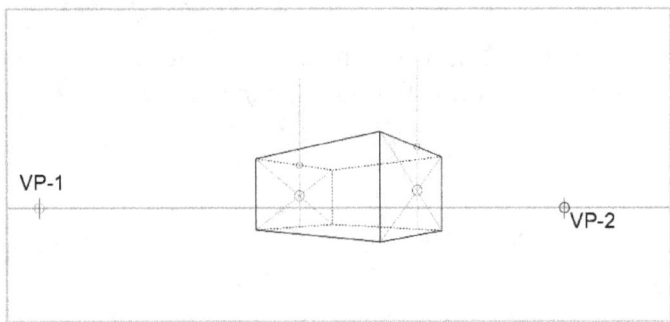

Now you need to draw the roof ridge, i.e. the uppermost edge of the roof. For this purpose, you first of all draw a point on the front vertical centerline. This point defines the height of the roof. And now you extend a vanishing line from vanishing point 1 out to this point. You will thus achieve the roof ridge and a further intersection point on the back vertical line.

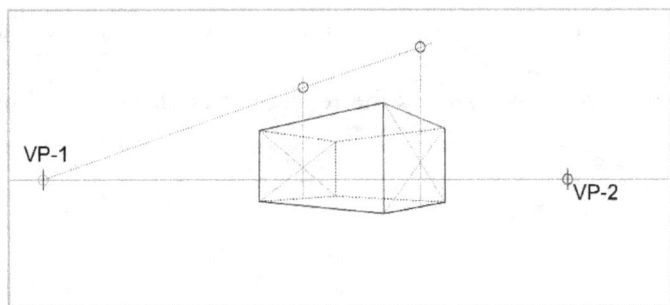

With the aid of the vanishing line just drawn, as well as the two points of intersection, the roof of the house can now be easily drawn.
That wasn't so difficult now, was it?

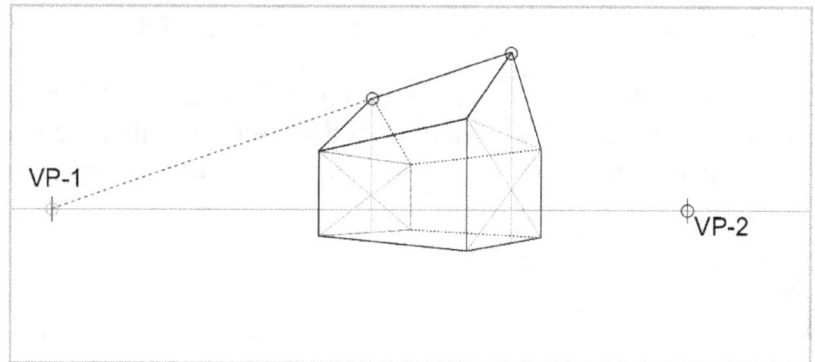

If we just add a bit of shading now, the end result can look like this:

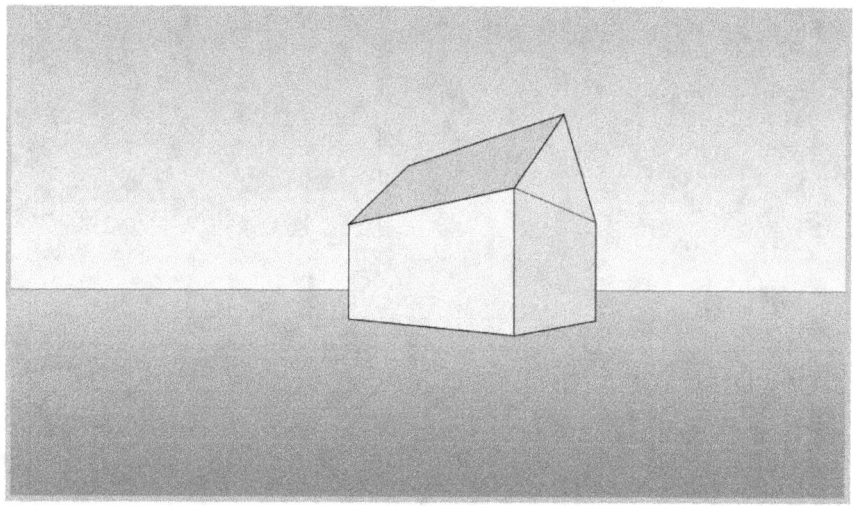

Alternative Methods for Drawing Diagonal Planes

There is a second method for representing diagonal planes. To understand the concept, take a look at the following illustration.
The advantage of this method is that the center points of the upper edges do not have to be determined. The disadvantage is that a third and fourth vanishing point are required.

As you can see here, we draw the two new vanishing points (VP3 and VP4) on a vertical line that runs through the vanishing point 2. It is important in this procedure that the two new vanishing points have the same distance from the horizon. This is represented here by the two lengths L in the following drawing.

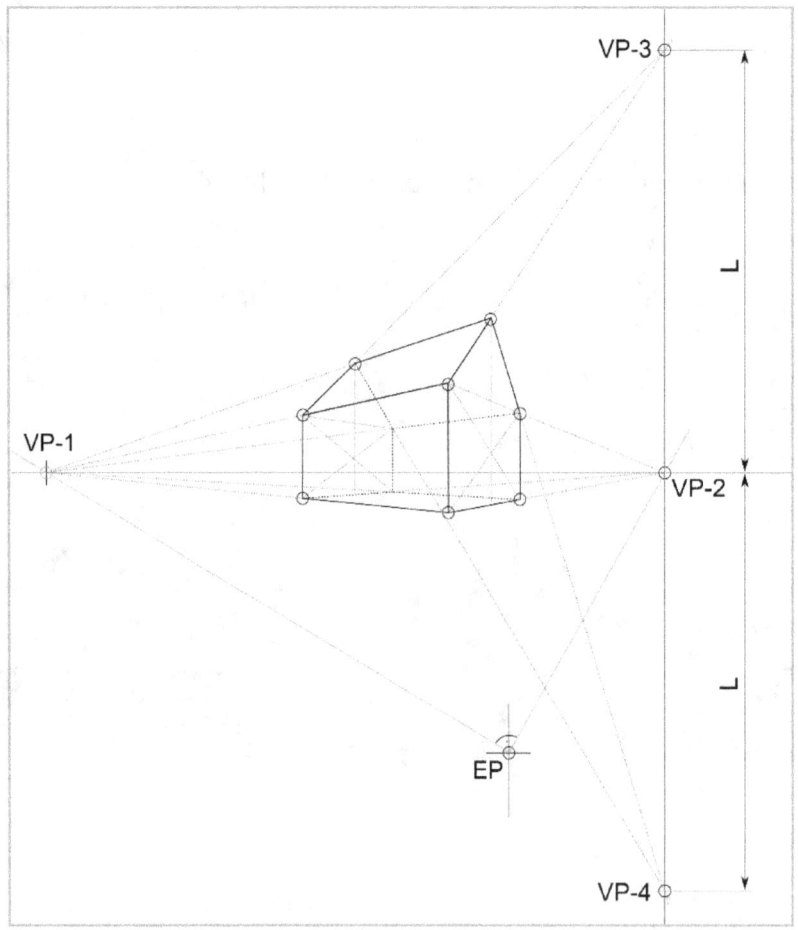

By using this alternative method, it is also relatively easy for us to complement the house with a chimney. The house has also acquired a door now.

This kind of detail work makes the motif livelier, but also involves more respective time and effort.

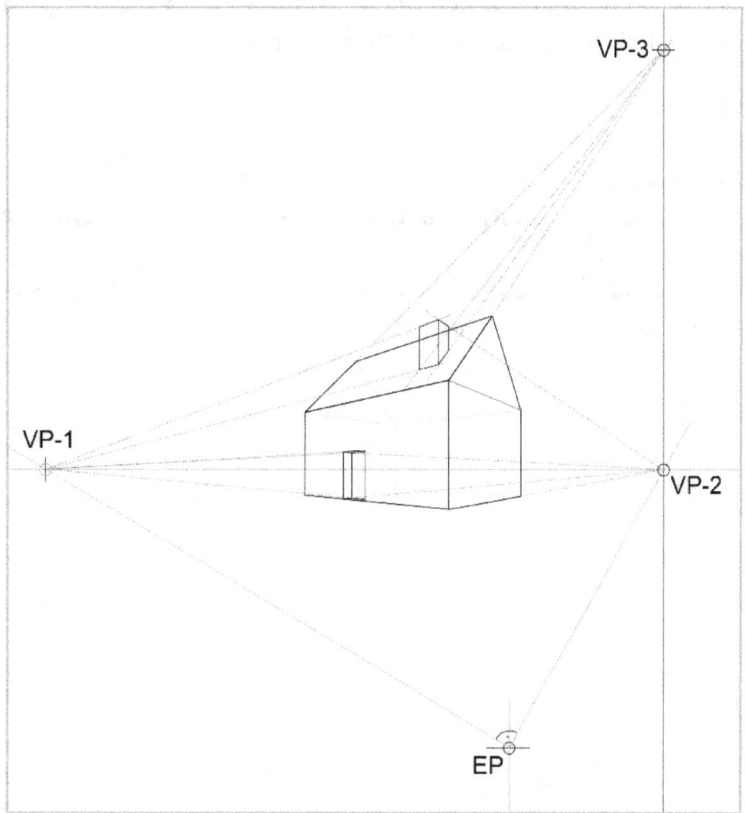

Here as well a version of the drawing with shading:

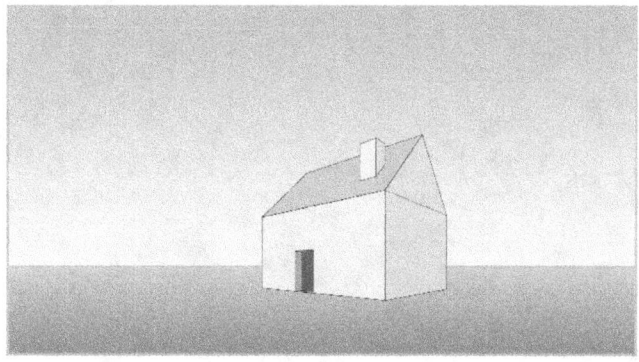

5.6 Drawing a Staircase

Here's another classic application of methods for drawing in perspective – a staircase.

Such a drawing might at first appear to be intimidating and complicated, but is actually simpler than you think. If you have completed all previous exercises, you are basically prepared to draw a staircase in perspective. But what we need here in any case is the third vanishing point, with which we became acquainted in the exercise with the house.

So let's begin:

The basis for this is once again the most important elements of drawing in perspective: horizon, vanishing points and eye point. In addition, a kind of scale has to be drawn for the staircase, with which we are later able to sketch the stairs.
This scale is a vertical line that is subdivided into several long sections. It is divided thereby into as many sections as are needed for the steps in the staircase.

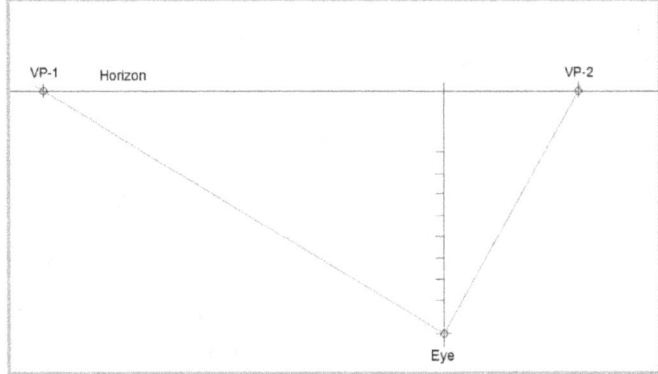

And now we can draw vanishing lines at that point where the markings are located on our scale.

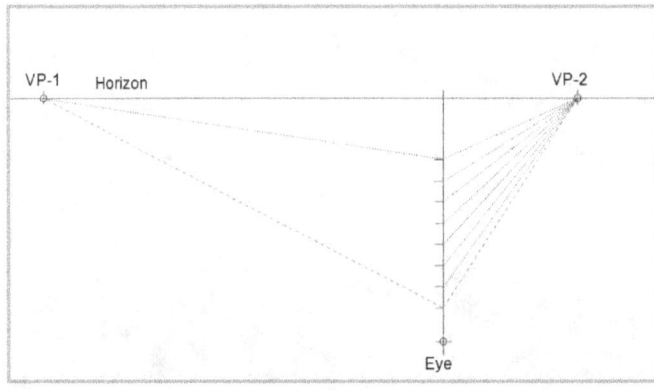

Now we need a third vanishing point once again. The entire exercise functions similar to the previous example with the house. After all, a staircase extends – similar to a roof – diagonally and upwards. But the difference is that the staircase has steps.
For this reason, we now have to draw two vanishing lines as well, as if we had two diagonal planes. To better understand the concept, just take a look at the illustration below.

The distance from the third vanishing point to the horizon determines the angle of gradient for the staircase. Additionally, the displacement of the two vanishing lines determines the depth of the individual steps.
The critical aspects here are the points of intersection along the vanishing lines from vanishing point 2 and vanishing point 3.

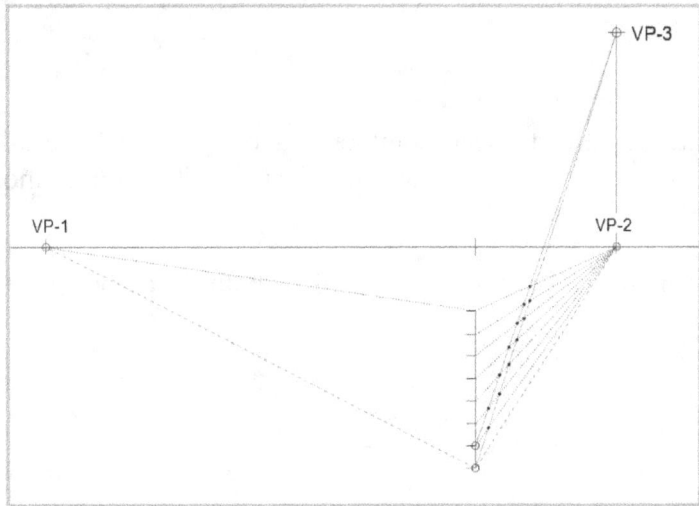

With the aid of the aforementioned intersections, we can now draw the steps.

Two points should always be situated one above the other, if you have done this properly and precisely. We always connect these two neighboring points by means of a vertical line.
These vertical lines are then connected together along the vanishing lines, thus achieving the step pattern.

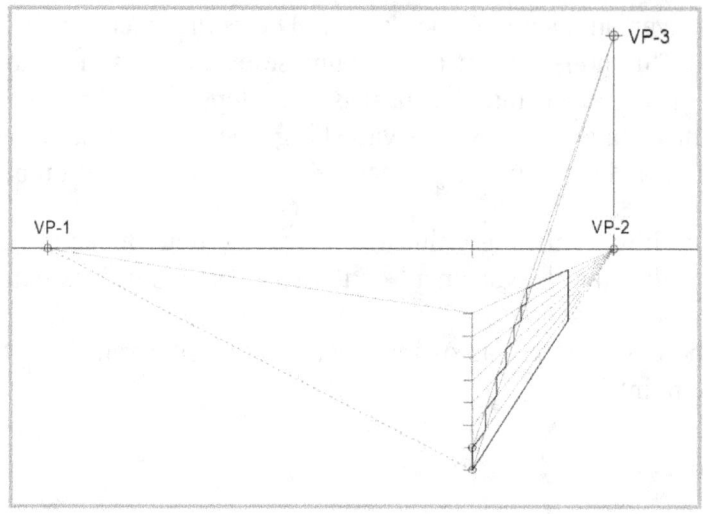

The most difficult part has already been completed! Now we just have to extend the staircase into the background. This is in essence not complicated – it amounts more or less to simple repetitive work.

Connect the vanishing point 1 along the vanishing lines with the corner points of the step.

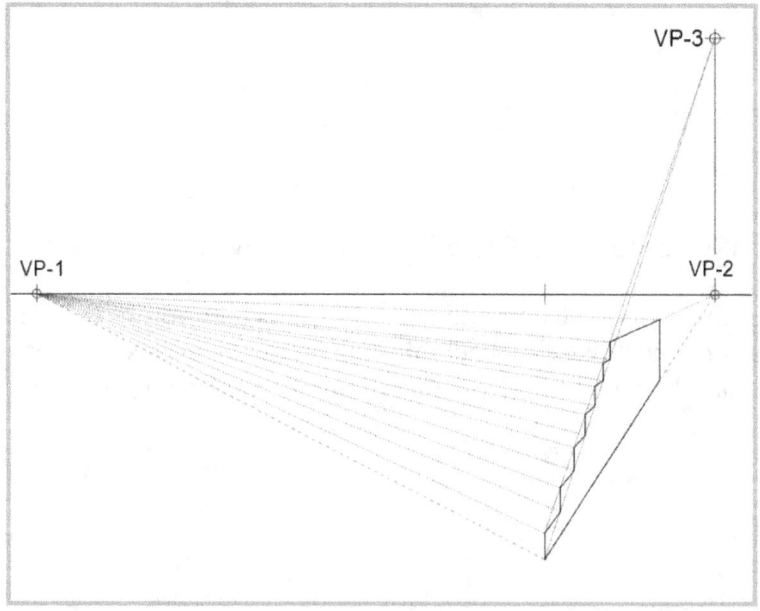

And now you have to determine how wide the step should be. Here you simply need to draw a point, to which a vanishing line is extended.

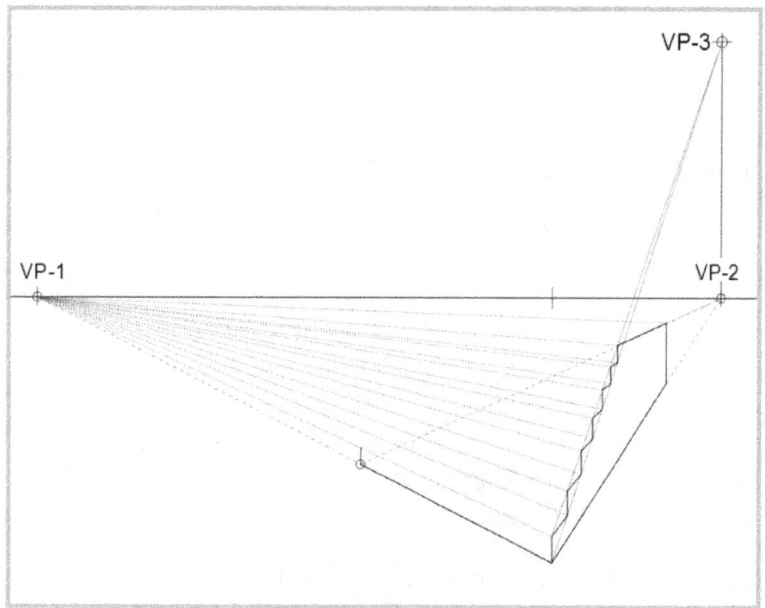

Now we do the same thing for the left side that we previously did for the right side – again draw two vanishing lines.

Watch out!

This time, you are not able to arbitrarily select the distance separating the two vanishing lines. You have to orient yourself to the previously specified height of the steps. The two decisive intersection points are marked in the illustration below.

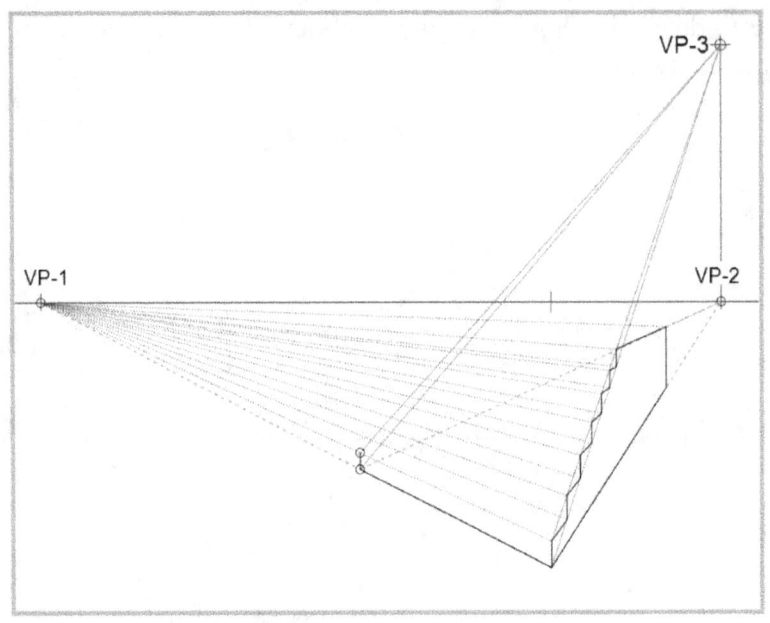

And now you can draw in the steps on the left side as well.

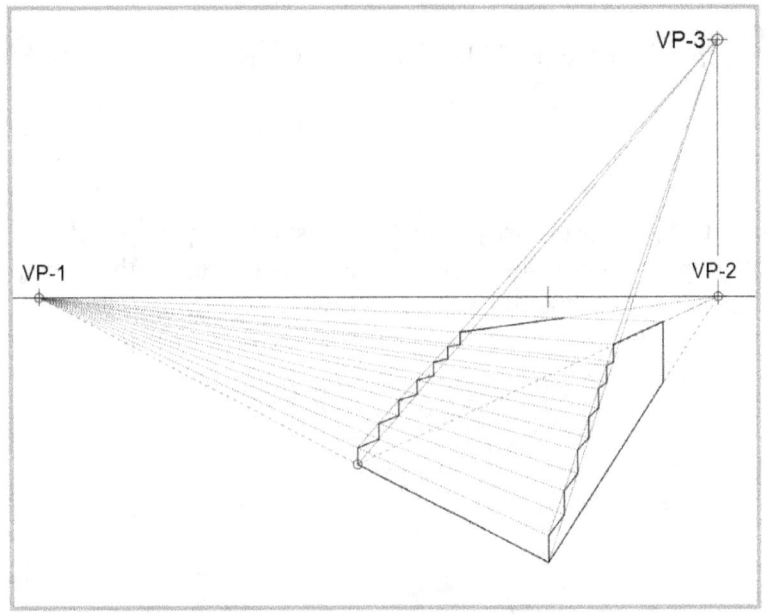

Now we connect the corner points of the steps together. The respective vanishing lines have already been sketched in.
After this step, the staircase is basically finished.

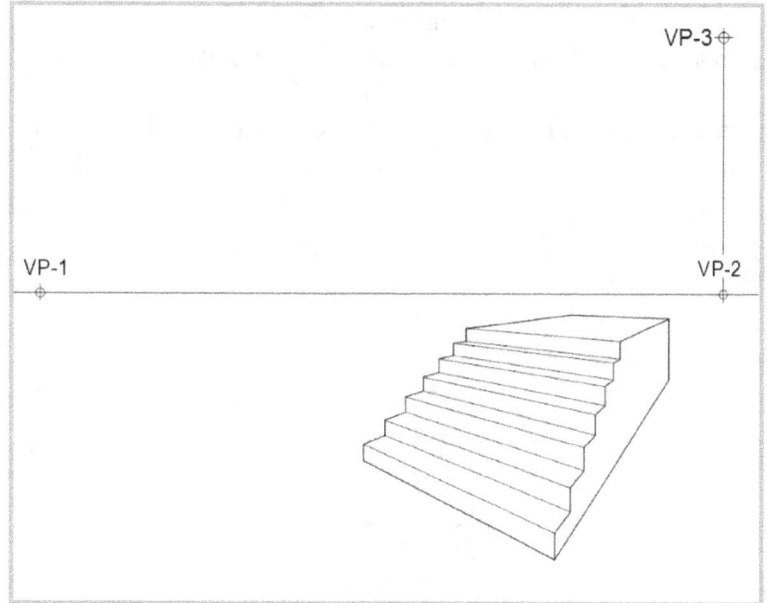

You can now add a bit of shading to make the final product more interesting.

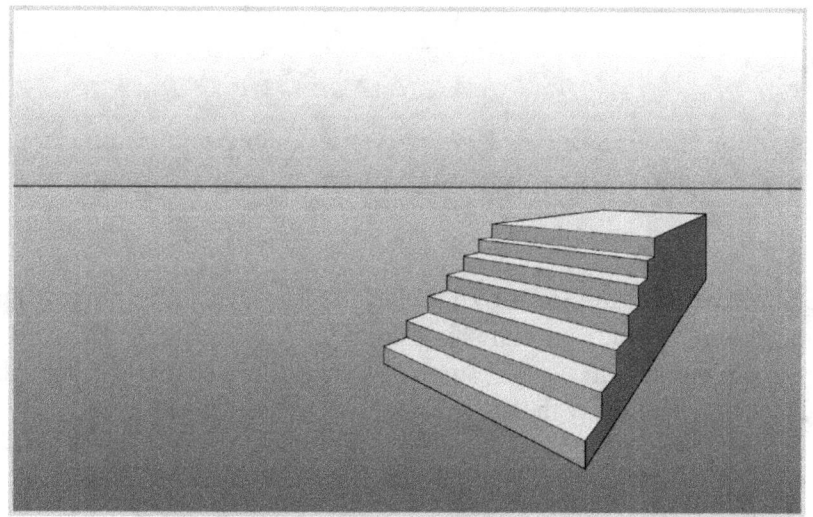

5.6.1 Exercise – Staircase with One Vanishing Point

Even though this chapter involves 'Diagonal Perspective', one more example of central perspective with one vanishing point should be presented here.

Now that you have some practice in drawing a staircase, try here to depict it directly from the frontal position. To do so we need only one vanishing point, but for this we have to rethink a bit.

You can see in the illustration here how a staircase is constructed with only one vanishing point:

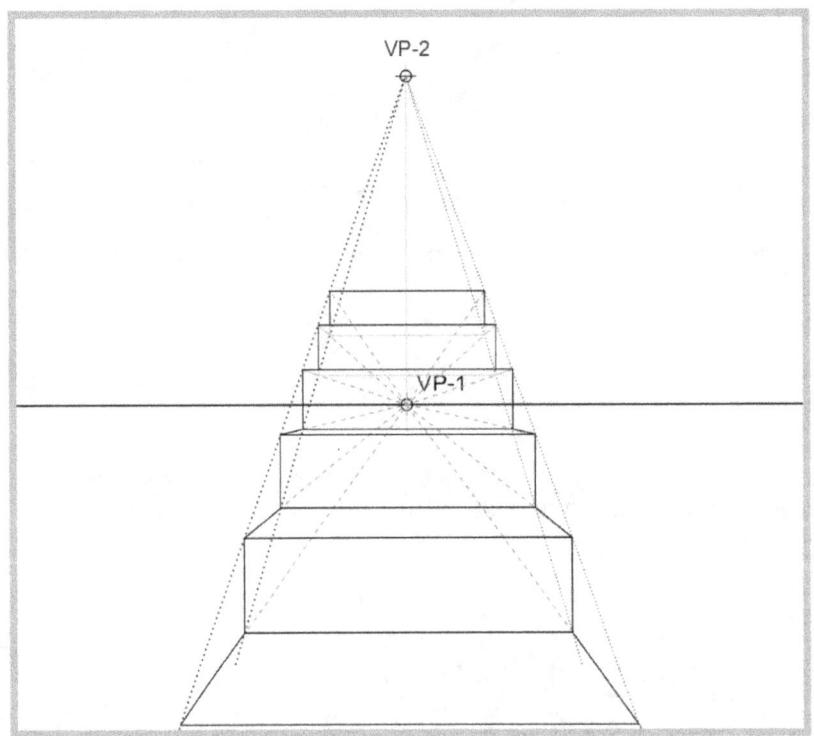

Staircase in central perspective with one vanishing point

We begin the perspective from the front by making the two vanishing points. Then we draw the reference lines that extend down from vanishing point 2. With the aid of these reference lines, we have now determined the depth of the steps. By making use of the vanishing lines from vanishing point 1, we can then draw the steps.

Now you can erase the reference lines and design the drawing according to your color preferences.

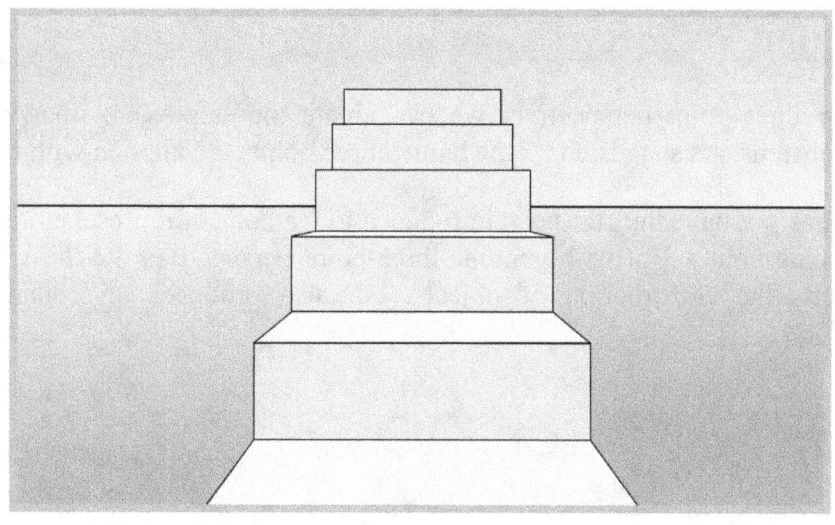

5.6.2 Exercise – Staircase from the Back

Let's stay for a bit with the topic 'staircase'. This element appears frequently, particularly in architectural drawing.

The objective of the exercise is to draw a staircase from behind – by once again using two-point perspective. If you would like, you can give it a try yourself. Otherwise, you can see a textbook example below.

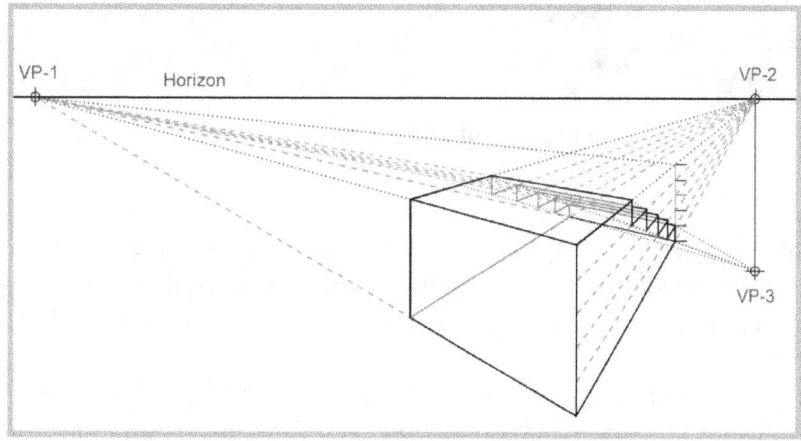

Staircase from behind in diagonal perspective

6 Three-Point Perspective

With the aid of three-point perspective, we can create the impression that we are looking upwards or downwards. As suggested by the name, three points are applied with this technique.

In previous lessons, we have thus far been introduced to methods of representation using three or even four vanishing points. But with genuine three-point perspective, the third vanishing point not only supports the construction of objects, but also produces an enhancement of the perspective effect.

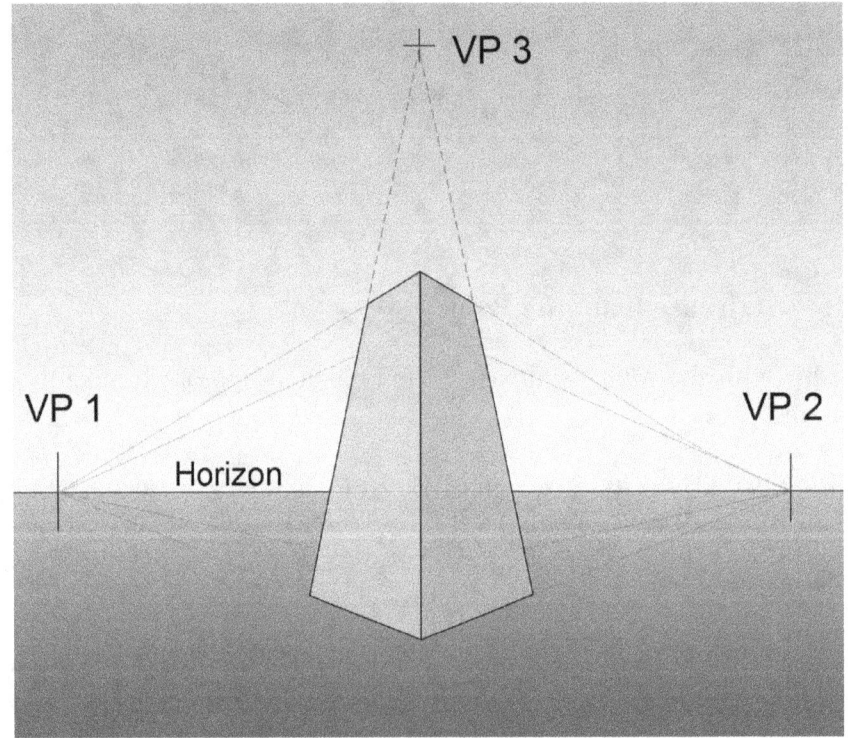

An example of three-point perspective

Three-point perspective is primarily put to use when the observer is looking upwards or downwards. Vertical extension, i.e. the height of the motif, is thus emphasized. Particularly typical cases for three-point perspective are representations of skyscrapers, high cliffs and other objects with height.
We can also deploy this technique in order to achieve special effects. For instance, a short person can look upwards toward a tall person. By making use of this perspective technique, a display of inferiority and/or superiority of an individual thus becomes possible.

Two examples for three-point perspective can be seen in the following photographs.

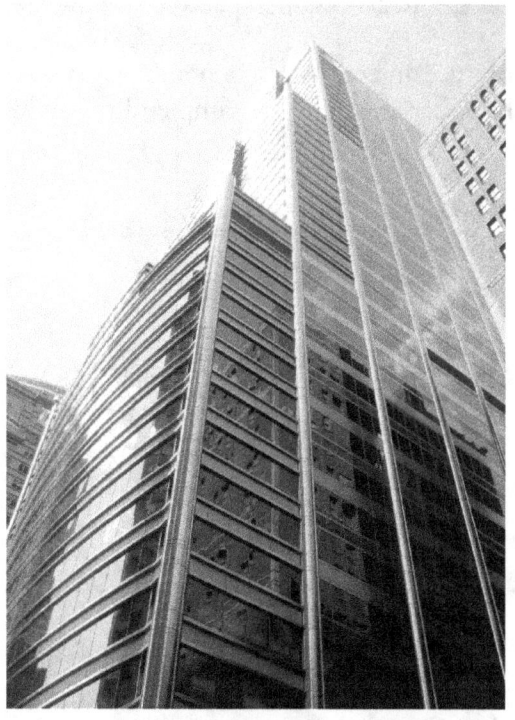

A skyscraper photographed from below (Sears Tower in Chicago)

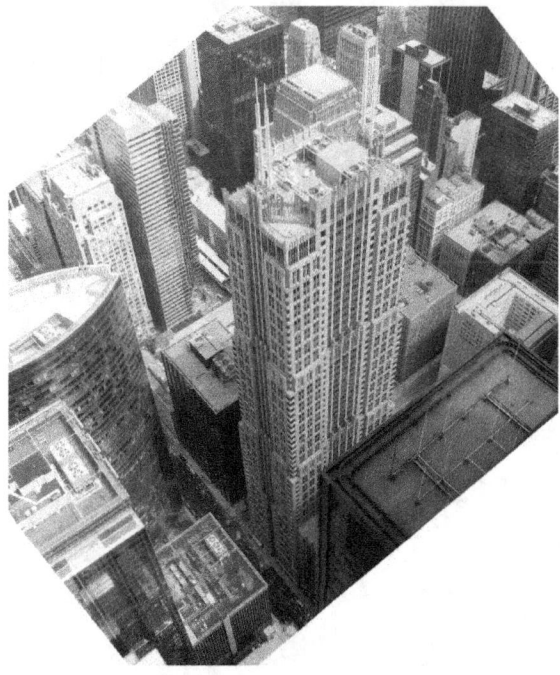

A skyscraper photographed from above (Chicago)

6.1 Three-Point Perspective Step by Step

Now let's try to draw an object in three-point perspective step by step.

Begin with the base area of the object. At this point, everything is the same as two-point perspective. You can draw the square, as in this example, directly in the center of the paper, or in another position.

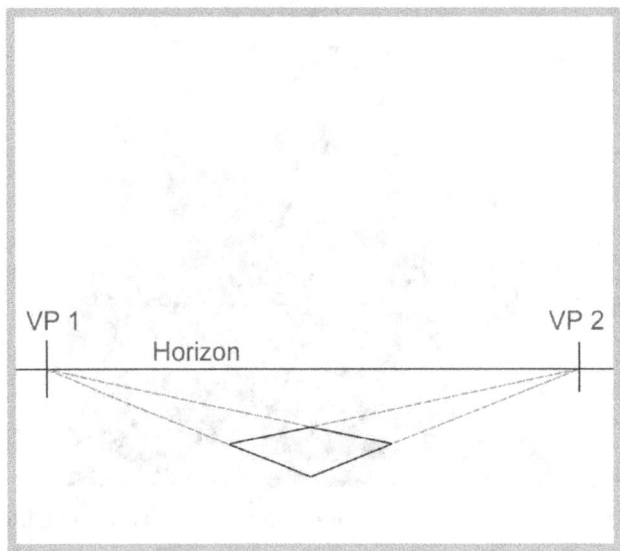

Now we add the third vanishing point. Draw it in the middle between the two vanishing points and in sufficient height above the horizon.

Important Note:
That the vanishing point is located in the middle is not absolutely necessary. It has just been implemented for this example because it is a bit easier to work with.

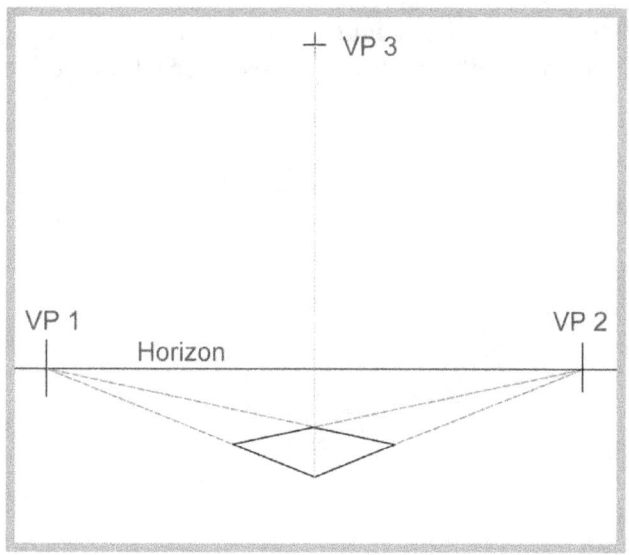

Beginning from the vanishing point, you can now extend vanishing lines out to the corners of the square.

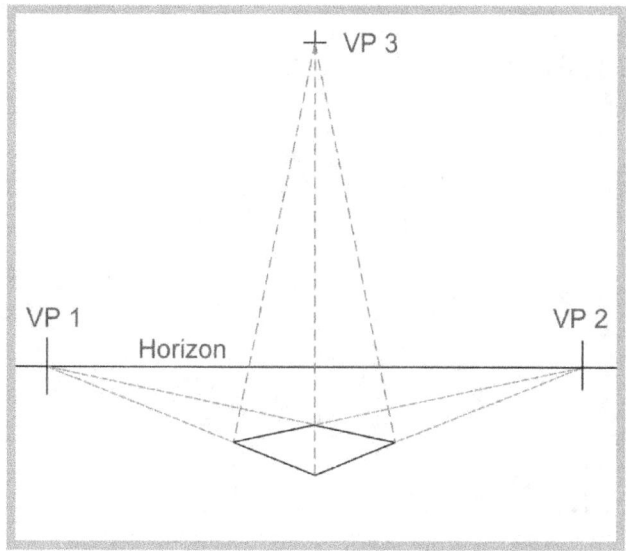

And now we have to establish the height of the rectangular solid. For this purpose draw a vanishing line from VP1 or VP2 at the height desired. Due to the points of intersection on the vanishing lines of VP3, the square that will form the upper surface of this rectangular solid has thus been acquired.

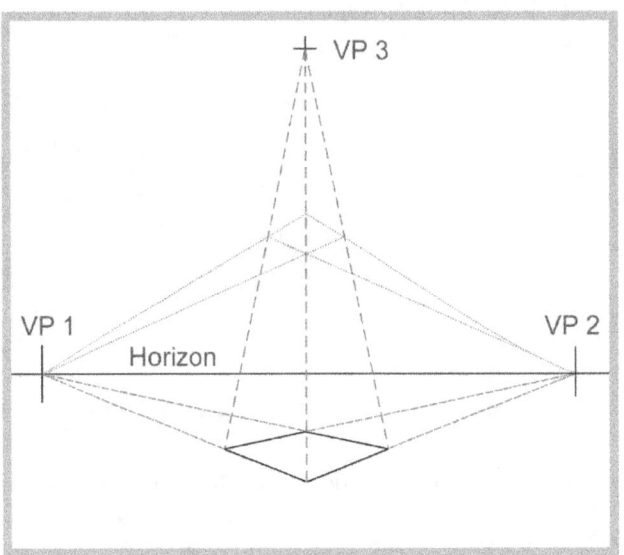

And now you can complete the drawing.

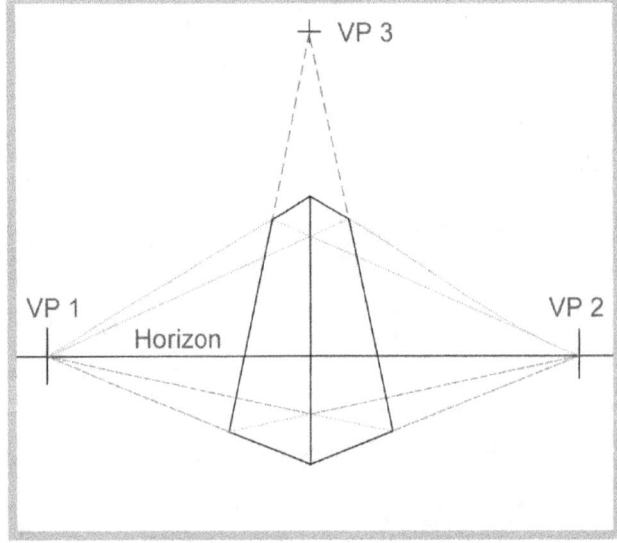

The graphic looks even better it is shaded.

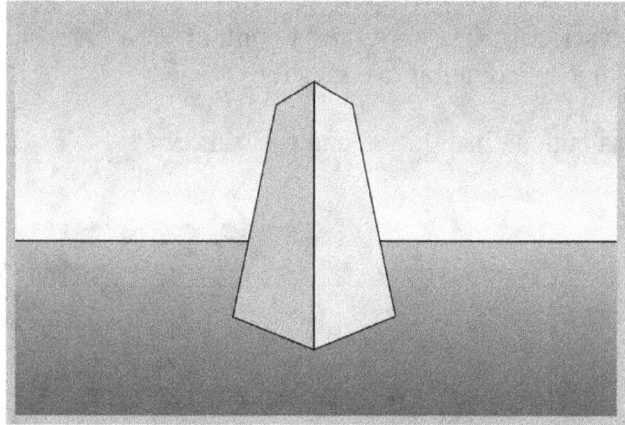

6.2 Three-point Perspective with Top View

Now try on your own to draw a rectangular solid with perspective from above. Imagine here that you are looking down at the object from an elevated point of view.

The finished sketch should then look something like this:

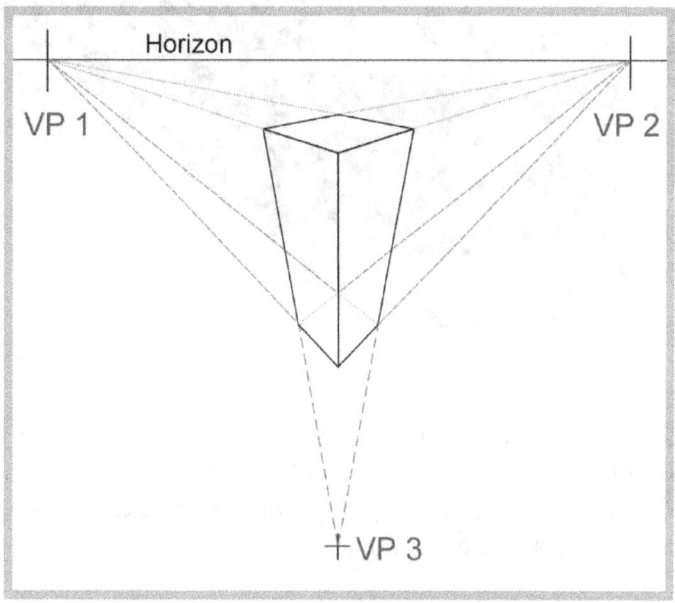

6.3 Exercise: Drawing a Cityscape

Now that we have had some practice, let's tackle a more complex task. We would now like to draw a cityscape with skyscrapers. The observer's point of view should be a lofty height to give the impression of flying in a helicopter above the city.

This photograph serves as both an inspiration and assistance:

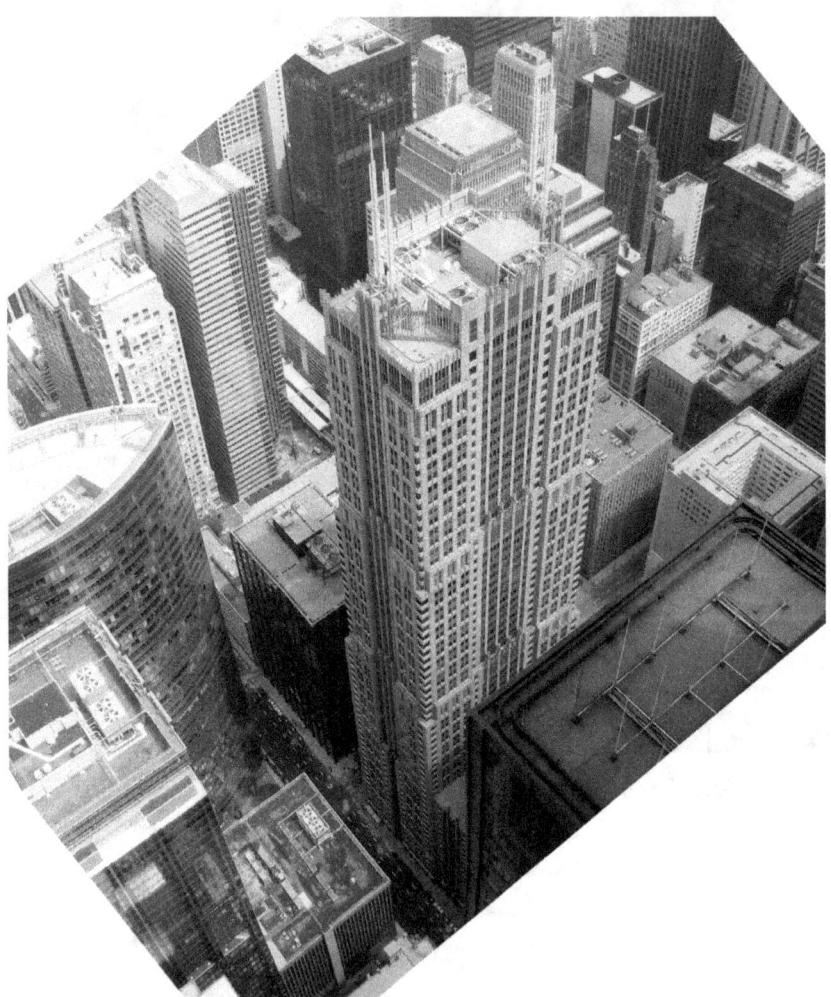

The unique thing about this example is that the vanishing points are so far away that they can no longer be located within the confines of our illustration space. In the following picture you can see a preview of the drawing in which the picture area is marked. You can also see here the position of the vanishing points and the horizon.

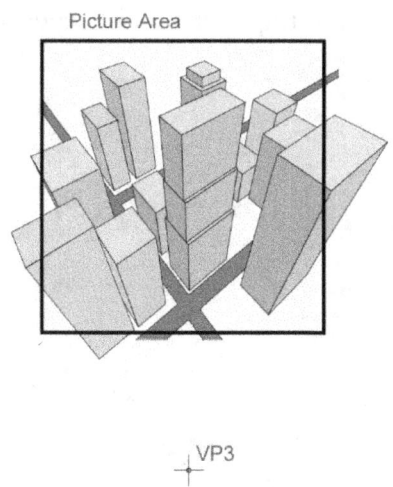

The image with the picture area marked. Vanishing points and horizon

In order to create a drawing with such distant vanishing points, we either have to use a large sheet of drawing paper that is cut back later on, or we indicate the vanishing points on the underlying table (without damaging it, of course).

Here once again the starting point without skyscrapers:

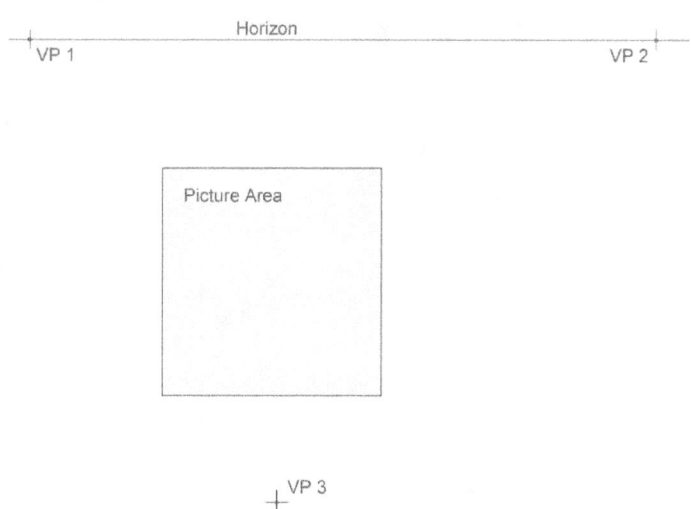

We begin here with the tallest skyscraper in the picture. This should serve as the eye-catcher in the drawing and is thus drawn with particular detail. Specifically, this means that we accentuate the graduations that make the edifice more interesting.

These graduations are displayed by simply drawing three different-sized rectangular boxes – one above the other. It is thus not so difficult, but requires a bit of repetitive work, which is also the case for the rest of the picture.

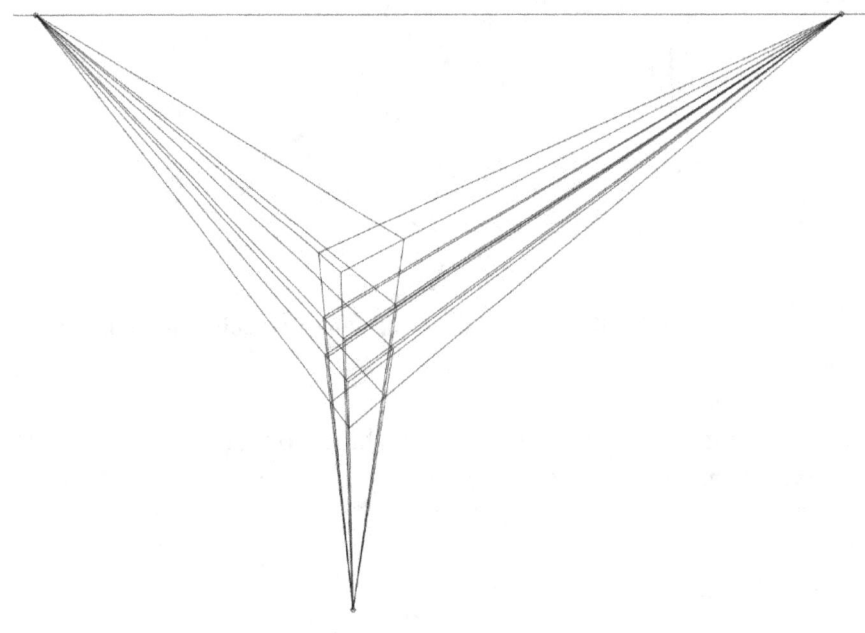

In the image below you can see the shaded drawing of the skyscraper.

When you reproduce the drawing, you should include the shadow and color at the end. This is because some skyscrapers will be covered by other buildings in later work steps.

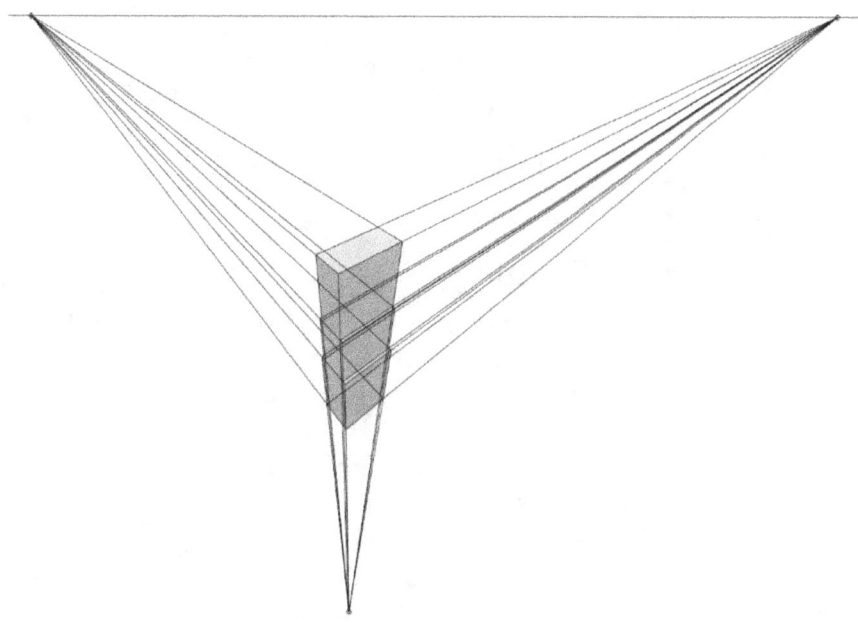

So that you can better imagine the entire scene, let's first of all draw two intersecting streets.

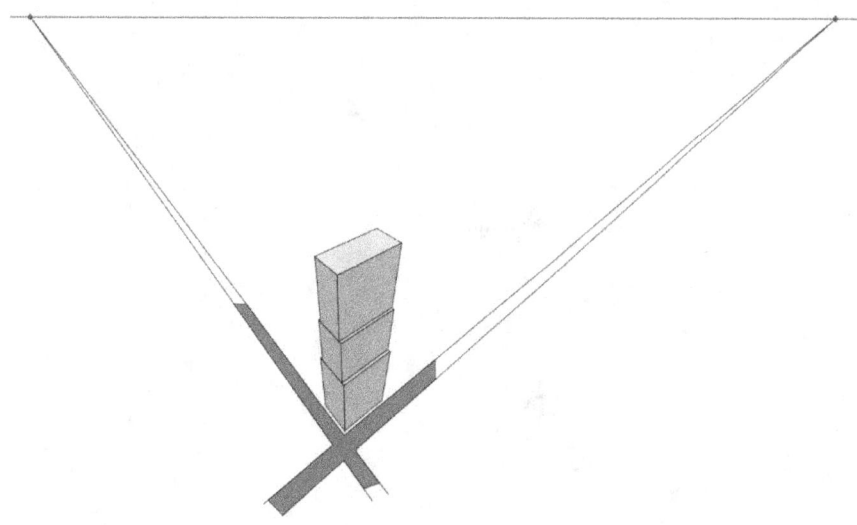

Then we add the second skyscraper behind the first one.

And now you just need to track the step-by-step development of the drawing. It always follows the same pattern, which is why we don't need a lot of description text.

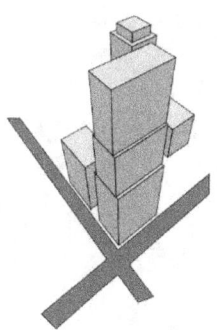

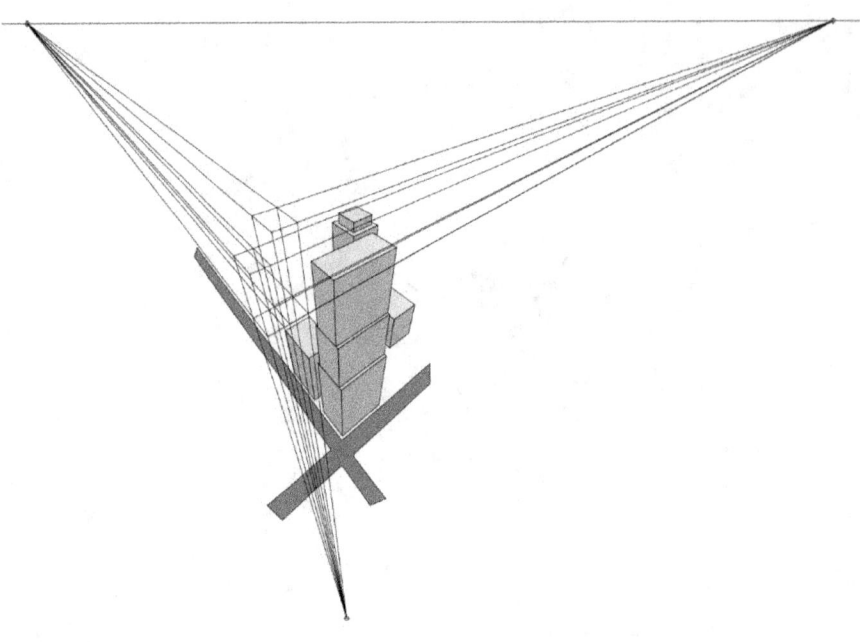
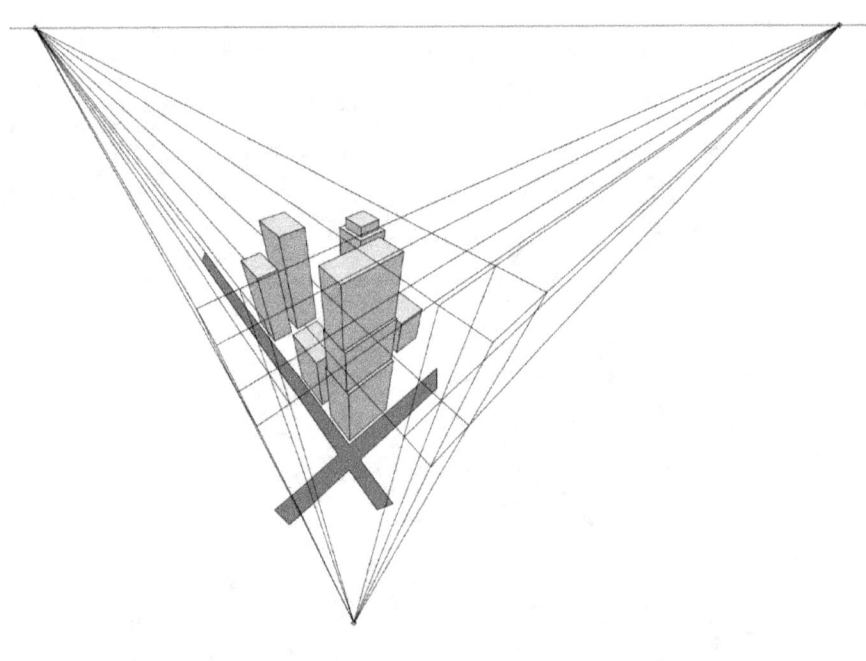

Some of the skyscrapers can be complemented with a bit of color. This color should have minimal intensity, since the image would otherwise appear too unrealistic.

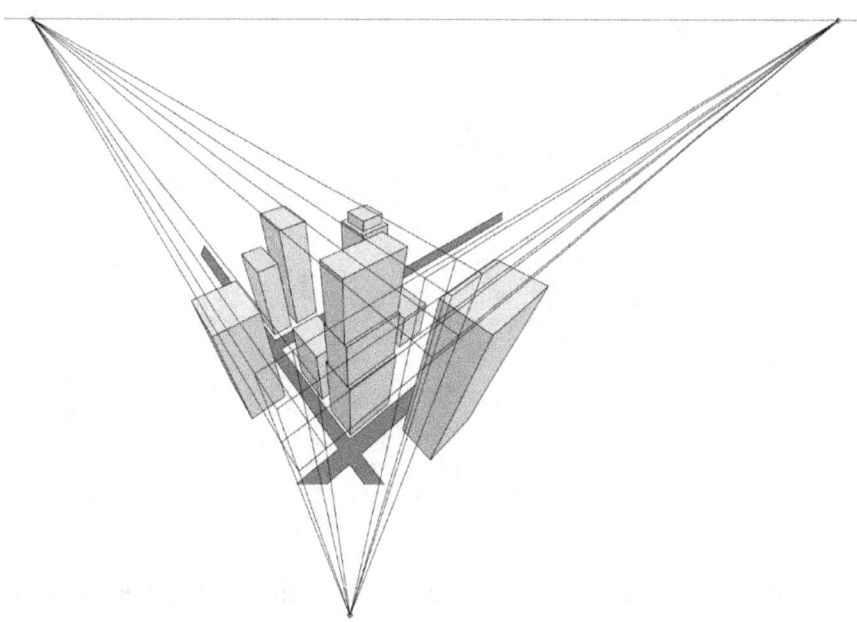

Here an expanded version of the picture:

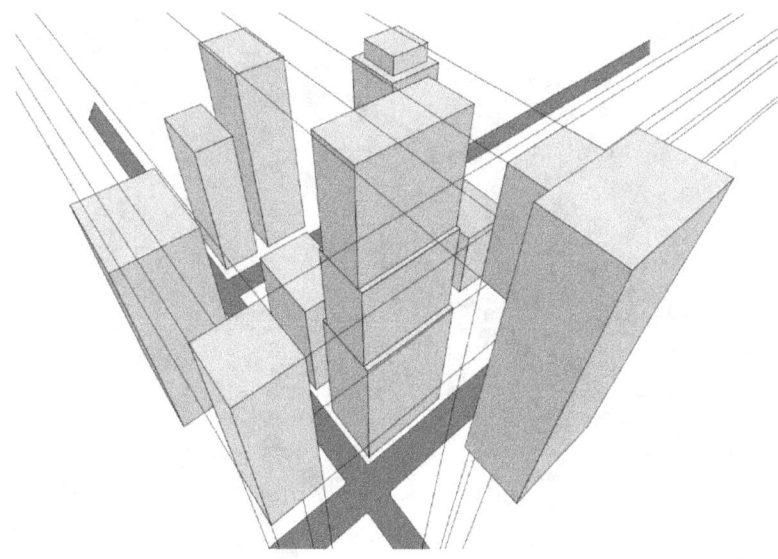

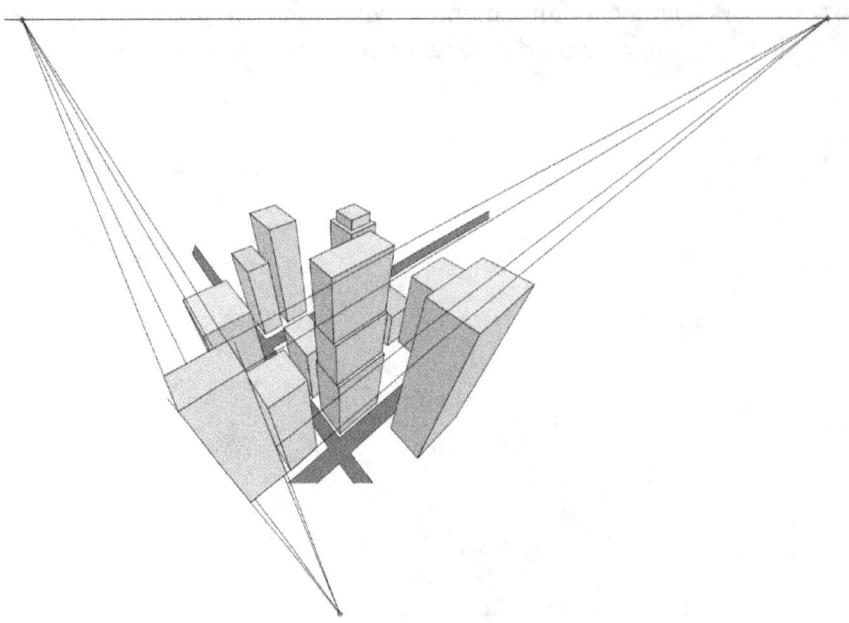

And with the following step, the drawing is basically finished. We just need to trim and frame it.

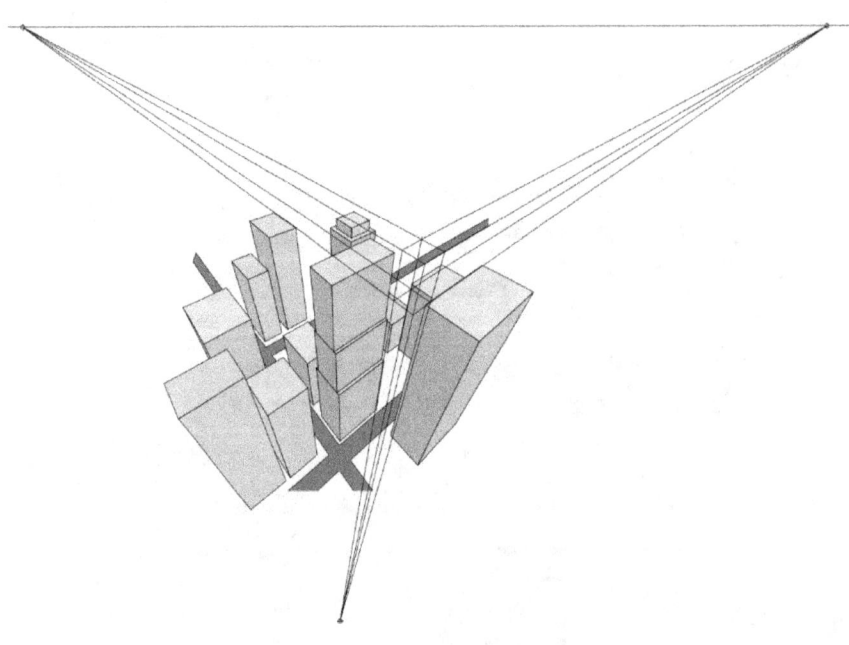

And this is the completed cityscape in impressive three-point perspective.

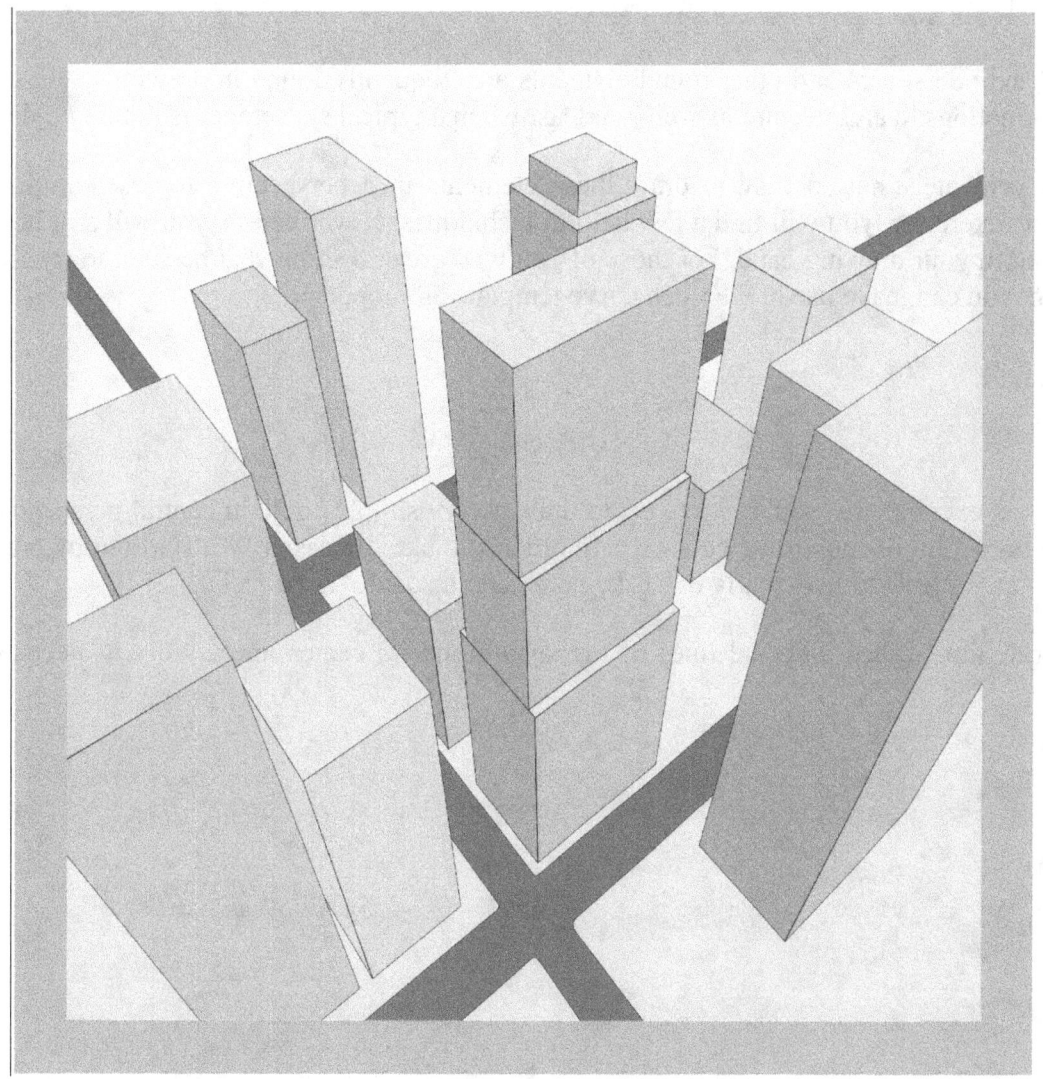

7 Circles, Cylinders and Arcs

Circles, cylinders, arcs and other round elements are frequently found in drawings. We can find these formations in architecture as well – at least when a typical skyscraper is not being depicted.

It is unfortunately not so easy to draw these elements in a perspective representation. In the following exercises, you will find a few helpful techniques. Nevertheless, you will still need a bit of feeling in your drawing hand. For those of you who are still somewhat hesitant to try freehand drawing, you can make use of a French curve template as support.

7.1 Drawing a Circle and/or Ellipse in Perspective

In this first exercise we would like to try to draw a very simple circle in central perspective. For this we need a bit of supportive geometry, in order to make life easier. We start out by drawing a square – as we learned to do early on. Take note here: a square, not a rectangle!

Also draw the surface diagonal lines of the square and its center lines. We will need both of them.

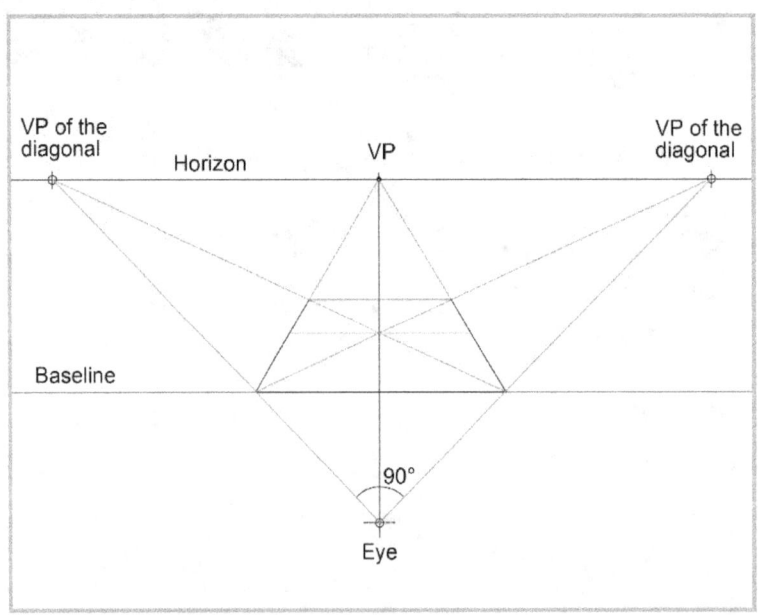

A square as initial supportive geometry to draw the circle

And now the second step – we draw directly under the perspective square another square that is not distorted by perspective. Here as well, we insert the face diagonals and center lines.

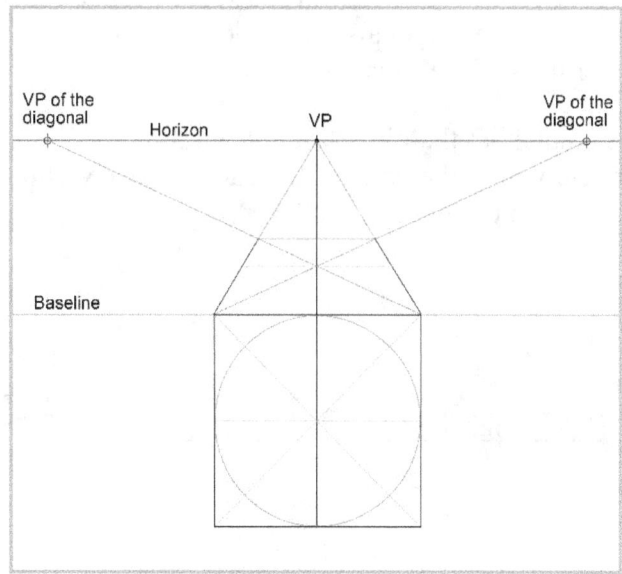

And now the important step – draw a circle within the confines of the non-perspective square. Mark the points where the circle intersects with the diagonal lines. Through these points of intersection, you can now extend two vertical lines that you transfer up to the square drawn in perspective. The two transferred lines extend back in the direction of the vanishing point VP, as illustrated in the picture.

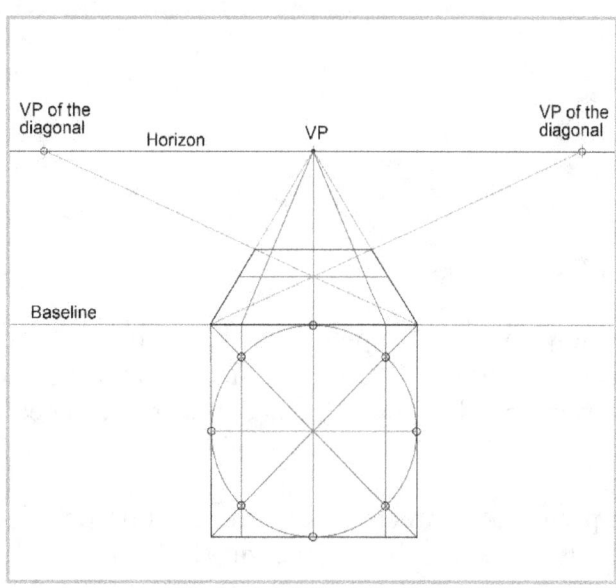

Now take a look at the circle that was represented without perspective. Look at the points of intersection that have arisen between circle, diagonals and the vertical reference lines. You have already transferred the reference lines onto the square in perspective. By using this trick you can now transfer the points of intersection in the circle as well. They are located at that point where the reference lines intersect the face diagonals. Four additional points of intersection in the circle are located where the center lines of the square intersect.

And now you have eight points that the circle should run through. With the aid of these points, you can now draw the circle within the square. In order to achieve this, you will need a bit of practice so that the circle ends up uniformly round.

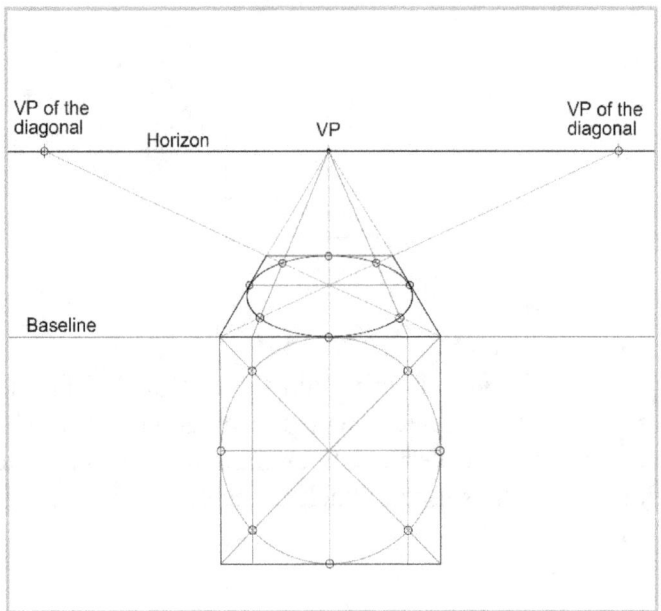

7.2 Drawing a Cylinder

So now you have learned how to draw a simple circle in perspective. Now we will go one more step by trying to construct a cylinder. All that is needed for this is a second plane. Finally, we have already drawn the lower face of the cylinder, and now we just need to do the same thing for the upper face.

Draw another square in perspective directly above the existing one. Here as well we need to include the surface diagonals and center lines of the square.

By extending vertical reference lines from the square without perspective up to the upper face, you can now transfer the reference lines up to the new square.

You can now draw the circle just like you did for the lower face in the former example. The points of intersection for the upper circle should be located precisely above the lower circle.

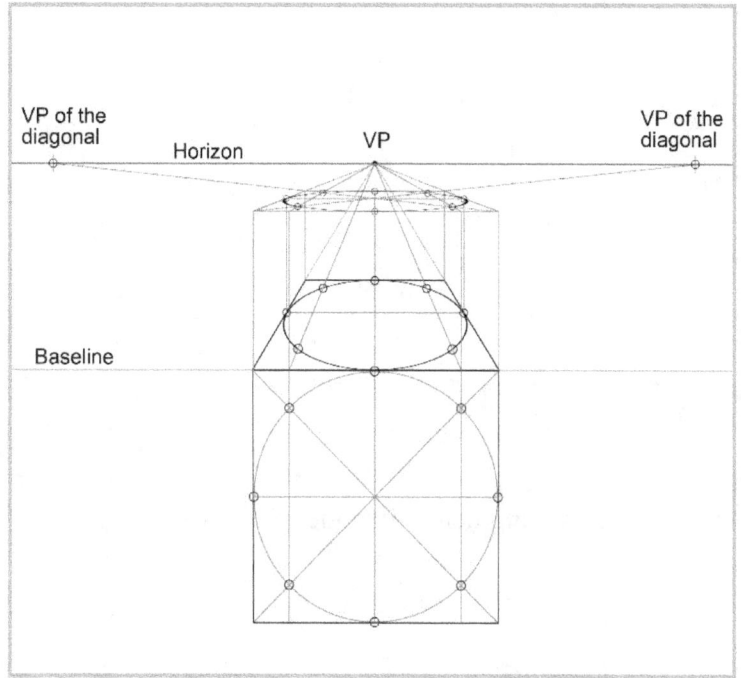

Construction of the upper face of the cylinder

Now connect the two outermost points of the circle with two lines in order to obtain the cylinder.

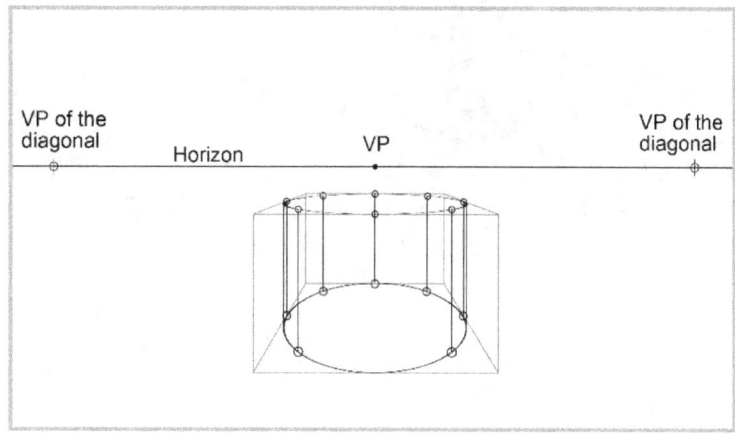

And here is the drawing without reference lines:

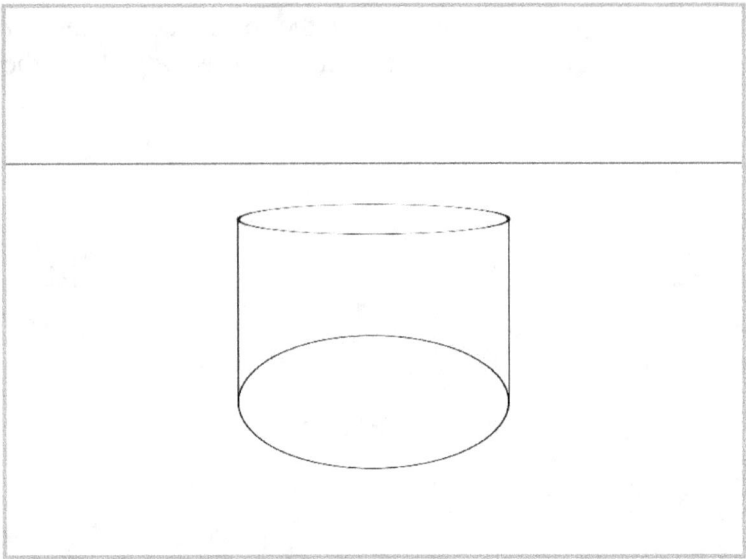

And for further inspiration, the drawing below includes a bit of shading:

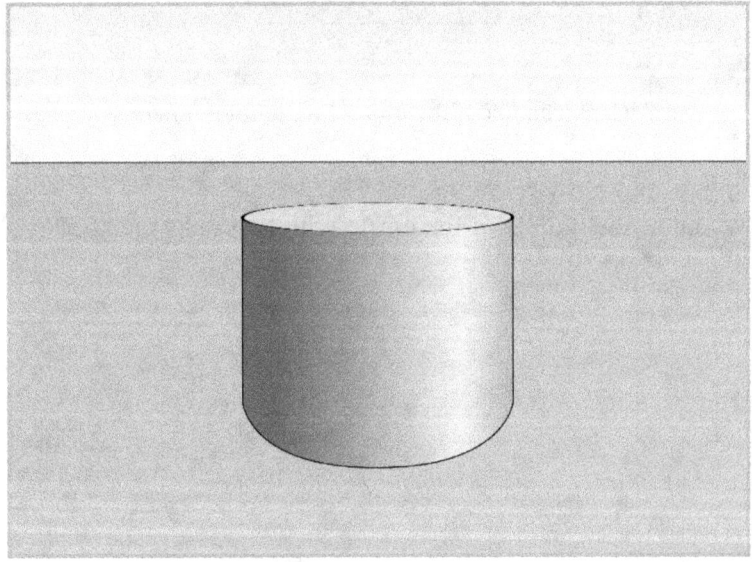

7.3 Drawing an Archway

A further classic architectural drawing with perspective is the archway. We'll take a look at this element in two separate exercises – first from straight ahead and in the second example with a side view, which is graphically a bit more complicated.

The view of an archway from straight ahead is relatively simple, since the semicircle is not distorted in its perspective. We just have to project the semicircle further back and reduce it in size. But first of all, let's begin with the simplest phase.

The starting point for the archway is central perspective with only one vanishing point. Draw two squares in perspective along the same baseline with a bit of separation. These two squares form the archway columns.

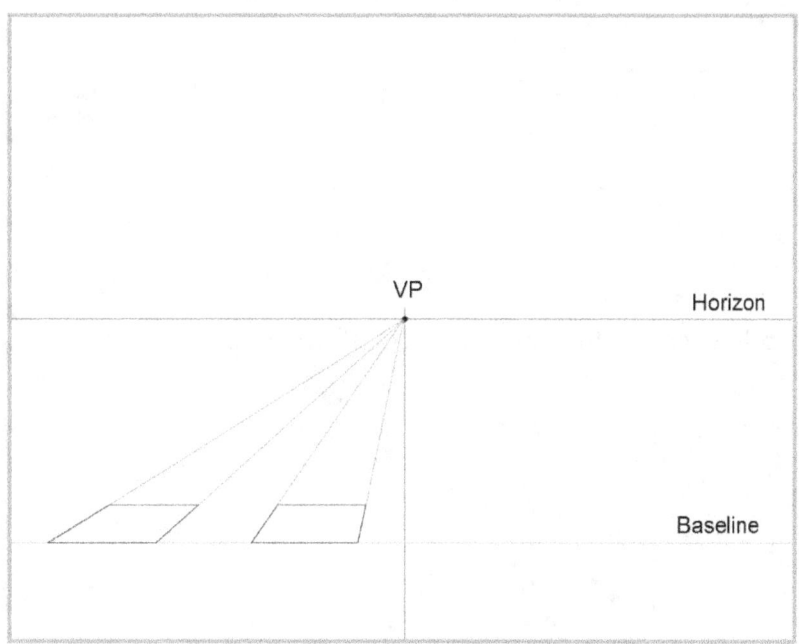

Now you can extend the two columns upwards. If the lines are too long, they will be erased later on.

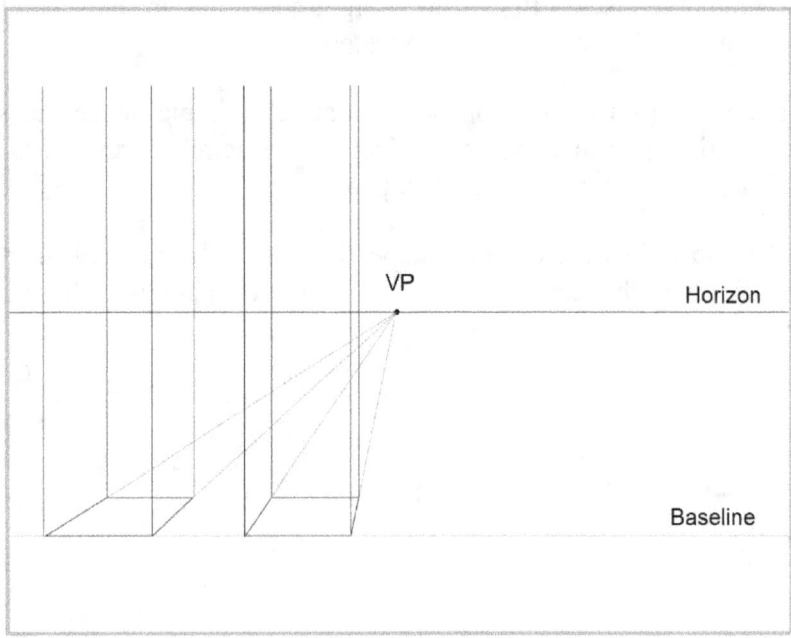

Draw a horizontal reference line to mark the height of the columns.

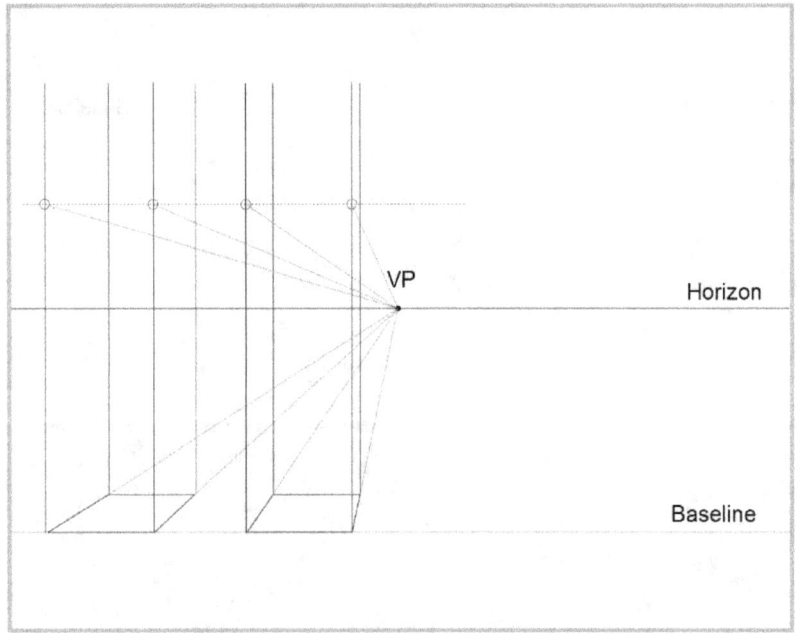

The unnecessary line extensions above the endpoint of the column are now erased. Make sure that the height of the background vertical lines is determined by the level of the intersecting vanishing lines.

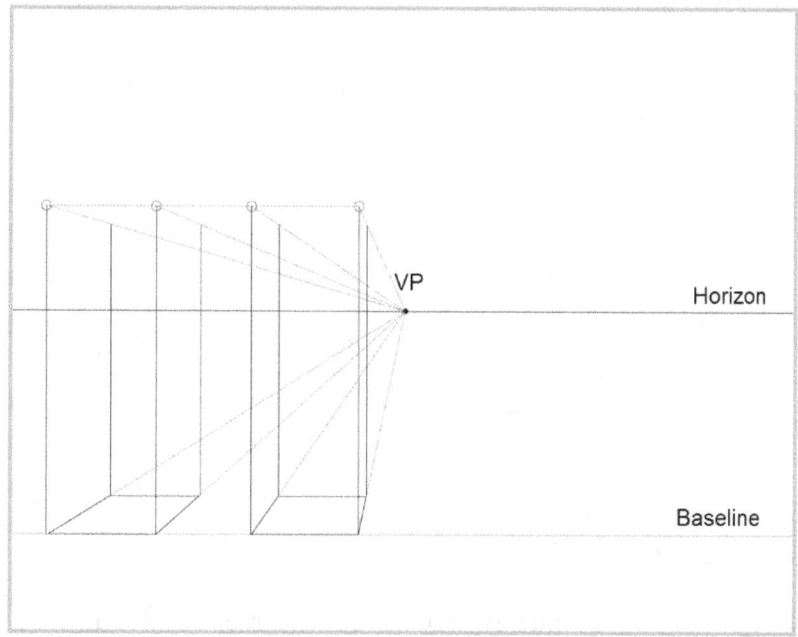

And now you can draw the frontal semicircular arcs for the archway. As previously mentioned, the semicircular arc is not distorted by perspective here. Hence it is an easy exercise.

Use a compass for best results when drawing these arcs. As shown in the image below, you have to draw an additional rectangle, i.e. two squares side by side, as geometric reference. Mark the points of intersection between the semicircular arcs and the face diagonals in the two squares, and extend vanishing lines back from these points of intersection.

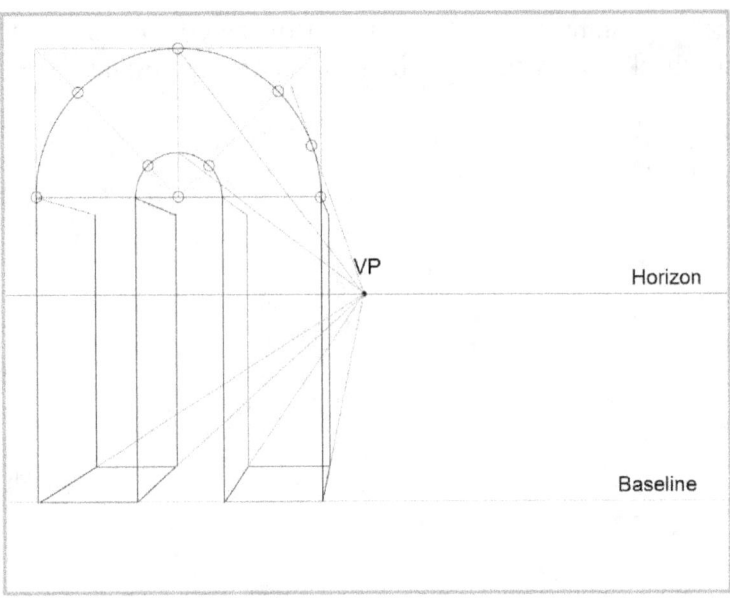

The semicircle in back is also not distorted in its perspective. However, it is displaced and smaller than the semicircular arc in front.

Once again, you have to draw two squares that serve as geometric reference. At that point where the vanishing lines intersect with the face diagonals of the new squares, the points of intersection form the new semicircle.

However, when you work with the compass here, only one of the contact points is necessary in the two squares. This is because the radius of the back semicircle is already determined thereby.

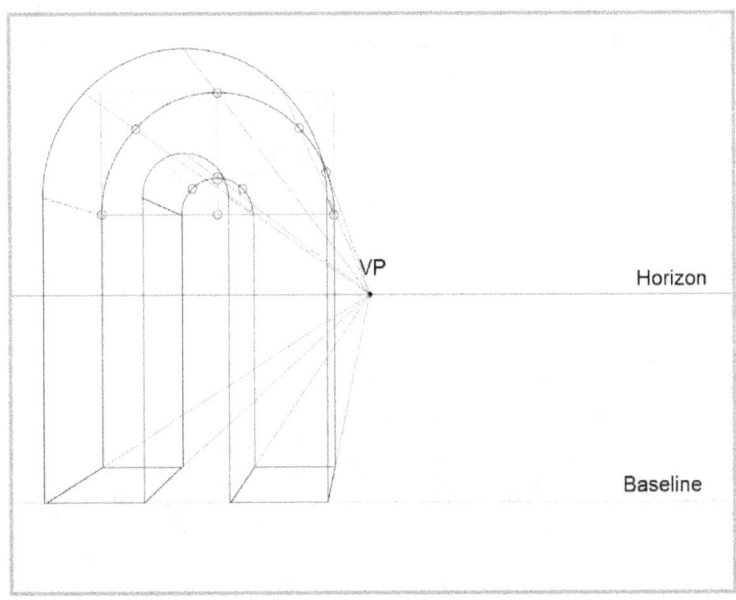

Here you can see the drawing once again, but without the reference lines. Hidden edges are represented in light gray here.

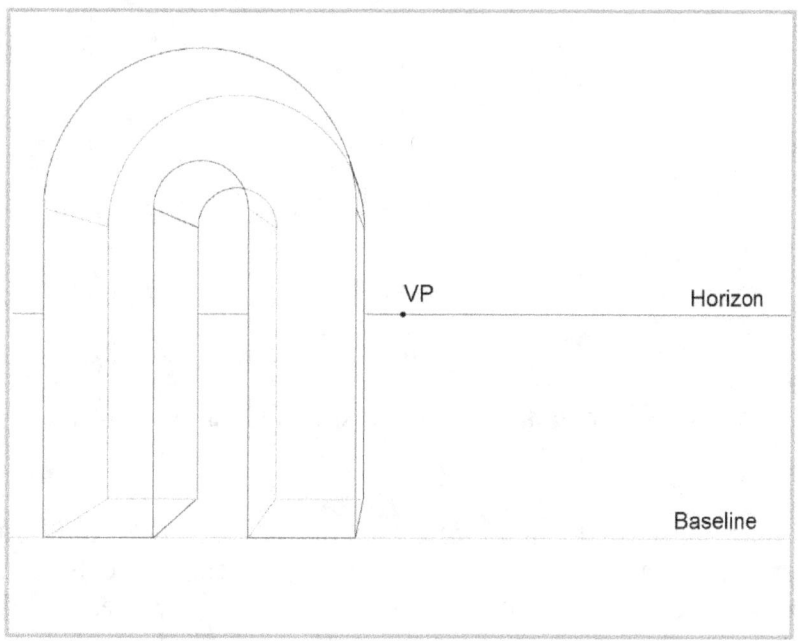

7.4 Drawing an Archway from the Side

As previously mentioned, we now have to tackle a more difficult task – an archway with a view from the side.

This drawing is a bit more complicated, since we have to draw the semicircular arc in distorted perspective. However, it all works similar to the circle in the first example of the chapter. The representational style is, once again, central perspective with one vanishing point.

We begin here with a simple square as can be seen in the image below. The square represents the base area of the front archway column. We could also just draw one rectangle here as well. However, with the square it is simpler to construct the archway later on.

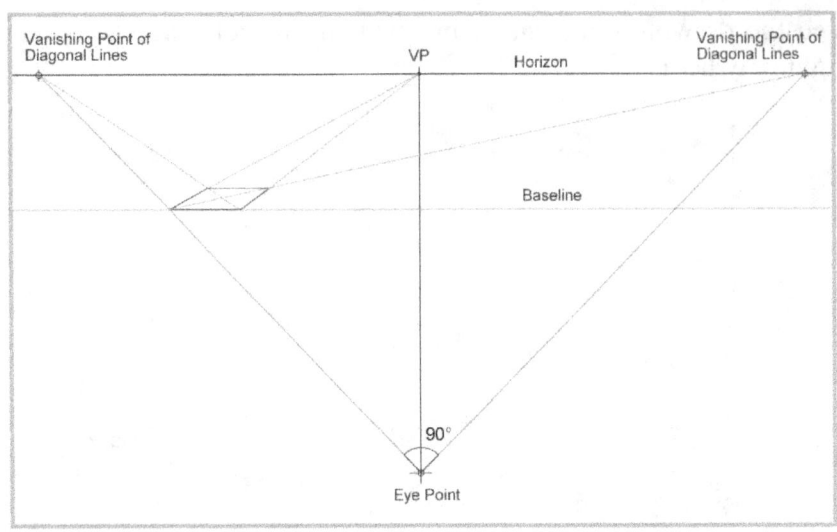

Construction of the first square as base area for the front column

Now we need to draw the second column of the gate that stands behind the first column. This means that it must be presented smaller in the drawing with perspective. Since we want to draw an archway with two equally-sized columns, we have to manage presentation of the second column that appears to be the same size. This of course means equally-sized in a situation that is undistorted by perspective.

To achieve this we need to make use of a small trick that works according to the same principles as we saw in the chessboard from one of the earlier examples.

We use the vanishing point of the diagonals for this purpose – it doesn't make any difference whether it is on the left or right side.

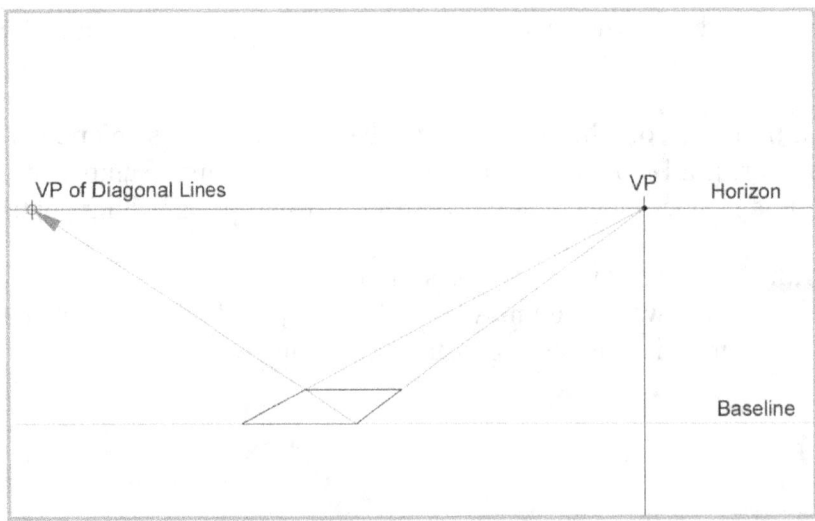

With the aid of the vanishing point for the diagonals, we now draw three more squares as in the image below.

The square farthest back is the base area for the second column of the gate. The two other squares form the section that the archway should span. This section does not necessarily have to consist of two squares, but it makes the work somewhat easier for us.

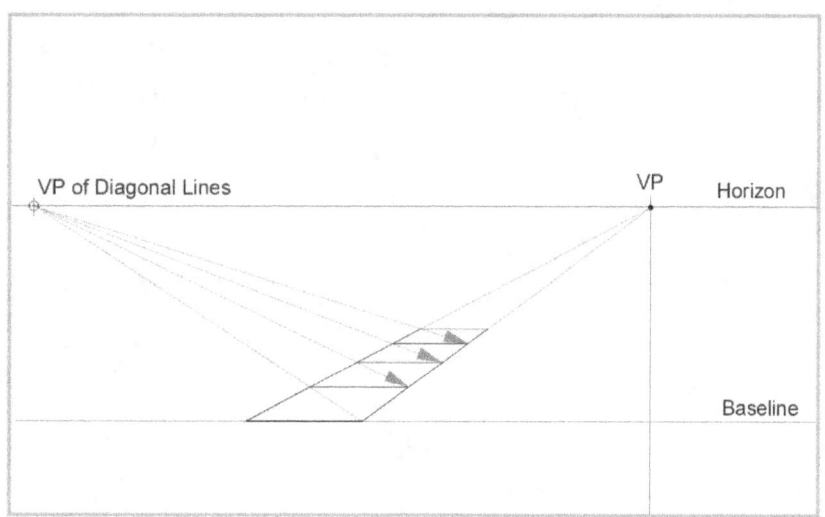

Now with a pair of vertical lines we can extend at least part of the gate upwards. With another pair of vanishing lines, we establish the start, or end, of the archway, and thus the height of the gate as well.

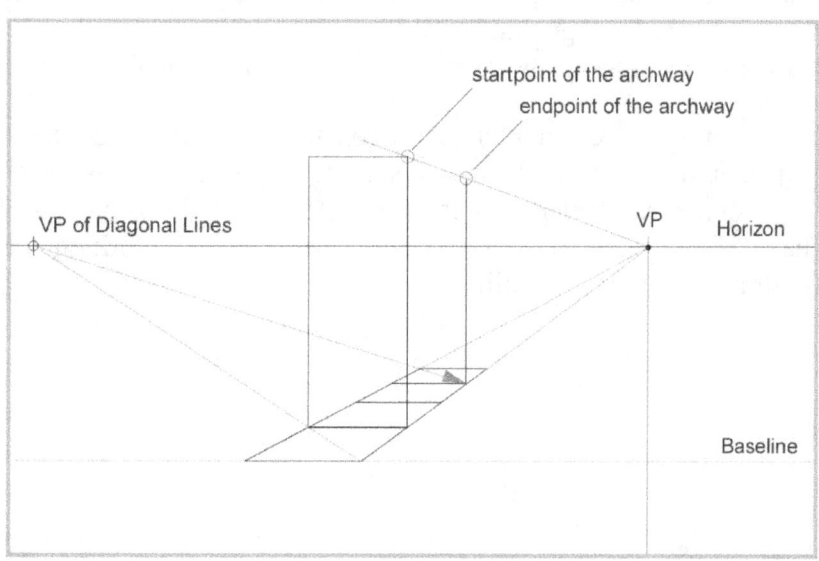

In order to draw the archway, we first of all draw a half square as the construction area. The important thing here is determination of the correct height of this rectangle. It is shown to be practical here that we constructed the base area of the gate out of equal-sized squares.

We transfer the width of the column up to the top with the aid of a compass or ruler. This procedure has been illustrated by the arrow in the drawing below.

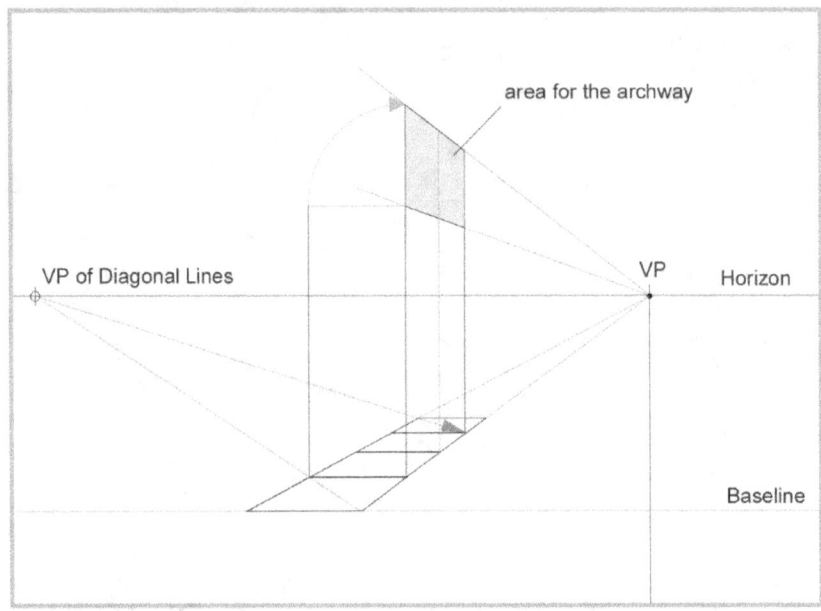

And now we need another front side construction surface onto which we draw a quarter circle. We draw once again a surface diagonal line onto this construction surface and mark its intersection points with the circle segment.

This undistorted circle segment basically represents the archway in an undistorted view.

Now we turn once again to the rectangular (side) construction surface for the archway. This is divided into two squares. In each of it we draw a surface diagonal, as shown in the image below. The patterning into square basic elements in turn helps us to determine the length of these squares, as we have intended in the beginning of this exercise. Working with squares also guarantees that we draw circles and not ellipses.

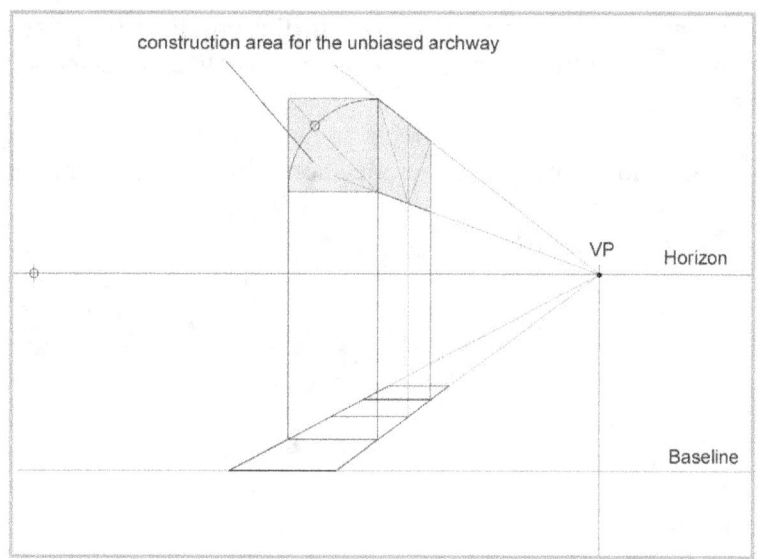

In the front side (left) construction surface, we have marked the point of intersection between the circle segment and the diagonals. This intersection point now has to be transferred to the other (right) construction surface.

This trick is accomplished with a horizontal line that we extend to the right edge of the left construction surface. A reference point arises here, to which we in turn draw another vanishing line.

Now let's take another look at the right construction face. At that point where the vanishing line just drawn intersects with the surface diagonals of the two squares, we draw intersection points. This will result in two points of intersection.

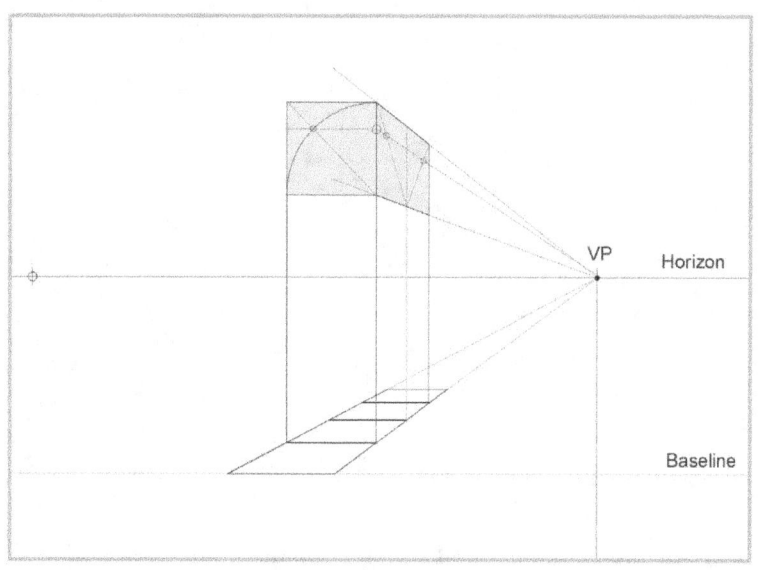

This procedure will probably look familiar to you. In the previous exercises as well, we drew circles and circle segments with the aid of diagonals and points of intersection. We will proceed in this manner here as well.

You can see in the image below how the semicircle should look in the right construction surface.

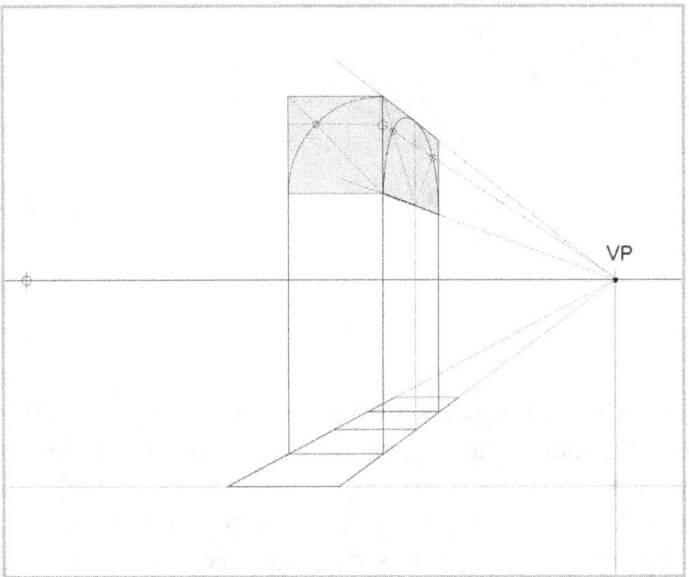

Since our gate has two sides, we need to draw another semicircle. This procedure is the same as before.

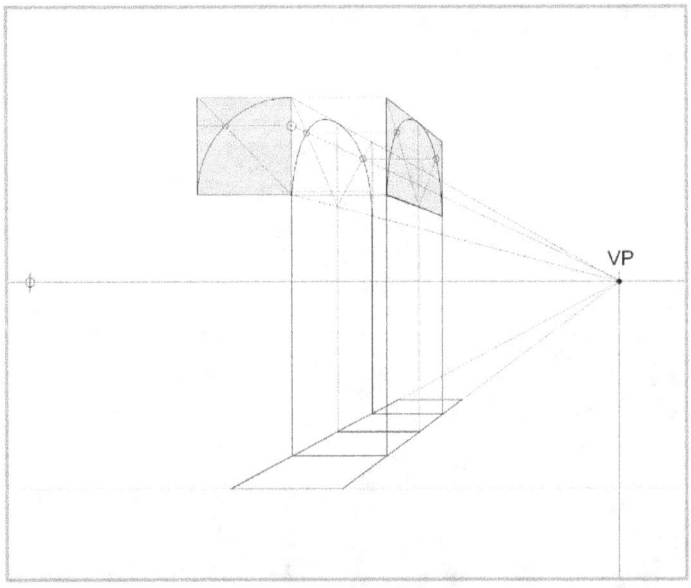

A bit of follow-up work, and now we have completed the exercise. The hidden edges are presented as dotted lines in the drawing below.

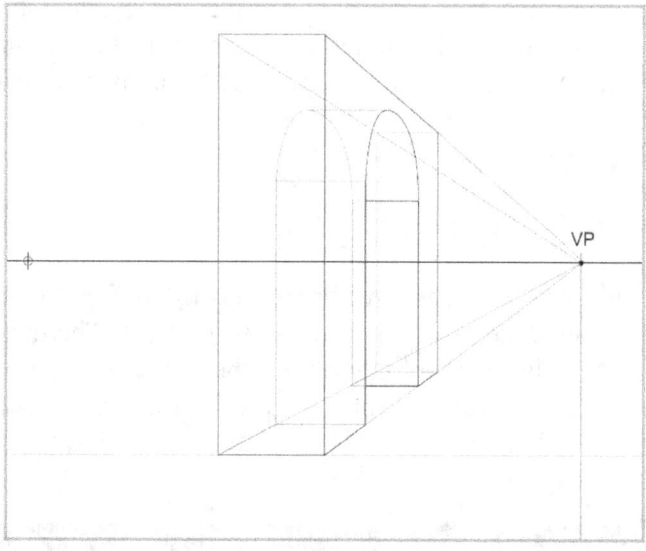

And now we see the drawing with shading, which makes the archway look quite realistic.

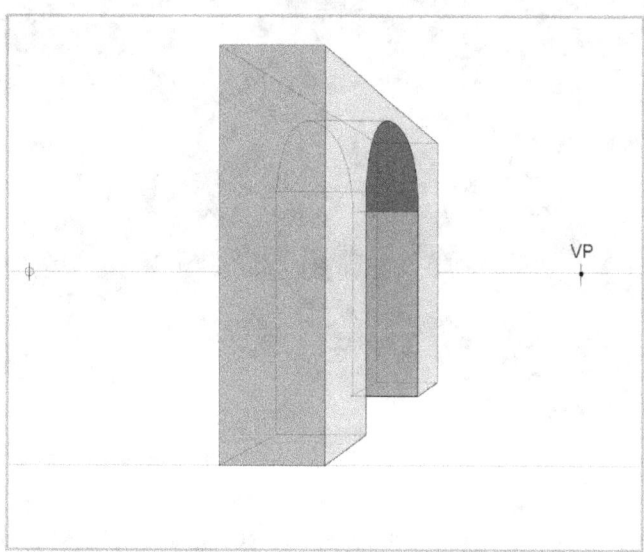

This example brings us to the end of the chapter "Circles, Cylinders and Arcs". The construction of objects in perspective is also finished. The only thing left is the representation of shadows in perspective. This is the topic for our next chapter.

8 Shadows in Perspective

In this chapter we will discuss the topic of drawing shadows with vanishing point perspective. Representation of shadows is not only important for making a drawing appear more realistic; shadows also render a drawing more plastic and exert strong influence on the spatial effect. For this reason, I have dedicated a special chapter to the topic 'Shadows in Perspective'.

8.1 Drawing Shadows without Perspective

Shadows always occur in those places where there is no light. For this reason shadows outline the form of objects and produce the majority of the plastic effect. The three-dimensional form of a body emerges more intensively in combination with the representation of shadows. We have to consistently pay attention, however, to proper proportions within the shadows, and to achievement of the proper tonal value.

Example: light and shadow in a still life (charcoal drawing by Markus Agerer)

8.1.1 Various Lighting Situations – an Example

Depending on where the source of light is located, an object's shadow falls in one direction or the other. The shadow can be either longer or shorter, and can also change its degree of darkness. Depending on the intensity of the light, the edges of shadows can appear soft and diffuse or clearly defined and hard.

You see a few examples in the drawings below that show how a cylinder can be shaded. In these three examples, each cylinder has been illuminated differently.

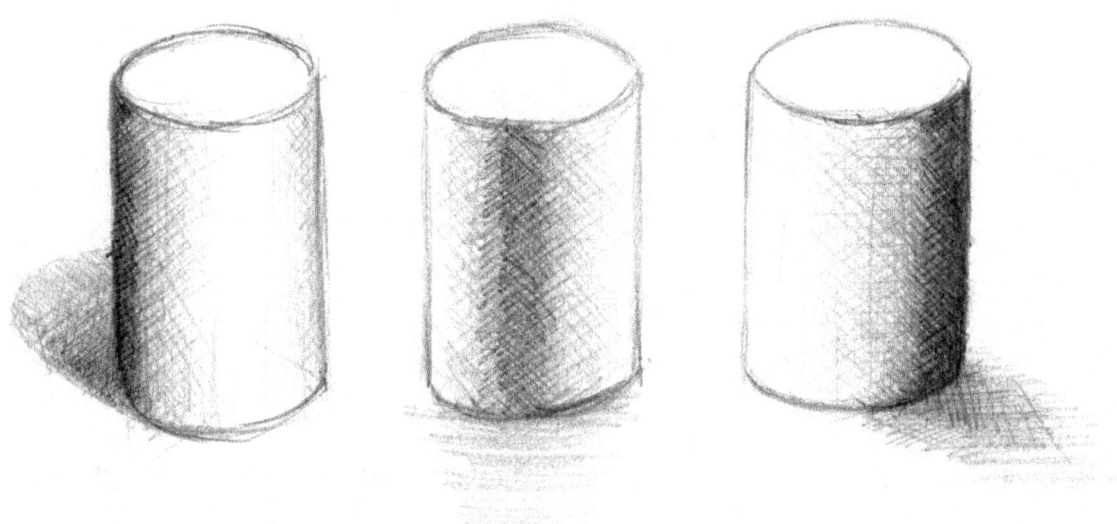

Cylinders in various lighting situations

Here are four more examples in which a cylinder and a cube can be illuminated from various directions:

Example 1 – Light from Back Right

Here the light source is located behind the objects on the right side. The cube and the cylinder hence cast shadows to the front and left. Furthermore, the objects are each somewhat lighter on their right side

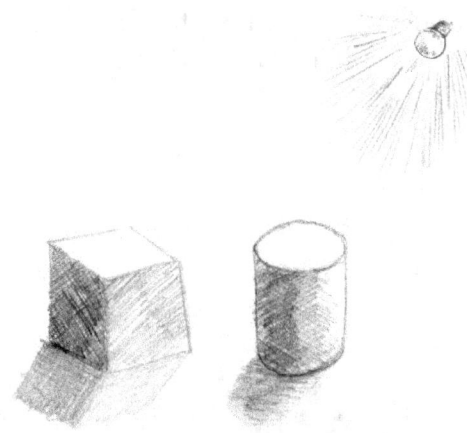

Light from back right

Example 2 – Light from Behind

Here the light appears from behind, whereby the two objects cast long shadows straight ahead to the front.

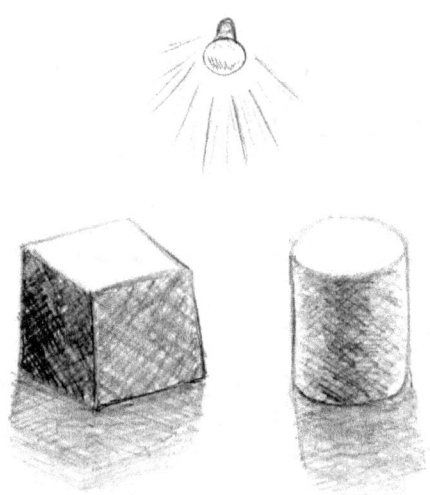

Light from Behind

Example 3 – Light from Above

When light shines from directly overhead, there are virtually no shadows at all cast next to the two objects presented here. In this drawing light shading was included, since the source of light is located between the two objects and they are thus slightly illuminated from the side.

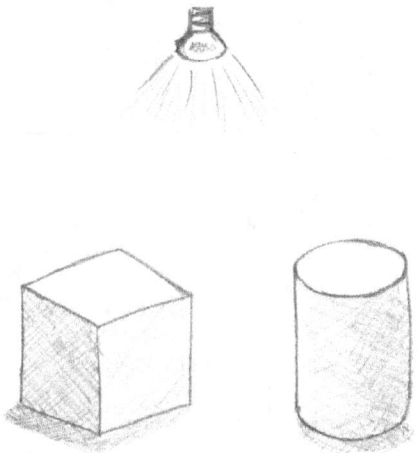

Light from Above

Example 4 – Light from the Front

If the objects are illuminated from the front, they cast a shadow towards the back. However, this shadow is hardly visible from the perspective presented here.

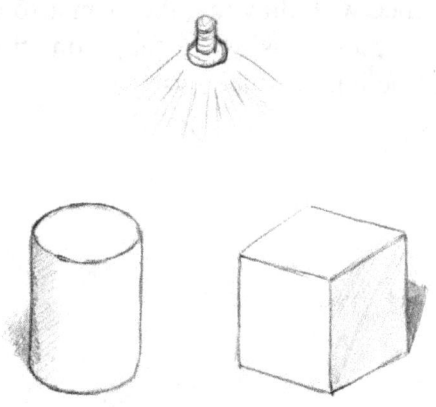

Light from the Front

8.1.2 Constructing Shadows

For simpler objects, we can construct, on our own, the shadow that is cast onto the ground by the object. To this end, we need to first of all determine at what position the light source is located. From this we can then figure out the light's angle of incidence and directional angle. With the aid of this information, we can then construct a shadow on our own, as can be seen in the drawing below.

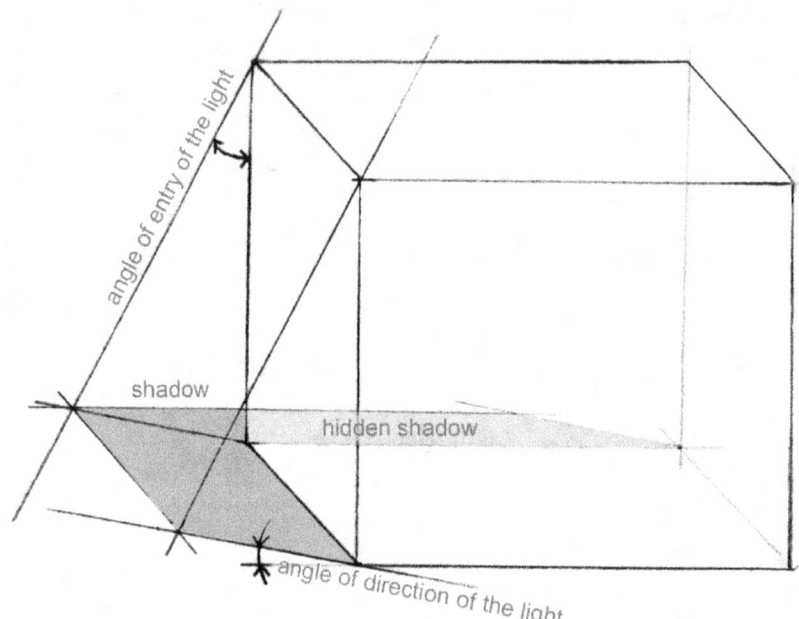

Constructing the casting of the shadow

If the artist has sufficient experience with drawing, they can also depict the shadow cast without reference lines. For complicated motifs as well, they sometimes have to depend on their experience and intuition. Construction of shadows similar to the example above would be extremely time-consuming for complex forms.

8.2 Shadows in Perspective Representation

And now that you have become acquainted with the most important fundamentals for drawing shadows, we can now tackle the issue of representing shadows in vanishing point perspective. We will begin with a simple exercise in which a rectangular solid is illuminated by a lamp.

8.2.1 Light and shadow from a lamp

The starting point is a rectangular solid that is drawn in central perspective with one vanishing point. Moreover, this corresponds to the rectangular solid that was introduced in the first exercise of the book.

The second thing to be done is to determine the source of light. The source of light is shown as a gray point in the image below. The light source here could be, for instance, a street lamp, a floodlight or a ceiling lamp. By using a vertical line and a small black point, the position of the light source was also identified on the floor. This step is necessary so that the observer knows where the light source is located within the spatial depth.

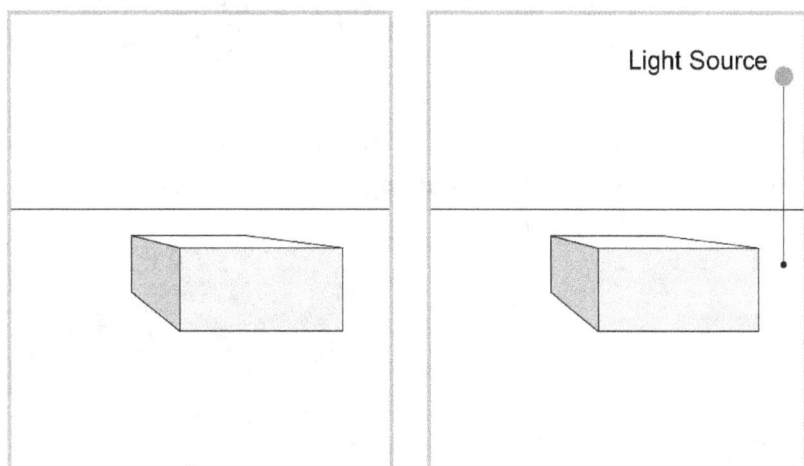

And now we draw rays of light that are emitted by the source of light. We first of all draw three rays of light to the three upper corner points that are positioned on the shadow side of the rectangular solid (drawing below left). These rays of light do not however end at the corner points; rather, they are extended out to the edge of the drawing.

Then three more (reference) lines are drawn which run from the floor point of the light source to the three lower corner points at the shadow side of the rectangular solid (drawing below right). These lines as well are to be extended out beyond the corner points.

We have to extend the reference lines at least far enough to intersect with the three rays of light, as can be seen in the image on the right below. If necessary the rays of light have to be extended once again for this purpose.

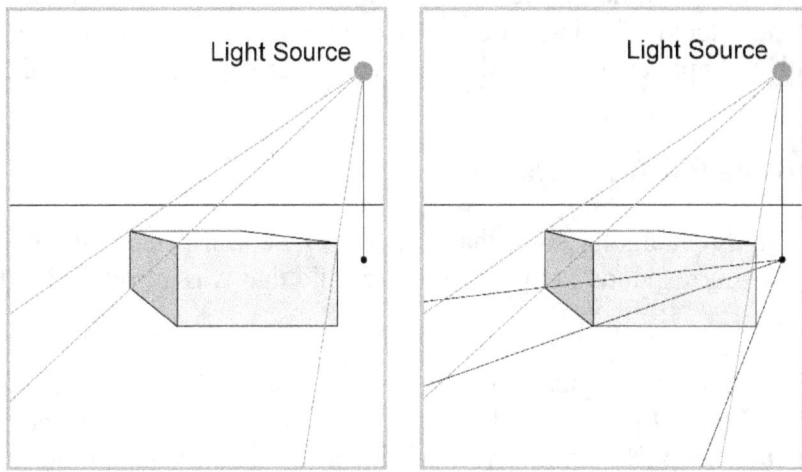

After the three previous steps have been taken, three intersection points have now emerged at that point where the rays of light intersect with the reference lines. These intersection points should now be connected together with two other reference lines, as shown in the image on the left below.

This step completes construction of the box's shadow. Extraneous reference lines are now erased, revealing the outline of the shadow (drawing on the right below).

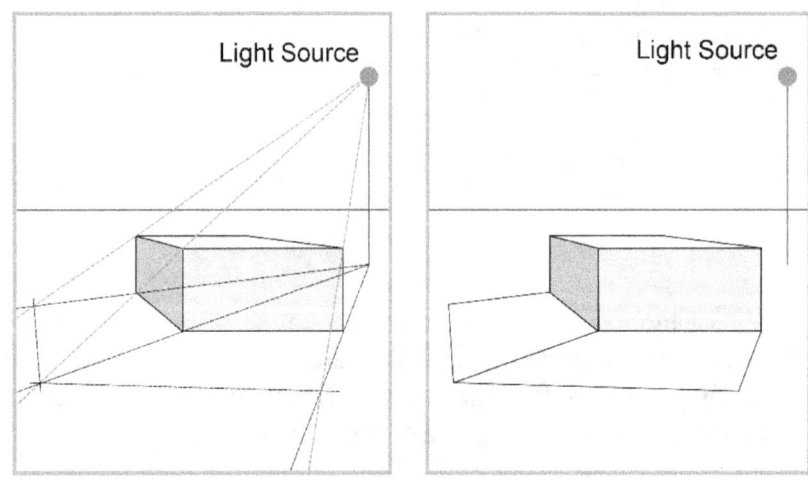

You can see in the next image on the left that the shadow just drawn is in accordance with the vanishing lines from our vanishing point. There is thus a logical correlation here.

In the drawing on the right, the shadow of the box has been shaded in with two different shades of gray – thus completing the drawing.

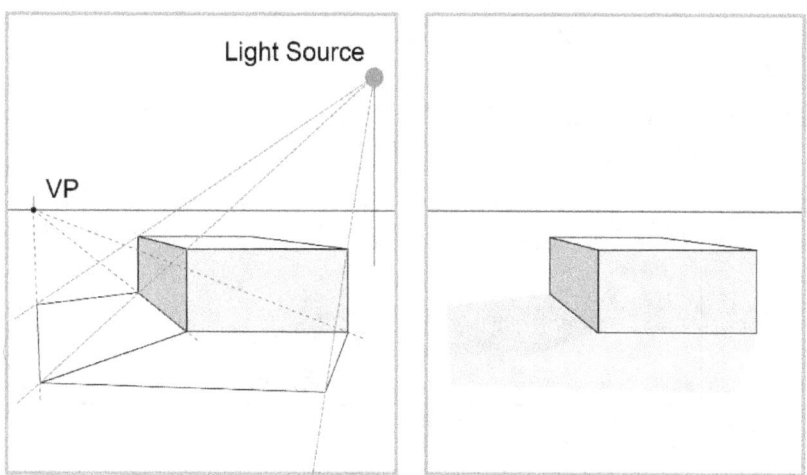

8.2.2 The sun as light source, and shadows in diagonal perspective

In this example, we want to examine two different lessons: first of all, how to draw shadows when the sun functions as the source of light (as opposed to a lamp) and, secondly, we'll take a look at the construction of shadows in diagonal perspective.

The Sun as Light Source:

In this example, the sun is in front of the observer. It would be a different case if the sun were shining on the observer's back. We'll take a look at this second situation later on.

If the sun, as in this example, is located in front of the observer, we can determine its position at any given point beyond the horizon. The critical difference in comparison to a lamp is its position within the depth of the room. We would still have to establish the depth position ourselves with the lamp example. The sun however is always located directly over the horizon line.
This means that the lower reference lines always extend from the horizon. Take a look at this in the following image.

Shadows in Diagonal Perspective

As you can see from the image below, construction of the shadow in diagonal perspective works the same way as central perspective. Here as well, we see the three rays of light and three reference lines on the ground. The points of intersection for these lines are connected by further lines and the hard shadow of the object emerges.

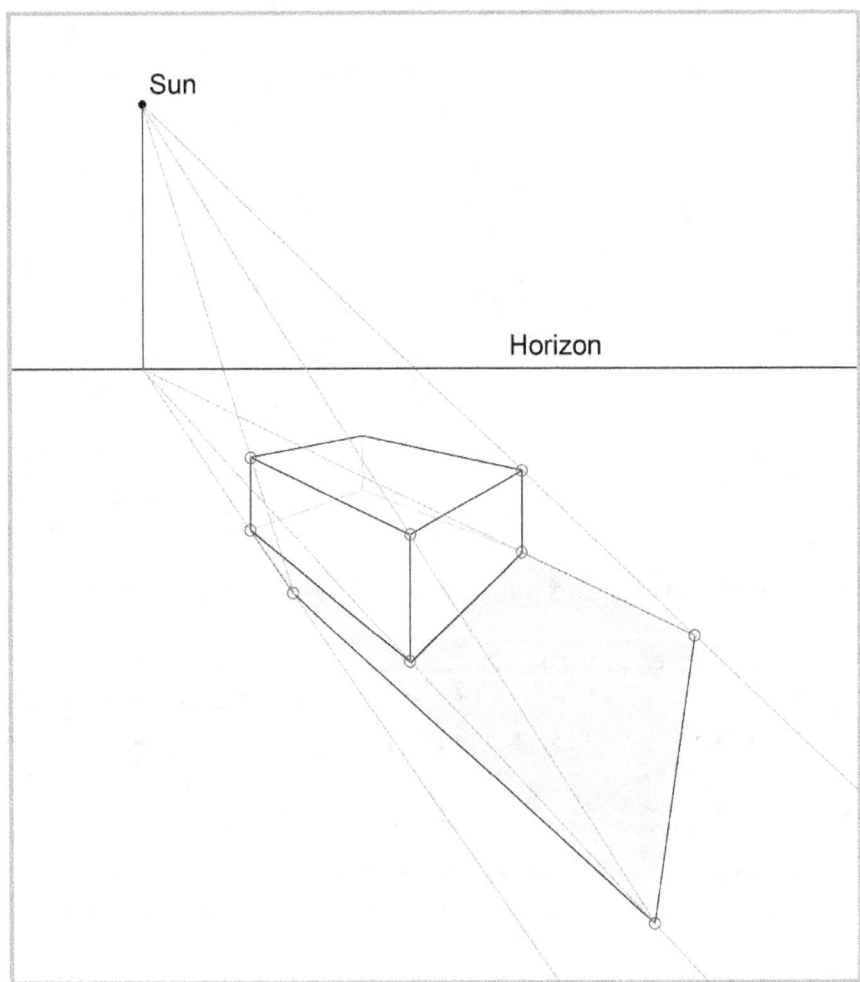

Aren't the sun's rays parallel?

I have frequently read that the rays of the sun are supposedly always parallel – even in a drawing with perspective. This is, however, only the case when the sun is positioned right next to the observer, i.e. neither behind him nor in front of him. In all other cases the sun's rays, and by necessity the shadow as well, have to be aligned in perspective.

8.2.3 The sun as a light source at the observer's ack

In this example, the topic was pre-announced in the section title, i.e. the sun is behind the observer. In order to construct the shadow for this case, we have to do two things:

1. The sun is located below the horizon.
2. The sun is located on the opposite side. This means that when the side is actually on the left, it is drawn in on the right.

In the following images, you can track step by step how a box's shadow is constructed for this situation.

First of all, we need to determine the position of the sun.

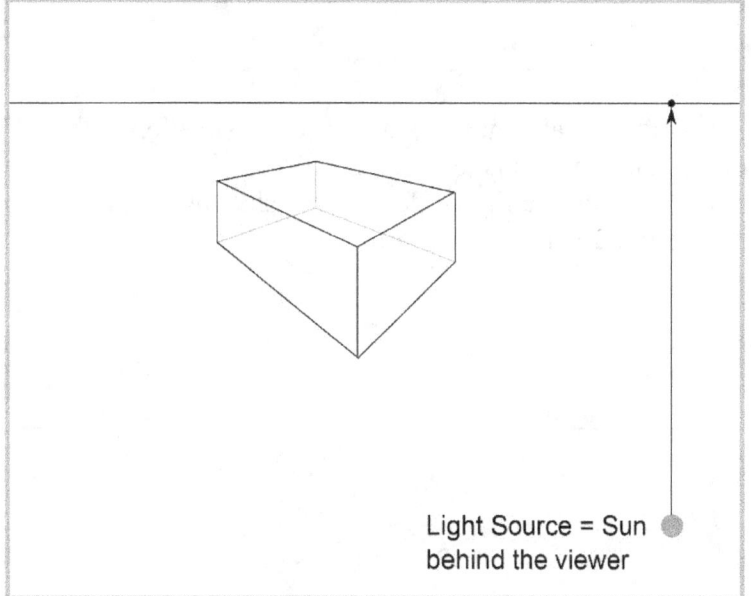

And now we draw the rays of the sun and reference lines as we did in the other examples. The intersection points of the construction lines are marked once again. We have to just be sure here that we always use only the intersection points from two lines that belong together.

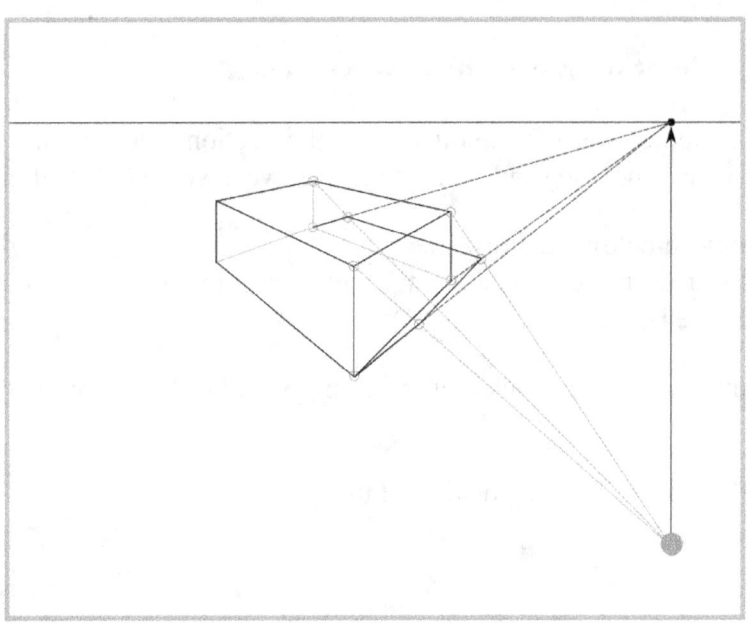

Now we can draw the shadow. Take into account here the situation as it was described, making sure that the point of the sun drawn in is located on the opposite side from its position in reality. In this case the sun is marked on the right side, and the shadow is also cast to the right. The sun has to be located on the left in reality.

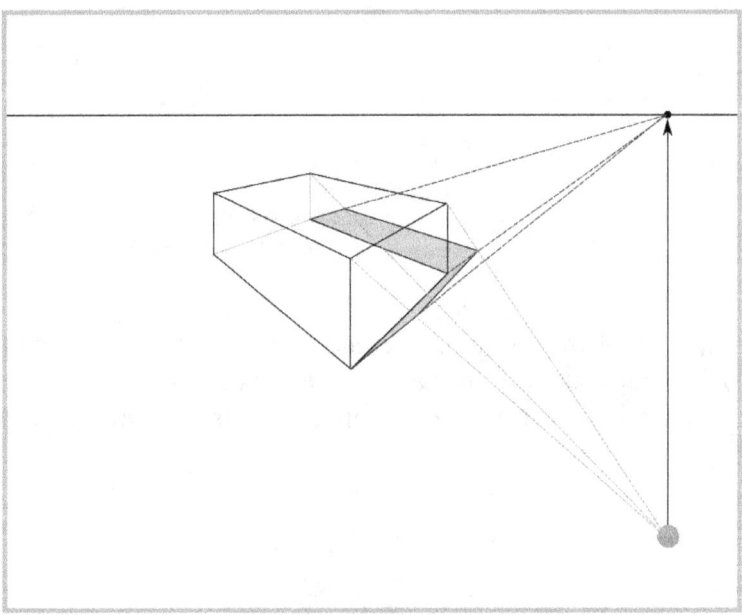

Here is the drawing without reference lines.

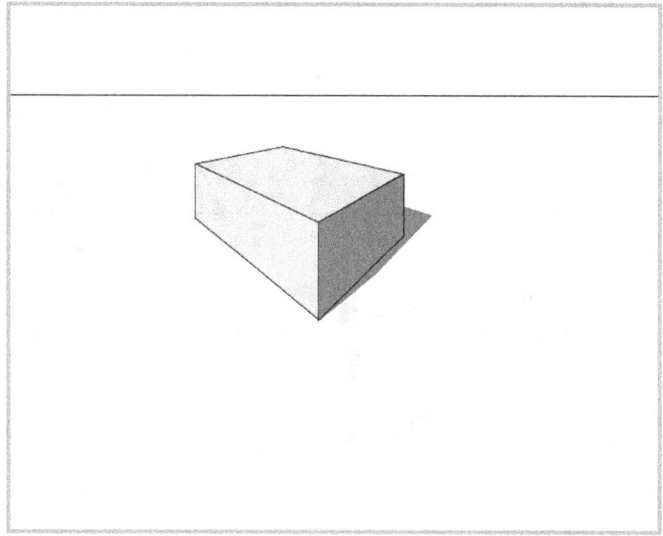

8.2.4 Further examples

Now I would like to show you three more examples of various positions for the sun. One can recognize quite well how the shadow changes in our drawing. In order to represent another position of the sun in a drawing, we have to shift the point of the sun in our drawing.
In the first example, we reposition the point of the sun farther back towards the horizon. When we compare the shadow with the previous example, we can see that the shadow is getting longer. This means that the sun is closer to the horizon.

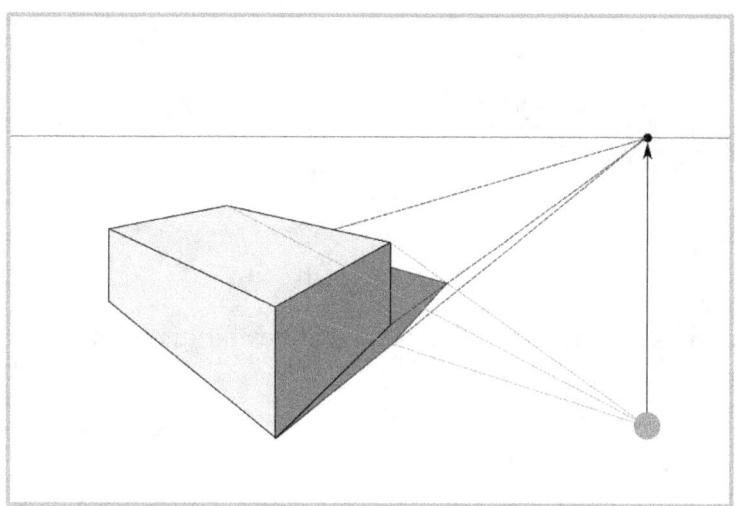

And now we push the sun point back further towards the horizon. What occurs then has previously been shown. Here we can see that a section of the shadow that was previously hidden behind the box now becomes visible.

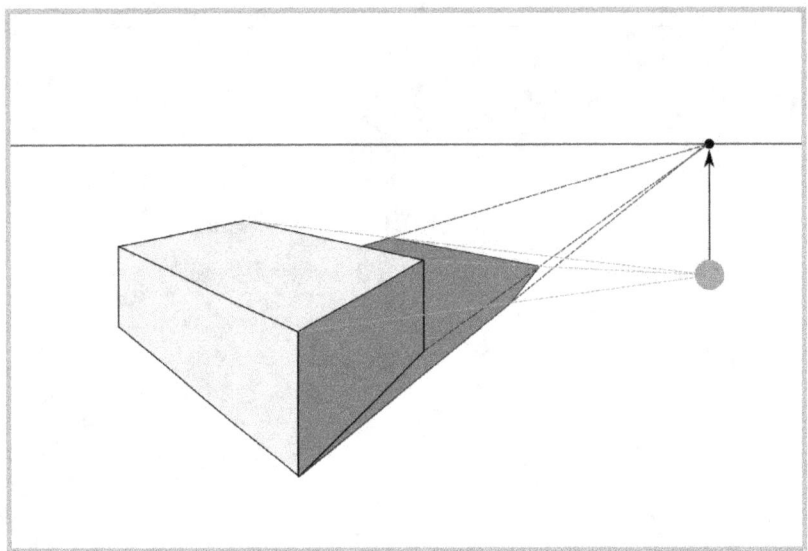

And now let's try something else: we shift the sun's position farther to the right. You can see the results in the image below.

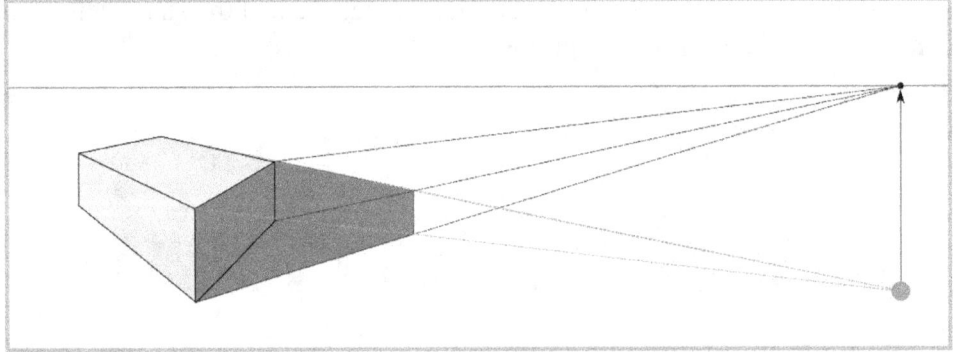

Due to this shift, a position of the sun is simulated that lies farther to the side (and less behind the observer).

8.2.5 Drawing the shadow of a multi-faceted object

Drawing shadows becomes a bit more difficult when we want to draw a more complex motif. Now we are looking at an object that is made up of two boxes. The motif is still relatively simple, but still presents a bit of a challenge.

You can see the drawing of the two boxes in perspective below.

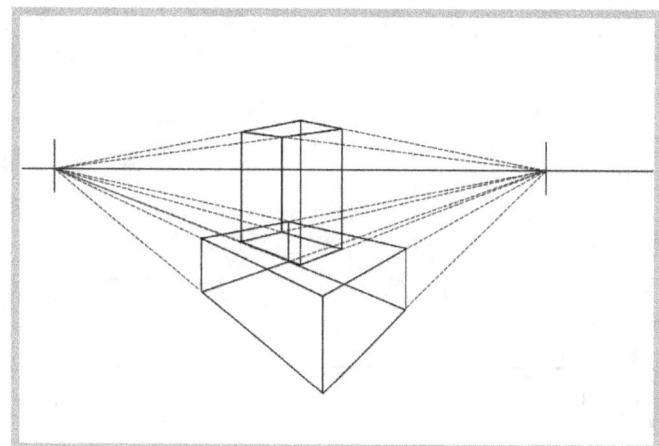

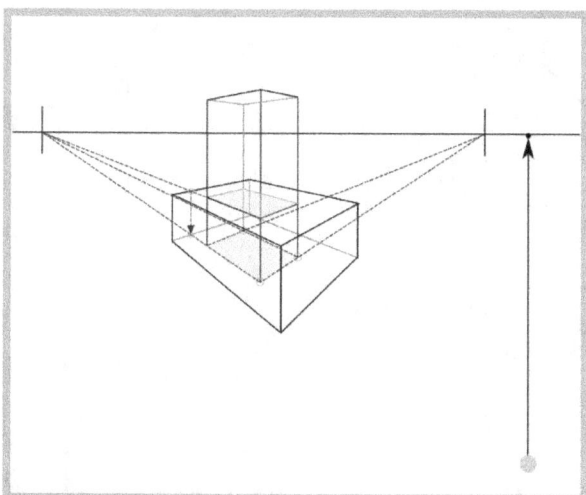

And now we begin the drawing of the shadow. First, we want to start with the shadow for the upper smaller box. The difficulty here is that the box's shadow first of all is cast onto the object underneath and then proceeds down to the floor.

In order to be able to represent this geometry of the shadow, we project first of all the lower surface of the upper box onto the floor. You can see how that looks in the image on the left here.

Now we'll draw the shadow that corresponds to the upper box as if it were an object that lies on the ground. The procedure is then just like it was in the previous examples.
But be careful! Later on, you have to erase a section of the shadow drawn in here. When you use the pencil to draw, don't push too hard.

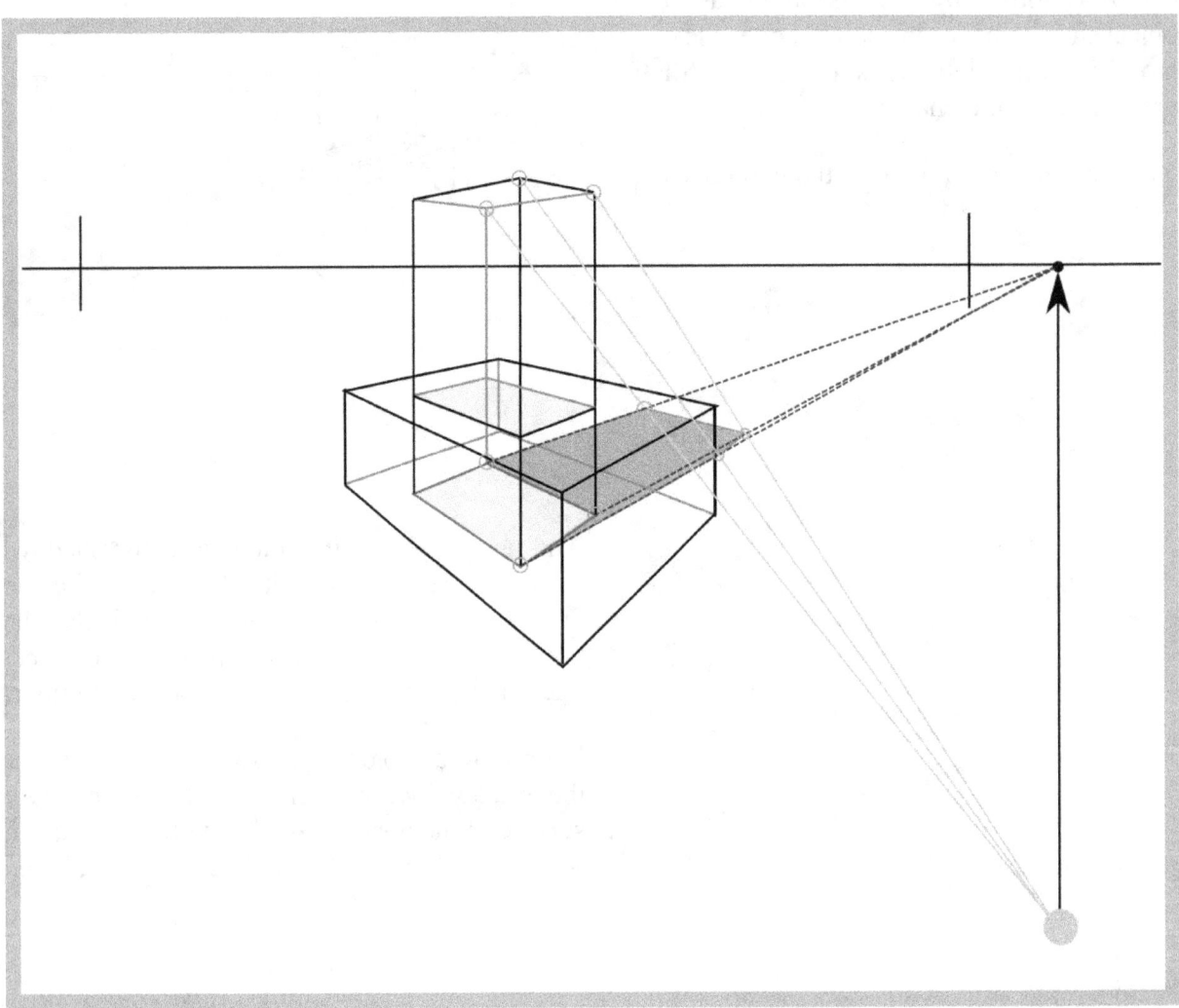

So now we draw in the shadow of the upper object as it is cast onto the surface of the lower object. In order to be able to properly represent the shadow using the method previously introduced, we have to draw the shadow in full length – down across the surface of the lower object as well. The section of the shadow that more or less hangs in the air has to be erased later on.

In the drawing below, the shadow of the lower, bigger box was also drawn in.

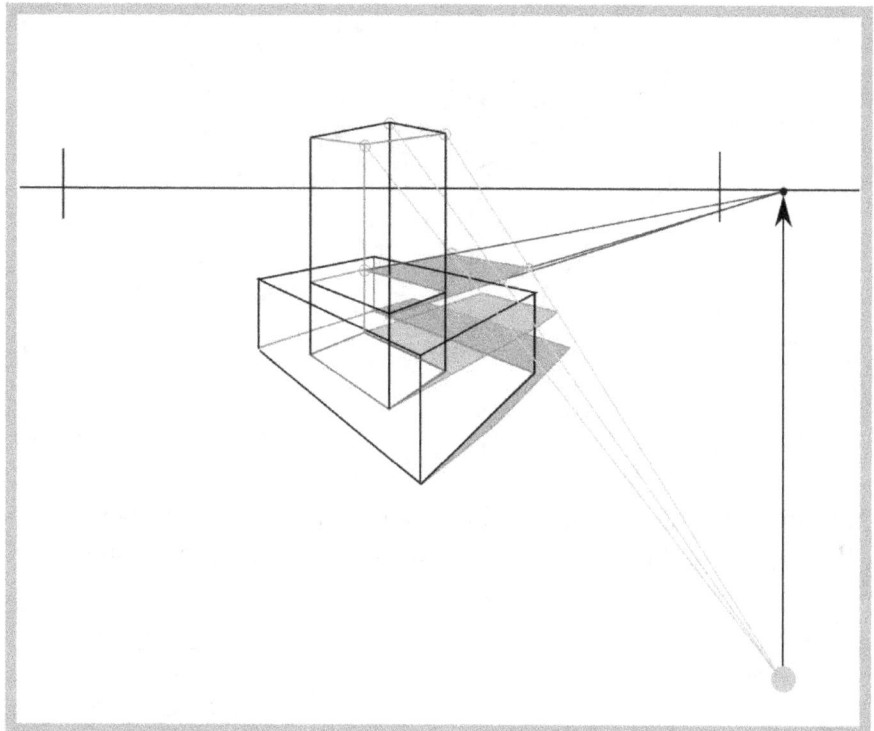

For the next step, we complete the shadow of the upper object. The unnecessary components of the shadow are removed here. The upper and lower sections of the shadow are connected together with two vertical lines (in red).

What we are facing now is – at least in this example – simple repetitive work. Since this section of the shadow lies on the side of the box hidden from the observer, this section has to be removed later on.
In order to understand this drawing technique better, it is helpful to display the entire shadow.

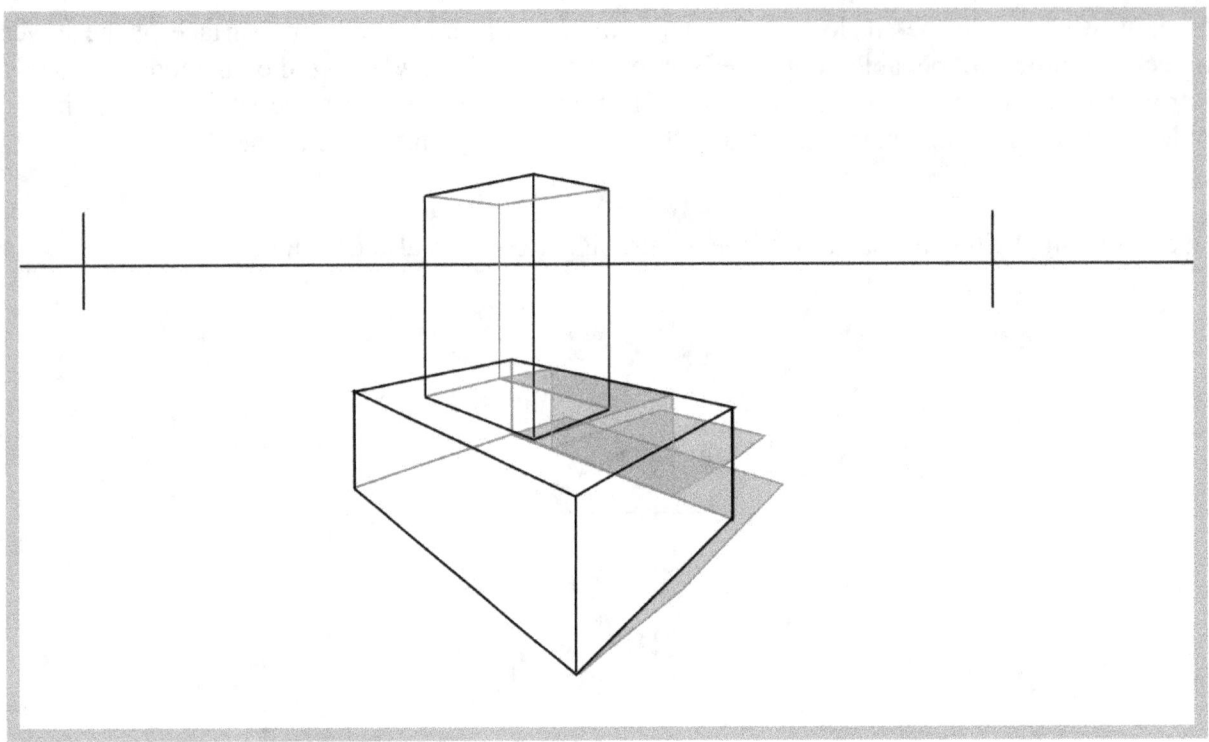

The sun is shining from the left side of the object, therefore the right surfaces of the box are also in the shadow. By displaying this shadow, the drawing is more or less finished.

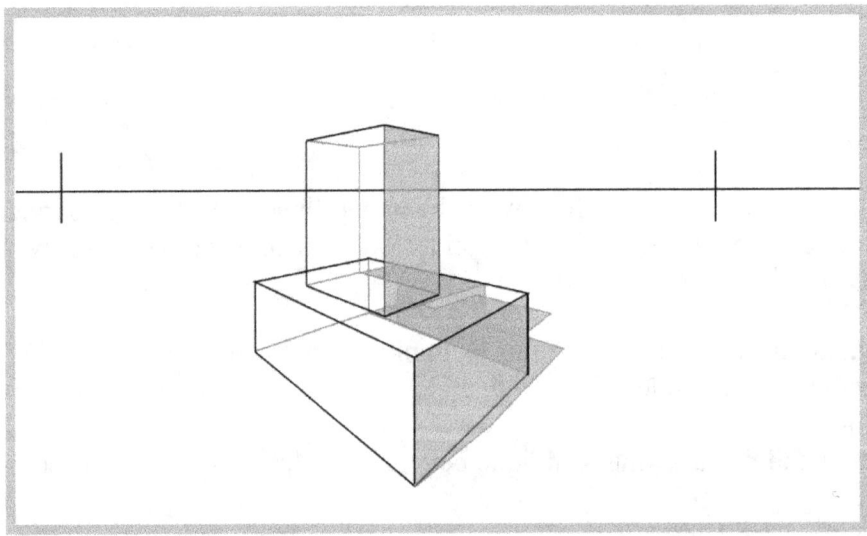

The non-visible sections of the shadow can now be removed. Add a bit of shading, and the drawing makes a good impression.

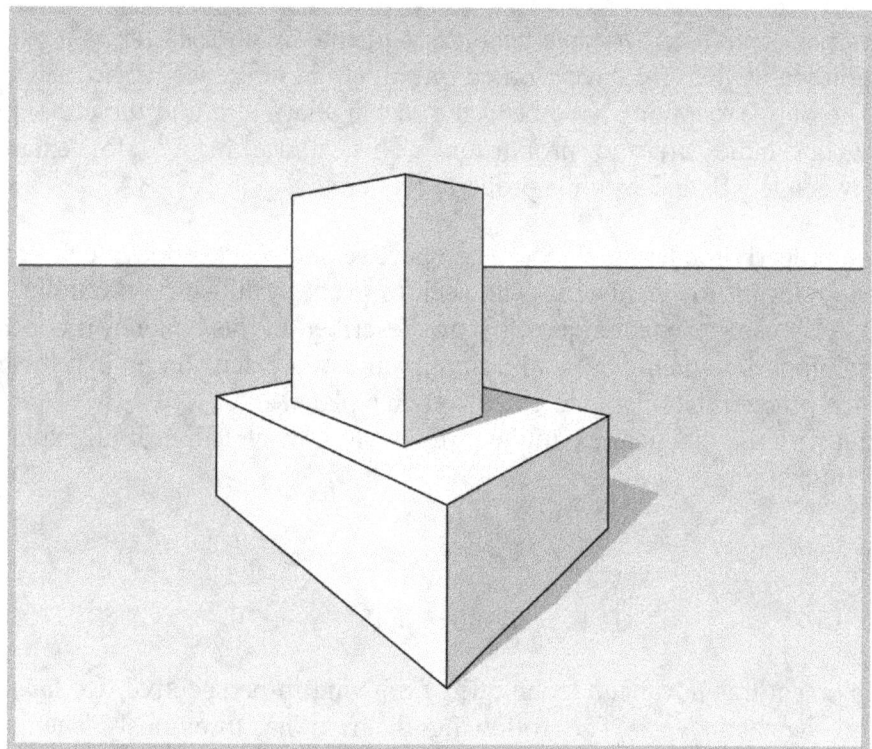

With these concluding examples, we now come to the end of the chapter "Shadows in Perspective" and take on new and bigger challenges: in the next chapter we will take a look at representation of motifs that are true to the proportion.

9 Representation that is True to Proportion

Vanishing point perspective, as we have become acquainted with it so far, is a technical method for representation with which we have worked intuitively in reference to the metric relationships of an object. The only exceptions have been the rectangular solid and the cube. Otherwise, the drawings were not quite 'true to proportion'. This phrase means, for example, that the relationship between length and width is properly rendered.

But how can we properly render an object in perspective and still keep it true to proportion? This question is quite relevant for architects, who seek to properly illustrate a building in a drawing with perspective. By using the techniques that are described in this chapter, it is possible to draw an object true to proportion on the basis of a floor plan. Even extension up into the heights can be represented in the proper relationship to extension on a plane.
Before we begin with the practical examples, we should however first of all explain a few more important basic terms.

9.1 Elements of Perspective Drawing that is True to Proportion

In order to implement this advanced technique of drawing in perspective, we have to first of all introduce a few new concepts. The following diagram has previously been shown at the beginning of the book. At that time there were a few elements missing – now we need to add these elements.

Eye point Ep:

The eye point is the position of the observer's eye. Perspective drawing is represented in such a manner as though we were looking through this eye. The eye point always has to be transferred to the floor in the process of drawing. You will see later on why this is necessary.

Eye level El:

The eye level is the distance from the floor, which the observer is standing on, up to his eye.

Principal point Pp:

The principal point is more or less the center of the drawing in perspective. It represents the plumb point from the eye point to the picture plane, and also plays an important role in production of a perspective drawing and the subsequent observation thereof. However, the principal point in this context is not the equivalent of a vanishing point – here we are talking about two different things.

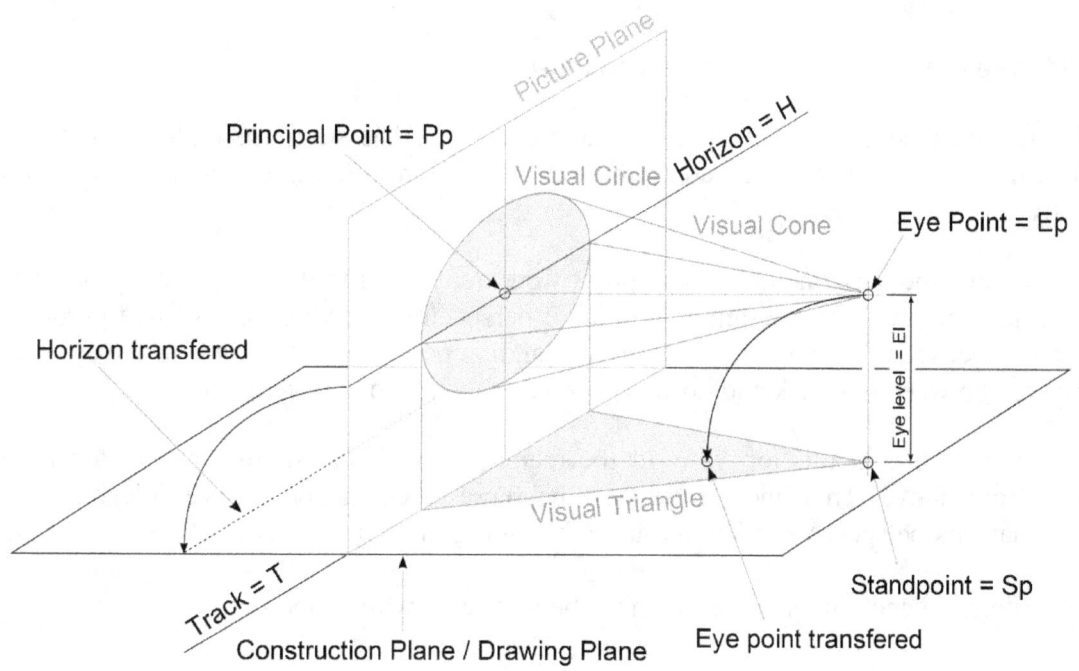

Elements of drawing in perspective that is true to proportion

9.2 Individual Lines

9.2.1 A line that extends back into the depths

The simplest exercise is representation of individual lines. The starting situation can be seen in the following diagram. The topic here is the top view down to the line that we want to draw in perspective.

In this top view, the horizon and the eye point were transferred to the floor. This procedure was also shown in the previous diagram (elements of perspective drawing that is true to proportion). The distance between the eye point Ep and the standing point Sp corresponds to the eye level El. The distance between the track and horizon also corresponds to the eye level.

We now draw a line in this top view in the manner in which it should be situated in space, observed from above. This line should now be represented in perspective. We have already defined what this perspective looks like by establishing the point of view, the eye level and the track.
The beginning and end points of the line have been labeled with A and B.

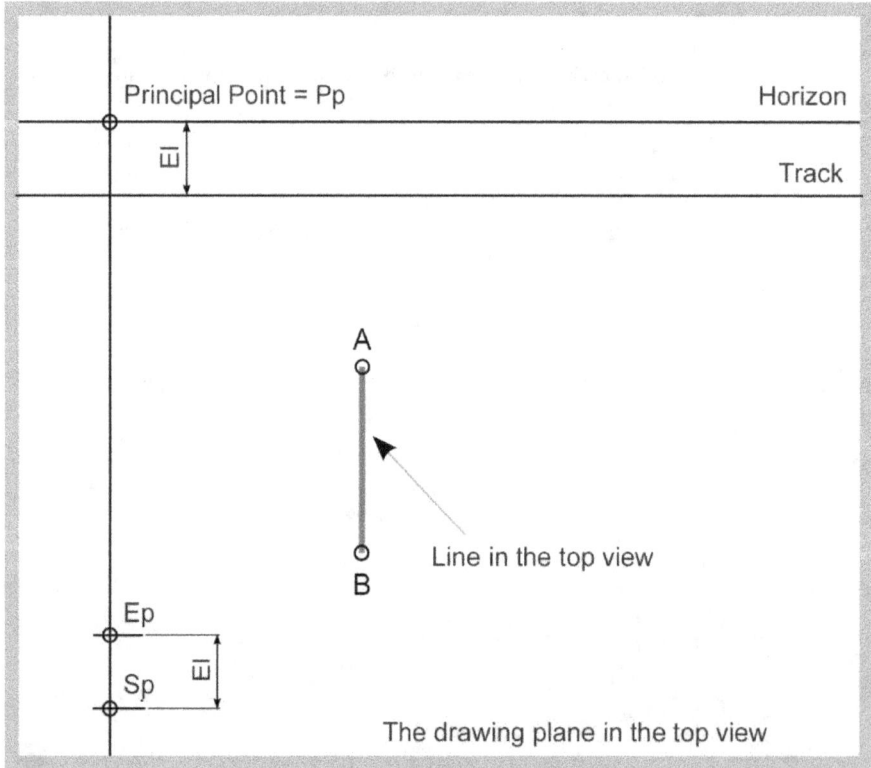

Starting situation: A simple line in top view

And now the actual work begins. You can view the procedure in the following diagram. An explanation is then provided below. The numbers in the illustration describe the sequence in which the vanishing lines and construction lines are drawn.

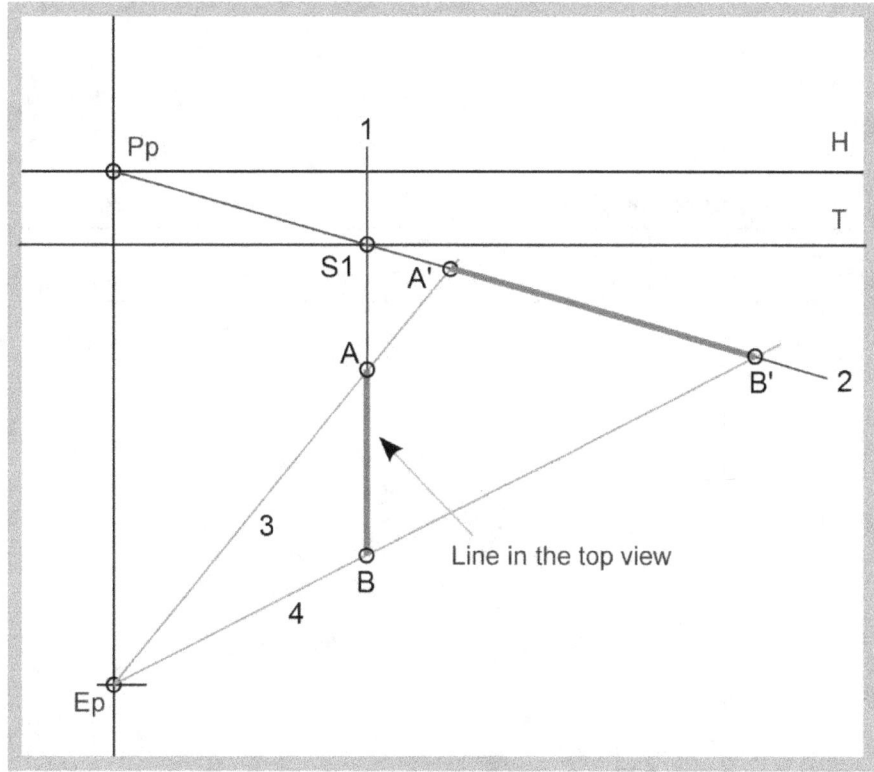

The final result

1. First of all, we draw a line (1) that represents an extension of the straight line (A-B). This line has to intersect with the track. The point of intersection (S1) that results is important for the rest of the procedure.

2. Now we draw a construction line (2), which extends from the primary point and through the point of intersection (S1).

3. Two more construction lines are drawn (3 and 4), which start from the eye point and intersect with the beginning and end point of our line A-B. The two construction lines (3 and 4) are extended out to the construction line (2) to intersect them. The points A' and B' emerge.

4. These points A' and B' define the lines A-B represented in perspective.

9.2.2 A line that extends horizontally

Drawing a horizontal line is almost the same process as reproducing a line that extends out into the depths. The starting situation can be seen in the following diagram. The line has been drawn in top view again.

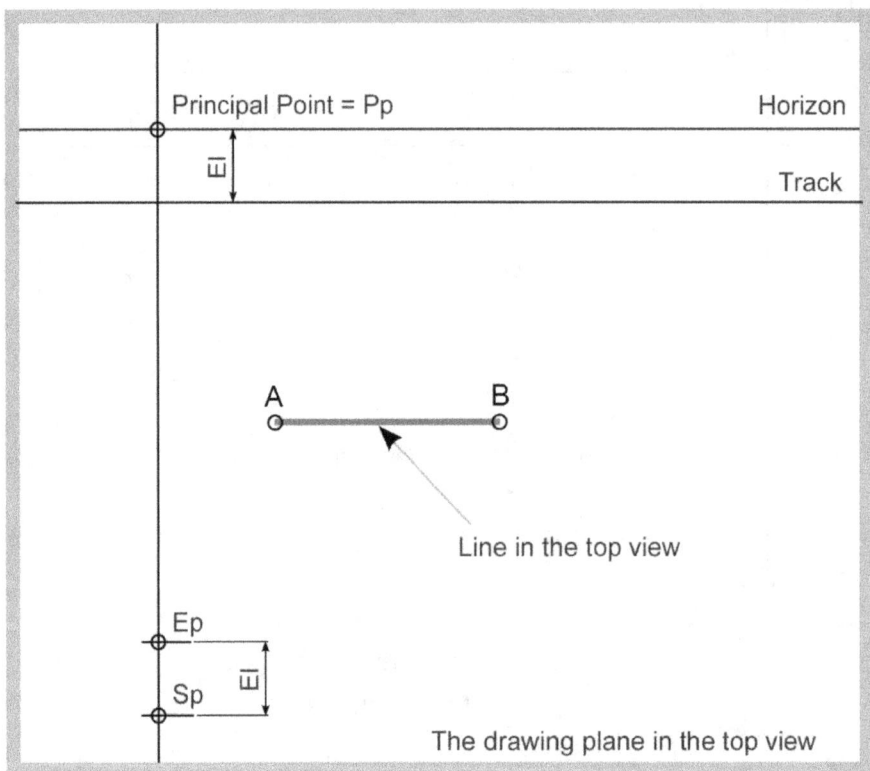

Starting situation: A horizontal line in top view

You can once again see in the following diagram how this line is to be drawn in perspective. The thing that is different this time is the fact that two more construction lines are required this time – lines 4 and 5. This results in an additional point of intersection – intersection point S2.

Starting point and end point for the lines (A' and B') in perspective are now no longer located on the same construction line. In this case, point A' lies on the construction line 2, while point B' lies on the construction line 5.

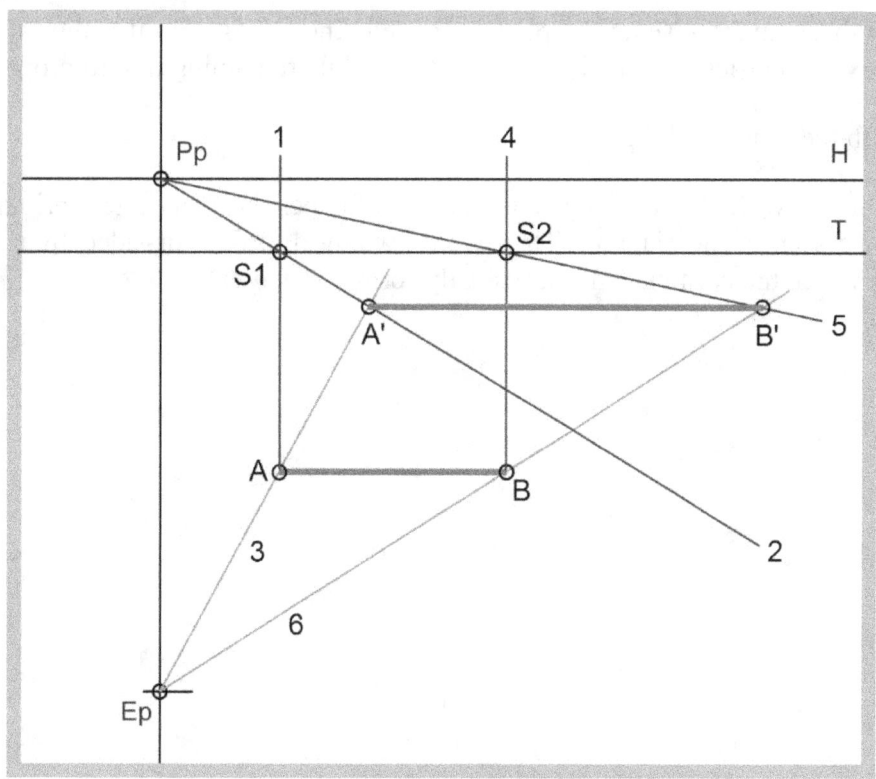

Representing the line A-B in perspective

As we can learn from this example, it is somewhat more complicated to draw a horizontal line in perspective. However, the same method is also used for lines that extend to the horizon at any other desired angle.

Only lines that extend vertically into the depths of space comprise the exception, in which the procedure is executed more simply.

9.3 Drawing Any Desired (Random) Four-Sided Figure

We can see from the following example how effectively the method described here works. Now we will draw any desired four-sided figure in perspective.

In order to understand the advantage of our new method, one has to keep in mind that previously we had needed a special vanishing point for each of the individual sides of the four-sided figure. In the end, the lines are not parallel to one another. A realistic representation here would probably have been rather difficult.

With this new method, only individual points are transferred into perspective. These points just have to be properly connected to one another. Construction of objects is indeed more

complicated in this manner – we need a plethora of reference lines – but it is thus also possible to display complex geometries in a highly realistic style, while remaining true to proportion.

Let's begin with the four-sided figure.

1. First of all, we draw the basic elements on a sheet of paper (horizon, track, primary point, eye point), as can be seen in the diagram. Then we draw any desired four-sided figure (i.e. a four-sided figure in which the corners don't necessarily form 90° angles).

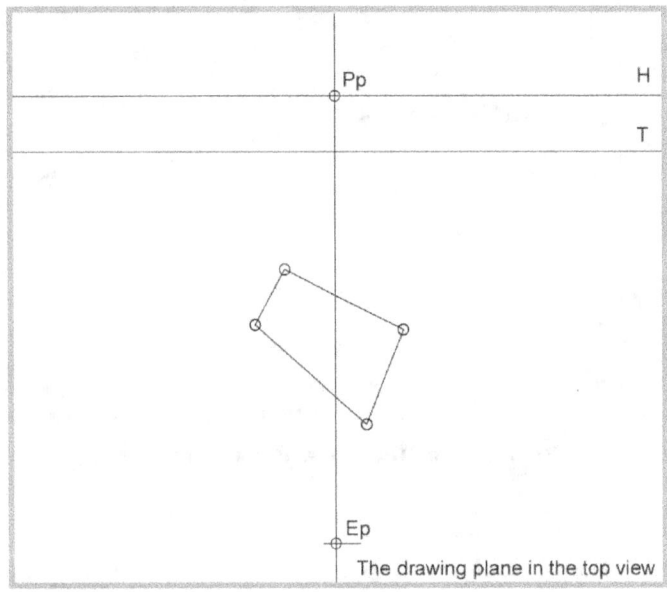

Starting situation – any desired four-sided figure

2. And now we continue as in the previous examples. The sequence of the lines can be seen once again in the numbers.
The first line (1) extends from one of the four-sided figure corner points in the direction of the track (T) to intersect with same. The second line (2) arises from the primary point (Pp) and runs through the previously produced intersection point. The third line (3) arises from the eye point (Ep), runs through the corner point of the four-sided figure and intersects with the line number 2. This point of intersection represents the corresponding corner point of the four-sided figure in perspective.

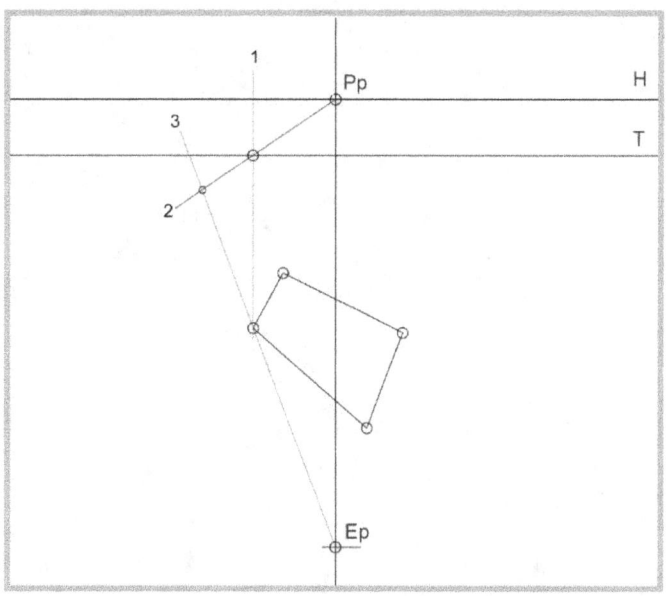
Representing the first corner point in perspective

3. The steps as described are repeated now for the rest of the four-sided figure. The following diagrams show the procedure once again.

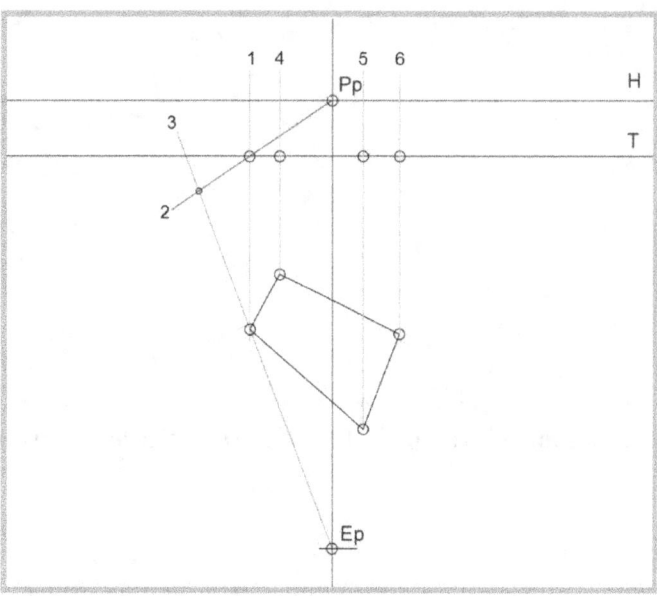

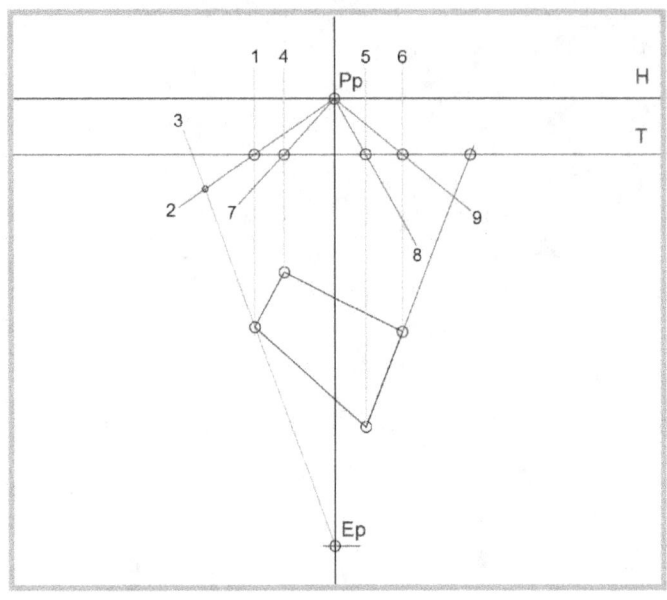

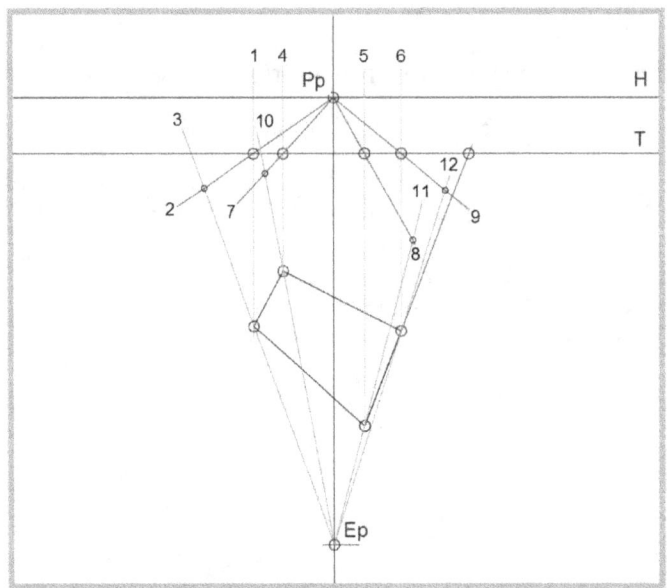

Transferring the corner points of the four-sided figure in perspective

4. In the last step, we just have to connect the four corner points with lines. We have to be careful of course that the correct points are connected. The standard is always the four-sided figure in the top view.

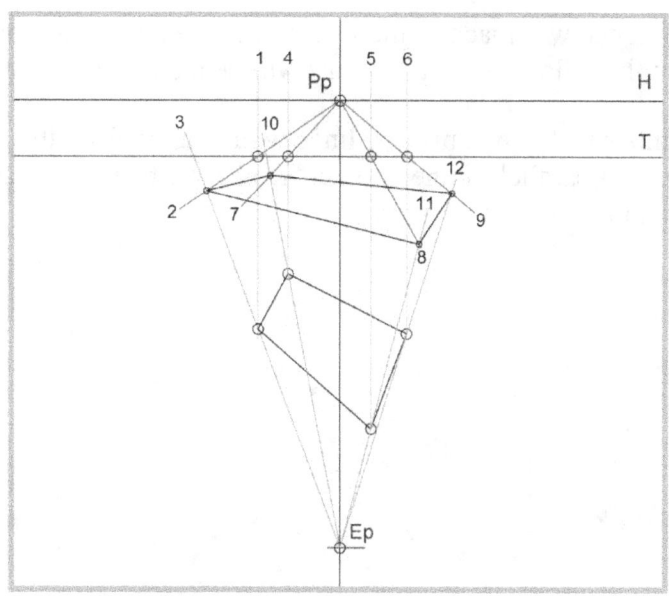

The finished four-sided figure in perspective

Further Comments:

And now a few complementary observations: if we extend the edges of the four-sided figure in the top view, as illustrated in its perspective reproduction, we discover that the respectively associated lines intersect with the track.

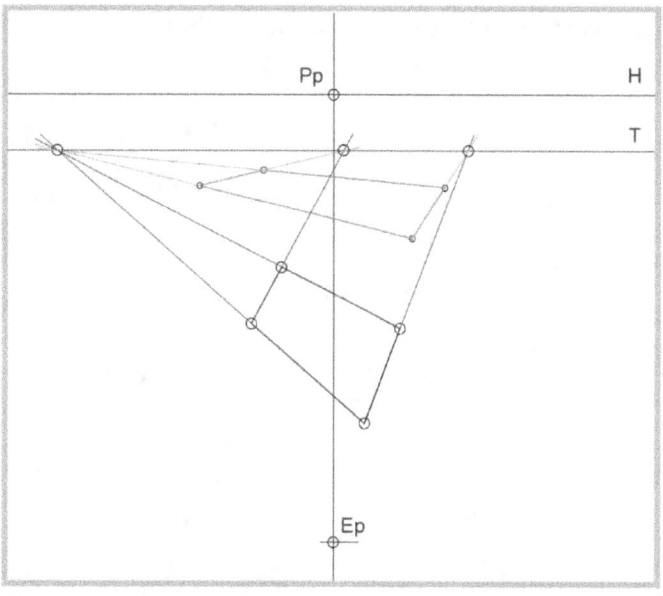

The extended edges of both four-sided figures intersect on the track

In the introduction, reference was made to the fact that each edge of the four-sided figure has its own vanishing point. In the following diagram, this will be made clear once again.

It is best here to remember that two vanishing lines, which arise from the same vanishing point, represent two lines running parallel to one another. However, there is no edge that runs parallel to another one in our random four-sided figure.

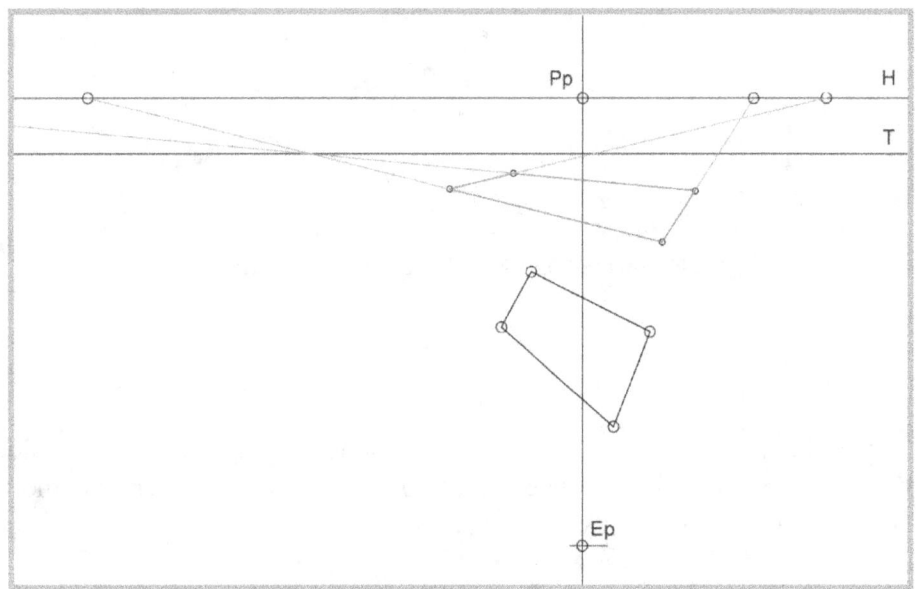

Vanishing points of the individual sides of the four-sided figure

9.4 Drawing Any Desired (Random) Form in Perspective

For this example, we will briefly stay with two-dimensional objects. In the process, we will now attempt the supreme discipline: an entirely random form.

1. We draw any random form on the sheet of paper. You can also draw round and/or curved forms. The starting sketch here shows the top view once again.

Random geometry in top view

2. Since the form drawn here reveals no edges and corners, we have to insert our own points that can be subsequently transferred into perspective. The points are drawn at characteristic locations, such as the point of inflection of a curve, the outermost edge points, etc.
It is advisable here to insert several points at the same horizontal level. In the diagram below, you can see this with the green horizontal lines.

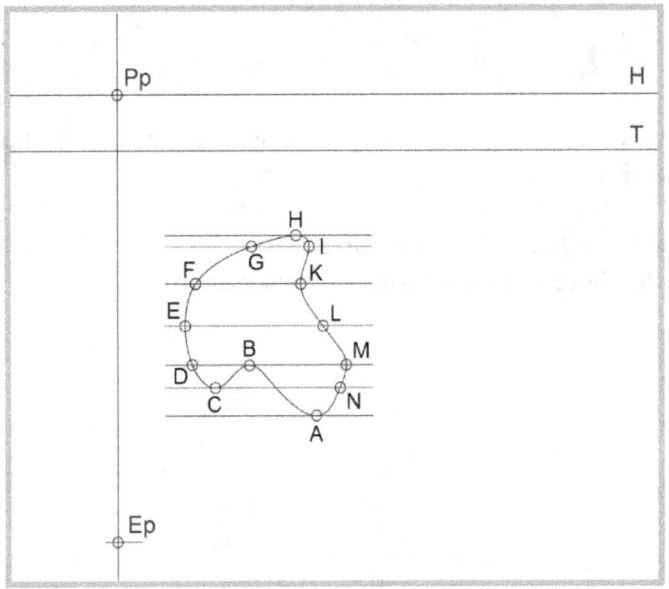

Insertion of points

3. These unique points now have to be transferred one after the other into the form represented in perspective. This works just like in the other previous examples – it is, again, just a matter of repetitive work. This maxim should work for the drawer – the more complicated the form, the more work it is.

As you can see here in the following diagram, each individual point is once again transferred with the aid of three reference lines.

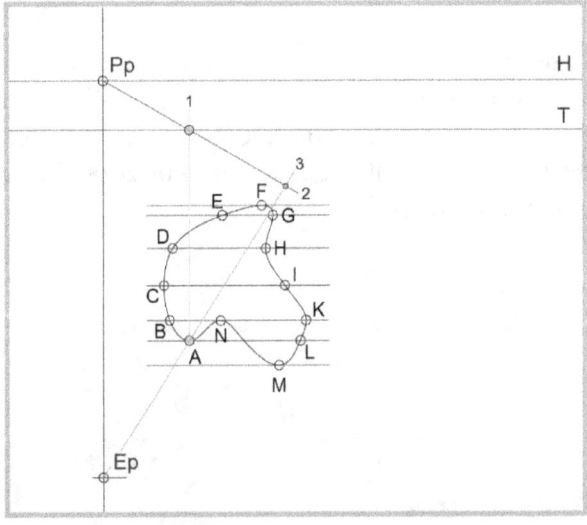

Transferring the points into perspective

4. In the next image, you can see how everything comes together once all of the points have been transferred along their reference lines.

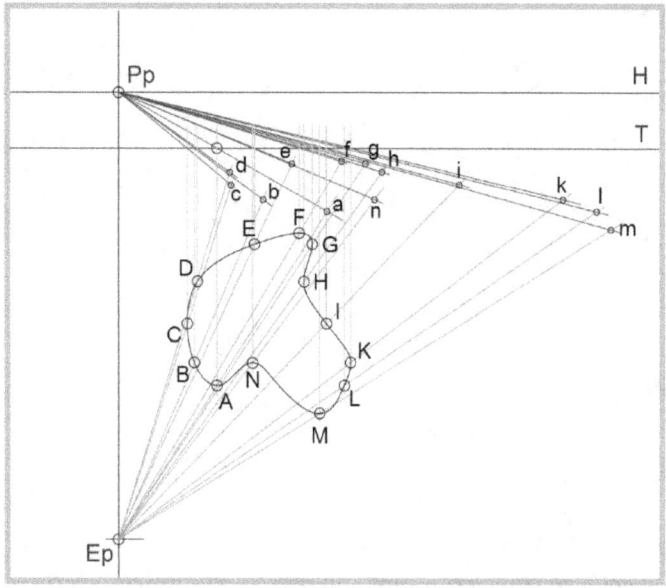

Transferring all points into perspective

5. If we now draw lines properly through the transferred points, we end up with a representation of the form in perspective.

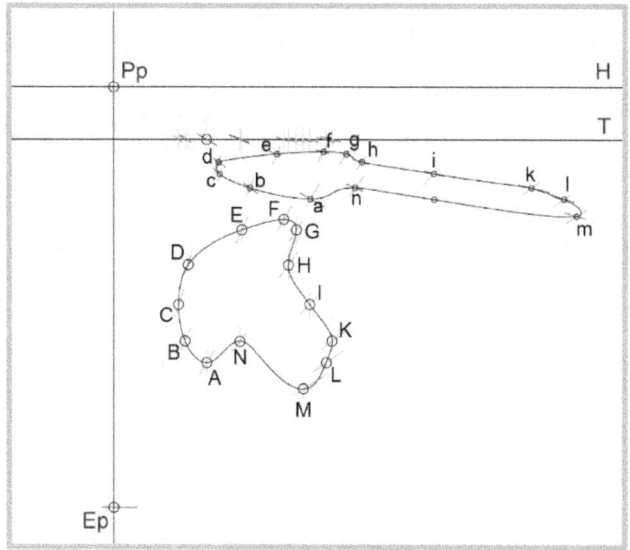

Connecting the points with lines

6. Once we have removed the unnecessary points with an eraser, the drawing should look like this.

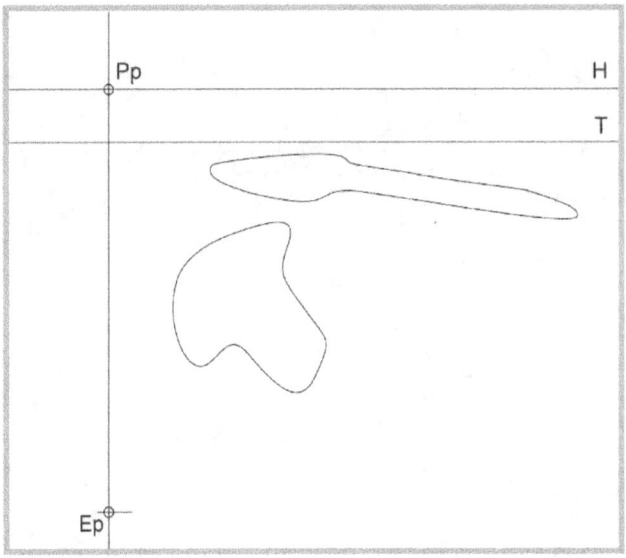

The form from a top view and perspective representation

With this last step, representation of the free form has been completed. As you can see here, it is actually possible to display highly complex geometries as well using this method of perspective drawing.

9.5 Drawing a Box in Perspective

Now we will finally draw a three-dimensional object using the new method. We begin here with a simple box.

The first thing to be drawn as usual is a sketch of the object in top view. In the sequence of diagrams, you will see how to proceed – afterwards, a thorough description is provided.

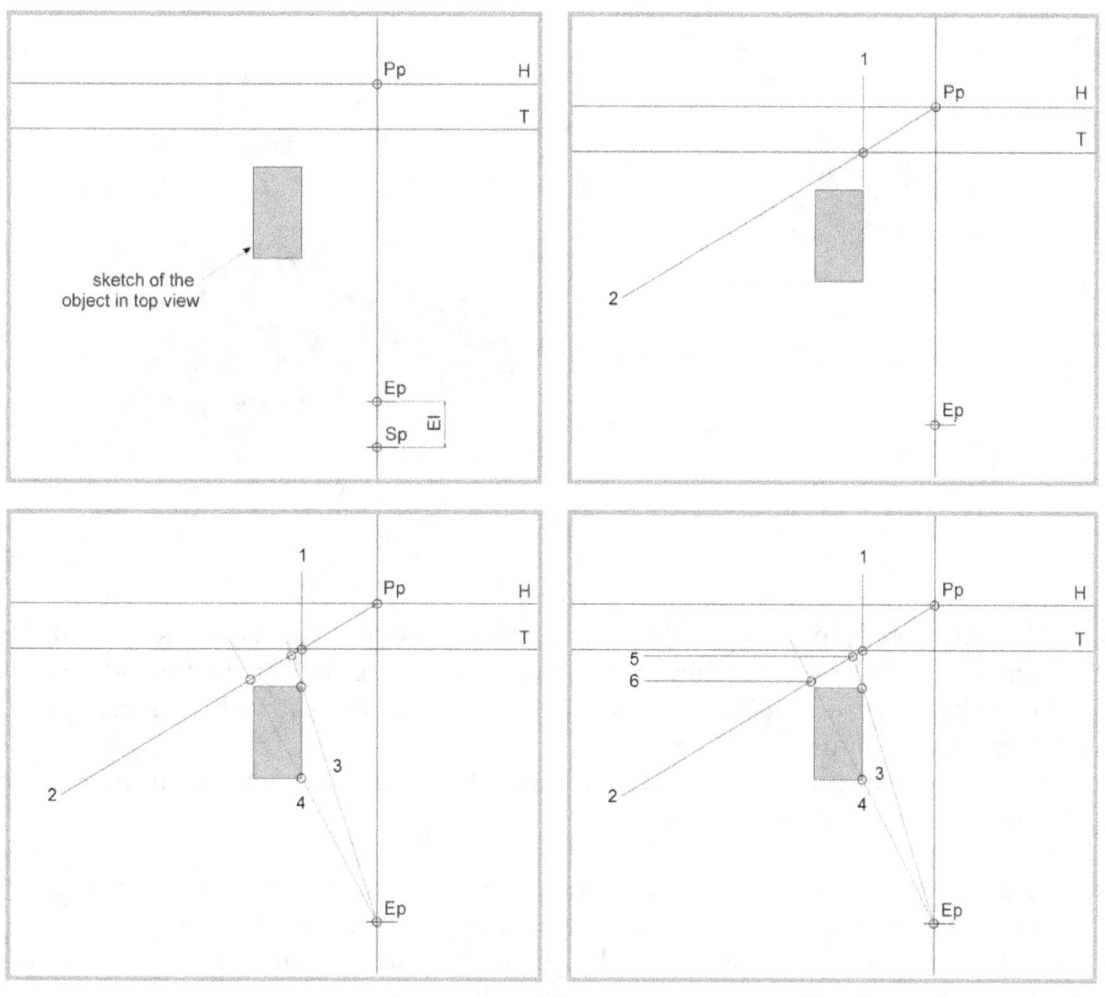

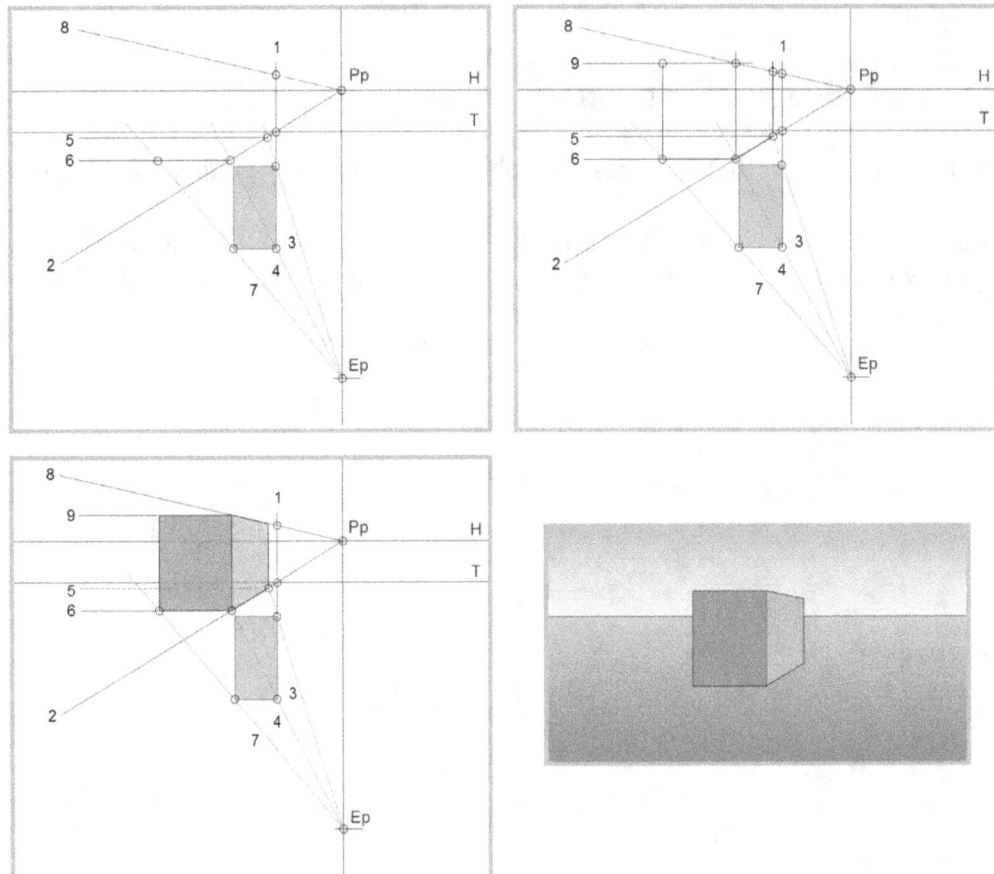

1. to 5.: The procedure is initially just the same as with two-dimensional objects. First of all, you can represent the entire base area of the object in perspective – but it is not necessary. Edges that will be hidden later on can be left out. In the sequence of diagrams shown here, representation of the hidden edges was omitted.
In image #5 you can also find line 8. With the aid of this line that emerges from the primary point, the height of the box is established.

6.: In image #6 we can see that vertical lines were extended upwards (3 lines) from the box's corner points at the base area. These lines represent the vertical edges of the box.
Line 8 is intersected by the front-vertical edge. From this intersection point, we have to draw a horizontal line (9), which represents the upper front edge of the box.

7.: The basic structure of the cube already exists and just has to be highlighted with thick lines. In image #7, the cube is shaded.

8.: The overall image looks even better with an attractive background.

9.5.1 Further examples

Now let's take a look at a few variations on the box theme. What would happen if we changed the position of the box, the horizon and/or the track?

a) The box is brought in closer to the eye point:

When the box is slid in closer to the eye point (in top view), it becomes larger in the perspective representation.

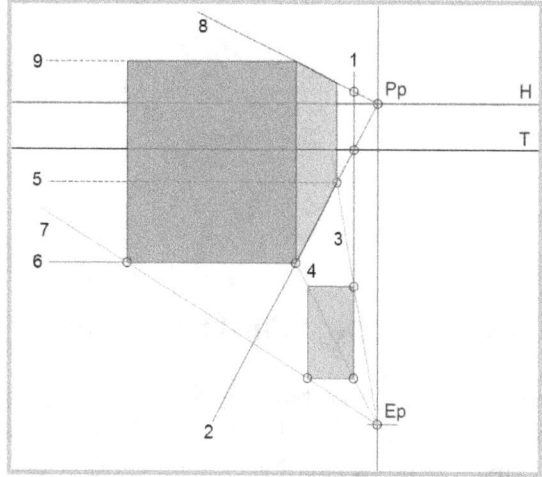

b) The track is slid downwards:

If the track is slid farther down (away from the horizon), the representation in perspective is transformed into a top view (bird's-eye view).

The large distance between horizon and track basically means that we are looking downwards from a higher vantage point.

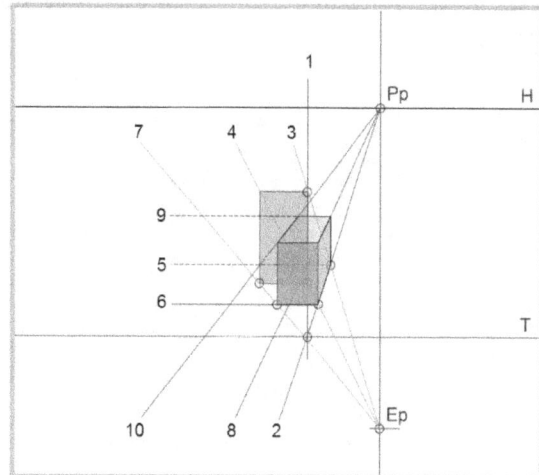

c) The box lies on the track

If we slide the track upwards again in the direction of the horizon until it intersects with the box, a view in perspective arises that still corresponds to a top view. However, the top view is not as pronounced as in the previous example.

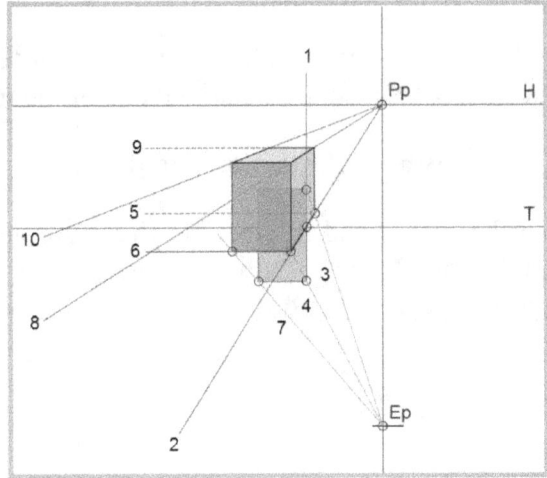

d) The box is located behind the horizon

If we push the box back behind the horizon (shown here is a box with different dimensions), the object becomes smaller in perspective.

The degree of perspective distortion is also decreased in the process. This occurs because the box is now located farther away from the observer.

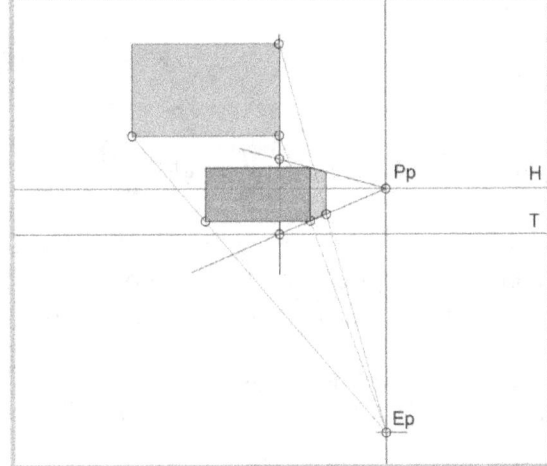

d) The track is located above the horizon

And now we have an interesting experiment – we'll slide the track up above the horizon!

This constellation results in the box being visible in the bottom view. If one proceeds exactly as it is described in the examples in this chapter, this spatial representation emerges automatically.

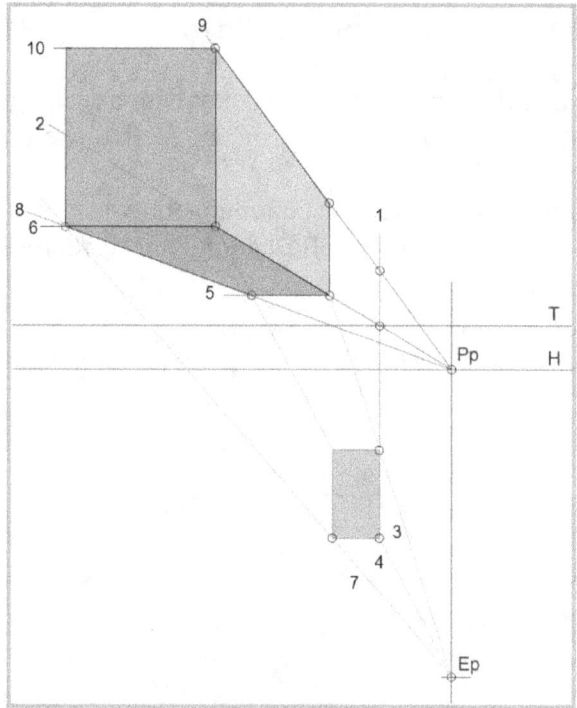

Emergence of a bottom view

Try to execute this example on your own. Also try out a few variations on the elements. You can learn to draw in perspective best through independent practice and develop your own understanding of the mechanisms in this style of representation.

9.6 Determining the Height of an Object

Now we will go one step further. You will learn in this sub-chapter how to transfer a certain height into a perspective representation that is true to proportion.

9.6.1 Defining the height of a rectangular solid

To avoid making it unnecessarily complicated, let's stay with a rectangular solid in this example. In order to properly draw the height of the object in perspective, we have to first of all specify a certain height for the object.

You can see this in the diagram below. The rectangular solid was produced in frontal view on the track. In our initial sketch, the rectangular solid has thus been represented in the top view and frontal view at the same time.

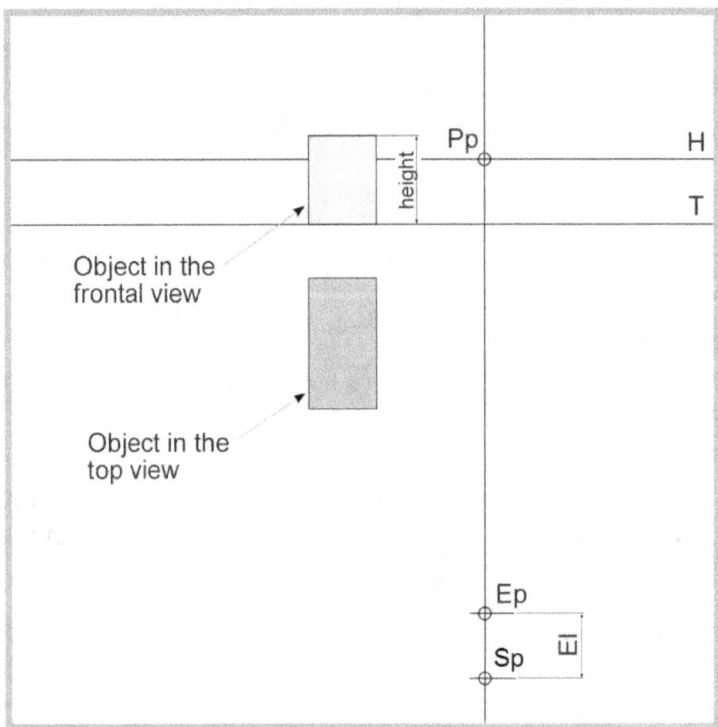

Sketch of the rectangular solid in top view and frontal view

Now we draw the representation of the solid object in perspective as usual. Things get interesting here with the specification of the height, in that the frontal view of the solid object was shifted to the right in the image – this can be done to enhance the clarity.

We extend a line from the upper edge of the frontal view to the reference line 1. The intersection point (a) now marks the height of the object. We then extend another reference line through this intersection point (a), which represents the vanishing line of the upper side edge of the object. The height of the rectangular solid is thus defined and properly represented.

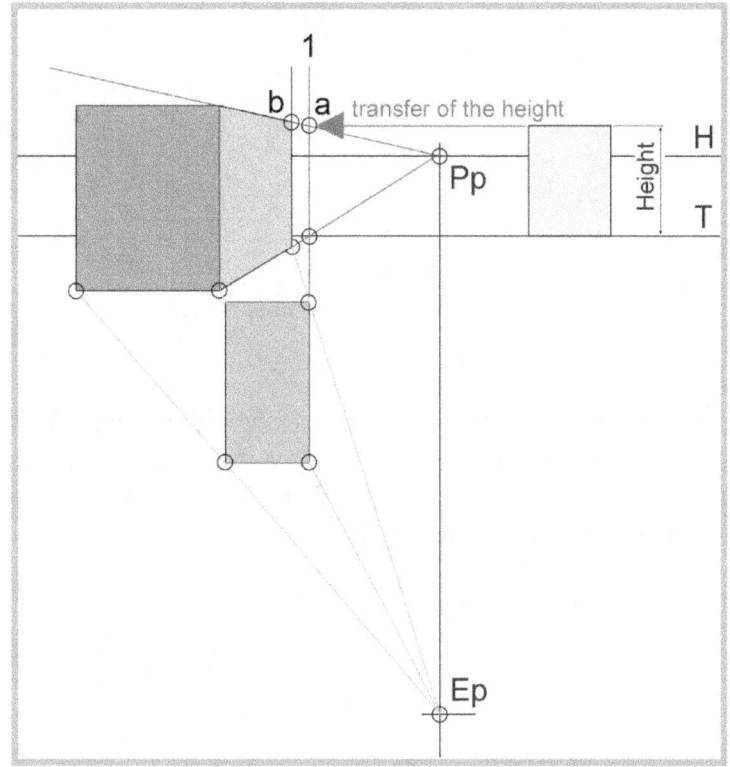

Representation of the rectangular solid with proper height

9.6.2 Defining the Height of a House in the Frontal View

And now we turn to an example based on everyday practice. We want to try to draw a house with a defined height. In the following diagram, you can see the starting situation.

The house is aligned in a frontal position vis-à-vis the observer. We can recognize this better in the top view. How the height extension of the roof is properly represented is interesting here.

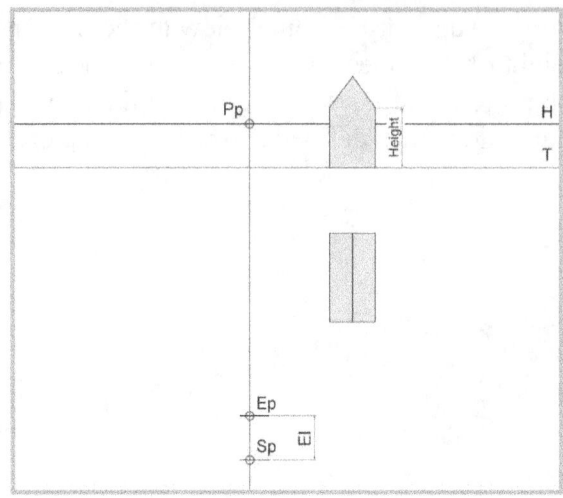

Sketch for drawing a house in perspective

1. For the most part, the perspective representation is executed as usual. The only additions here are the height lines (highlighted in orange). To display the roof, two height lines 2 and 3 are drawn. With the aid of these height lines, we can then draw the two reference lines 9 and 10, which function as the vanishing lines for the roof.

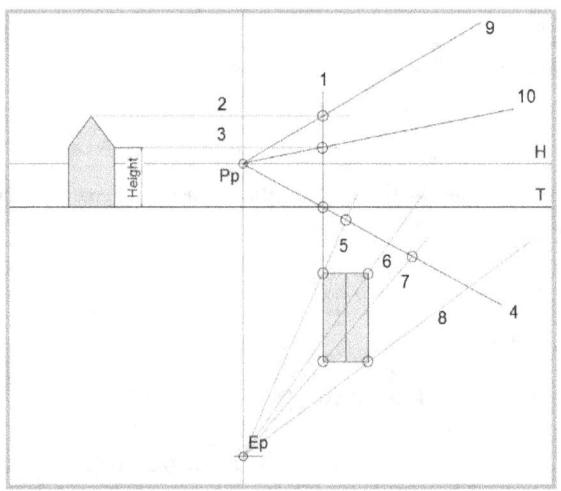

Reference lines for perspective representation

2. By using the reference lines now in place, we can properly construct the basic form of the house.

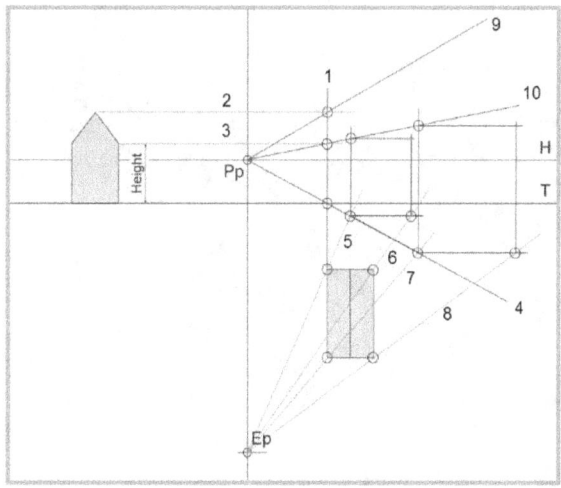

Construction of the house

3. The vanishing lines 9 and 10 are essential for representation of the roof in perspective. However, first of all we have to determine the vertical center line on the frontal and back side of the house. To this end we just draw the two diagonals for the two faces. With the aid of the surface center point that emerges thereby, we can simply extend the center lines upwards until they intersect with the reference line 9.

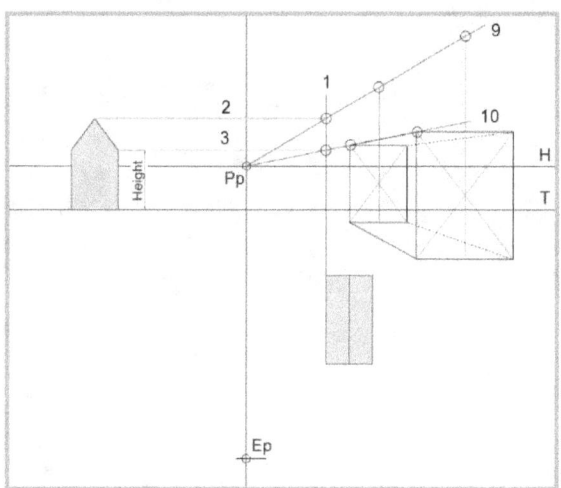

Determination of the center lines for the frontal and back faces

4. Thus, it becomes a simple matter to draw the roof of the house.

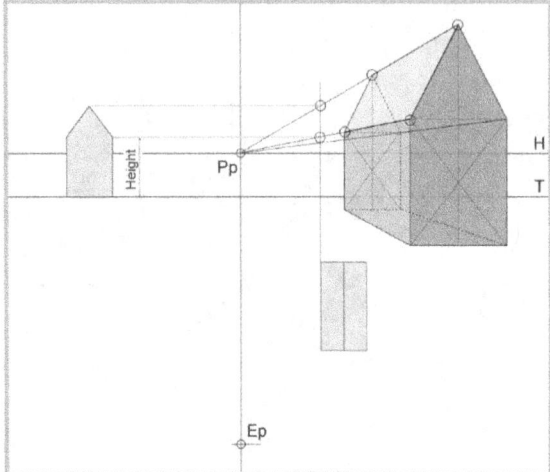

A house drawn in perspective

9.6.3 Defining the height of a house in the side view

And now we'll take a look at another example with a house. This time we'll tackle the representation using a side view.

1. In the first step, as always, we draw the basic elements and the house in top view and frontal view.

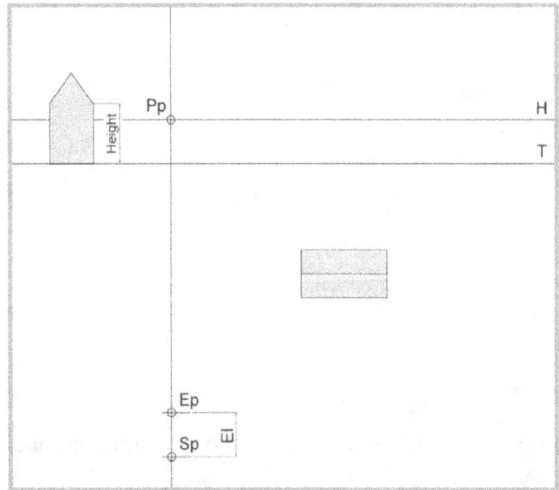

Starting sketch for the drawing

152

2. First we need to construct the side face of the house. For this purpose we need only a few construction lines, as you can see in the following image.

In order to establish the apex (top) of the roof, the vertical central line of the frontal face has to be defined. This is accomplished once again by drawing the diagonals in the face.

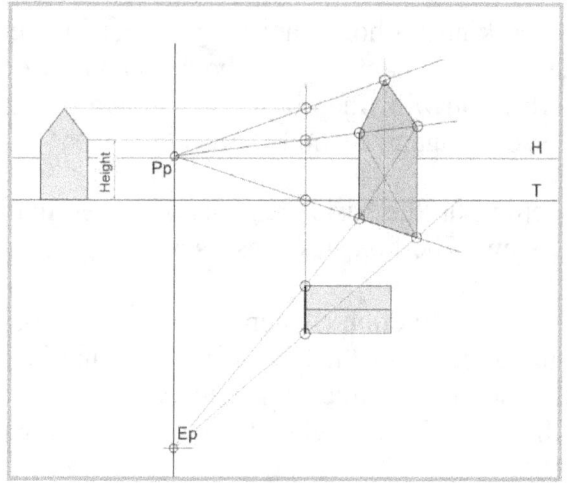

Drawing the side face of the house

3. Once this step has been completed, the house just has to be extended out in its width. For this purpose, a few more reference lines and some graphic-design details are required.

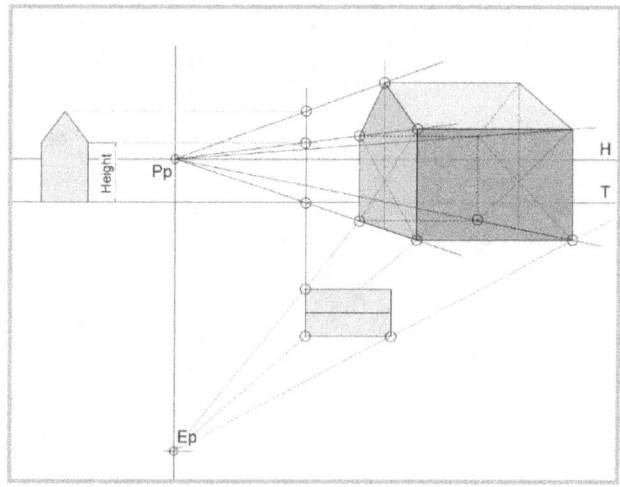

Completion of the drawing in perspective

153

9.7 True-to-Proportion Representation in Diagonal Perspective

As we have seen, all forms can, in principle, be drawn in perspective by using this method. For right-angle objects in diagonal perspective, however, there is one more special technique that simplifies our work.

Until now, we have been working without vanishing points in the 'new' method from this chapter – different from the previous chapters in the book. So now we re-introduce the vanishing point! Exactly how this works, you will find out in the following step-by-step instructions. The object that we are drawing is, once again, a simple box.

1. We start once again by setting up the basic elements of representation in perspective and the sketch of the object in top view. The box lies – as usual in diagonal perspective – oblique in relation to the observer.
We then draw, as an additional construction element, two construction lines that extend from the eye point and run parallel to the edges of the box. This technique involves the triangle of sight, which is nothing new to us, since we became acquainted with it in one of the previous chapters. The points at which the lines of the triangle of sight intersect with the horizon mark the vanishing points VP1 and VP2.

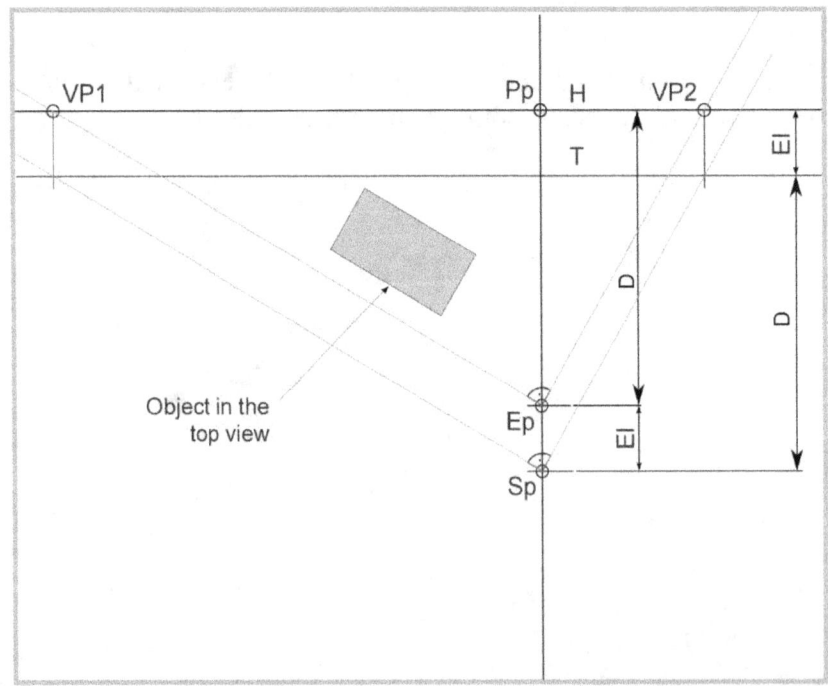

Initial sketch with displayed triangle of sight

Furthermore, in the sketch displayed here the same lines for the point of view (stand point Sp) are included. This should only be shown for the sake of thoroughness, and is not really necessary.

2. In the second step, we extend two construction lines from the front two edges of the box out to the track (red line).

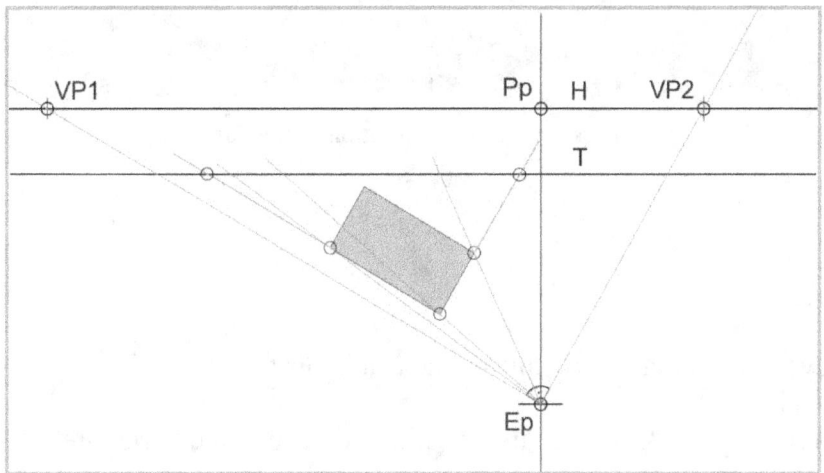

Construction lines to the track

3. With the aid of the intersection points and vanishing points that have emerged hereby, we can now represent the box in a simple perspective style.

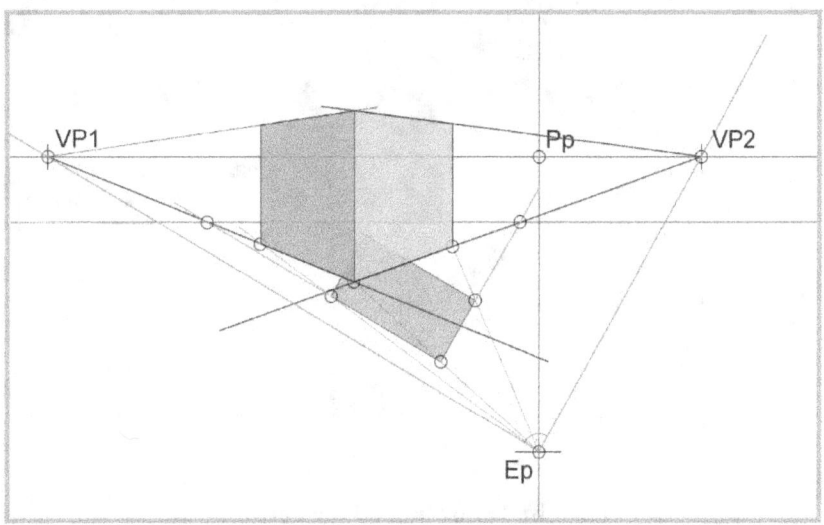

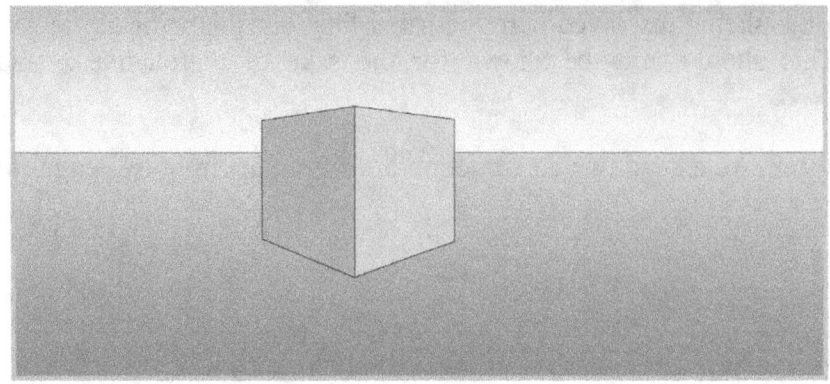

Perspective representation of the box

9.7.1 Exercises

Now we can draw a few variations on this theme using this technique. Just try drawing the object yourself as shown in perspective.
For the first exercise let's look at a box in top view and beyond the horizon.

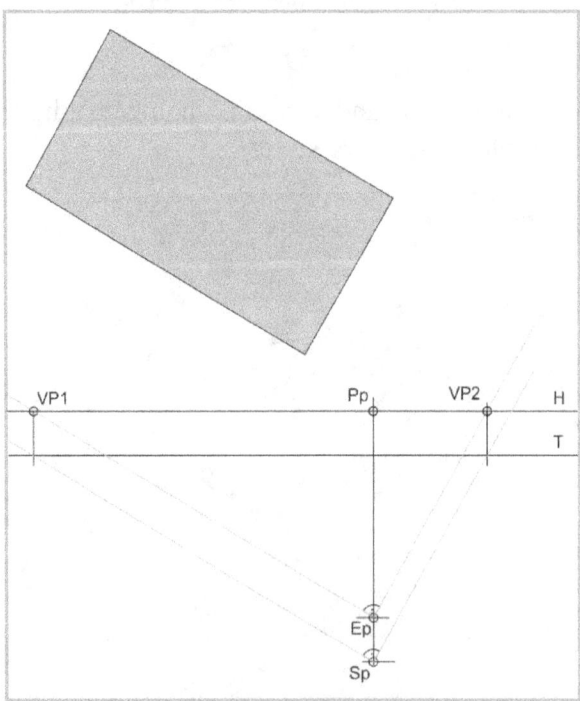

Exercise 1: Box beyond the horizon

You can see from the following diagram how the box can be drawn in perspective.

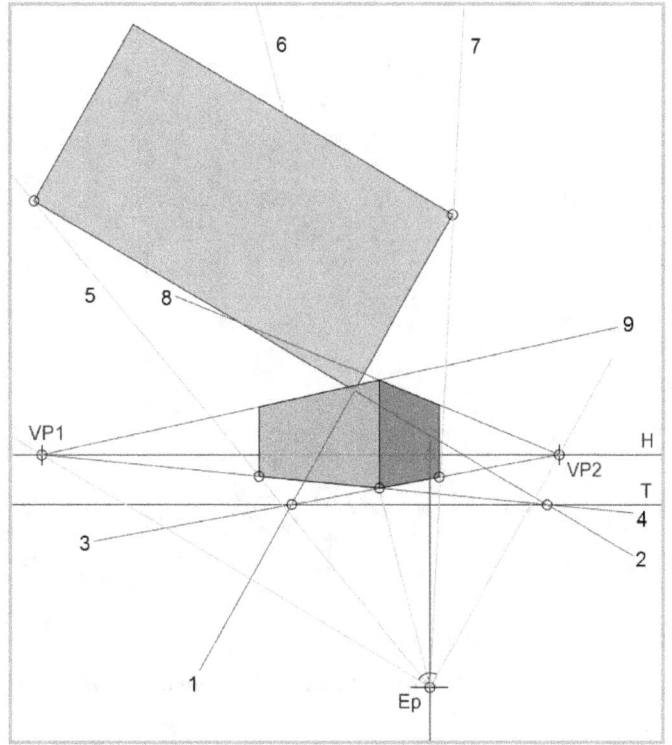

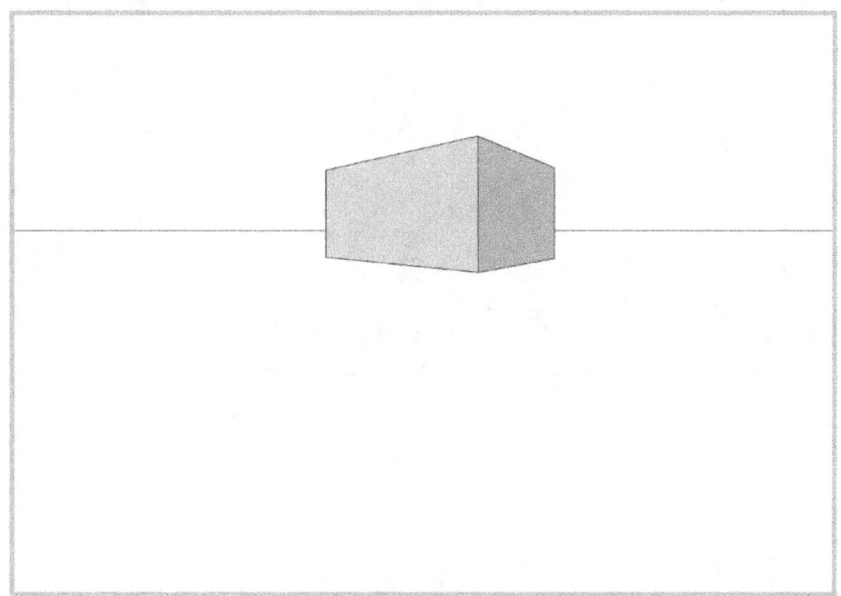

Perspective representation of the box

And now let's take a look at a small box, which is also placed beyond the horizon in top view. This time you can try to define a certain height for the box.

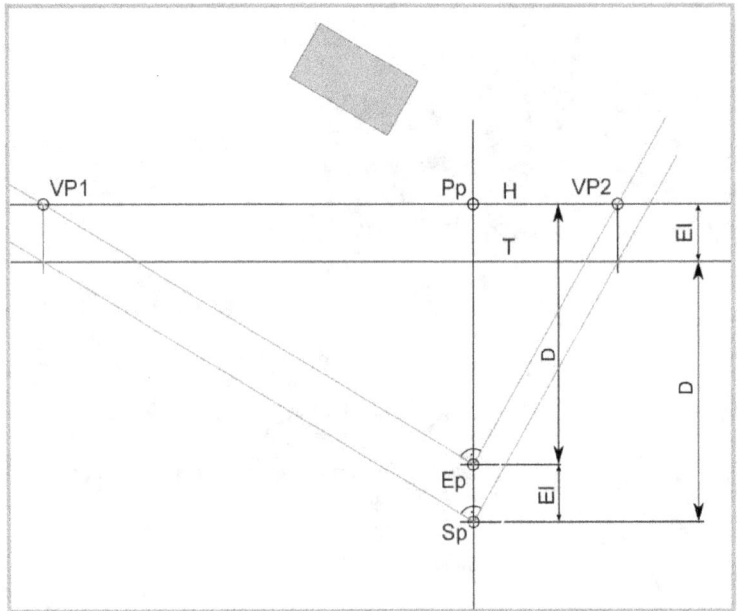

Exercise 2: Drawing a box with defined height

Here you can see how the height of the box can also be represented in diagonal perspective.

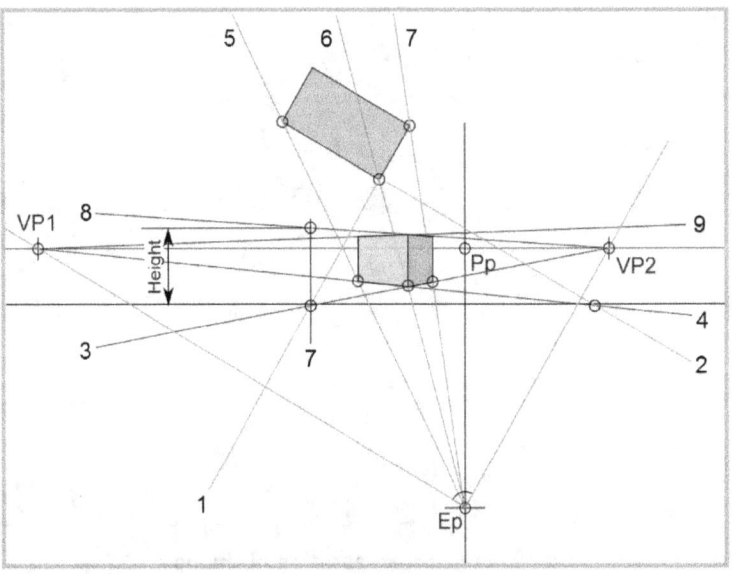

Perspective representation of the box with a defined height

9.8 Perspective Representation of a Complex Object

In this last example for the chapter, we want to try to draw a complex object in perspective that is true to proportion. This involves an object that is made up of several sections. In the end, most of the objects that we are drawing here can be broken down into various individual geometric shapes. It is thus possible to also display complicated motifs in perspective. This exercise is therefore ideal for learning perspective drawing.

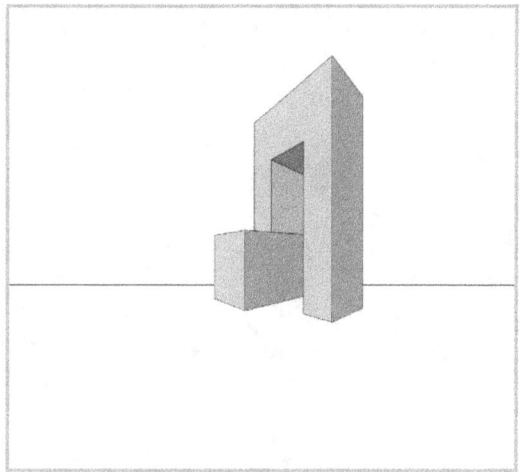

A complex object in perspective

In a technical drawing, this object can be represented as in the following diagram. In this three-panel image, a relationship is generated between the three different points of view (side view, frontal view and top view). The reference lines drawn in gray show these relationships.

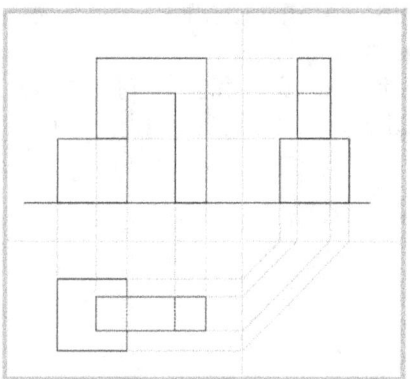

Technical drawing of the motif

1. Now we start the exercise and come back once again to our well-known starting sketch, in which the object is drawn in both top view and side view. In the top view we can see that the object is situated in a certain angle to the observer – thus we are drawing a diagonal perspective. This makes no difference for the side view.

Now we would like to make use of the new technique for diagonal perspective that we got to know in the previous example. Accordingly, the visual triangle has to be drawn once again in order to determine the vanishing points (VP1 and VP2).

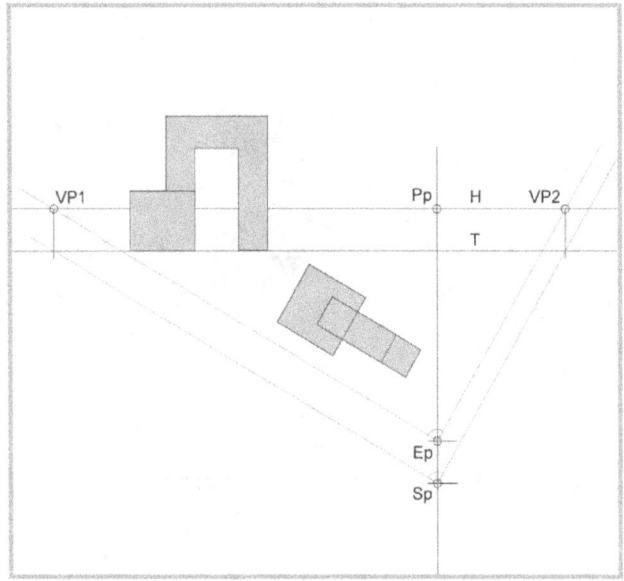

Starting sketch for the perspective drawing

2. Representation of this object works the easiest when one, first of all, draws the base areas for the individual objects. In the following diagram below, you can see how the first base area was represented.
As in the previous example, we use, for this purpose, the vanishing points and points of intersection between the extended edges of the object in the top view (red lines) and the track.

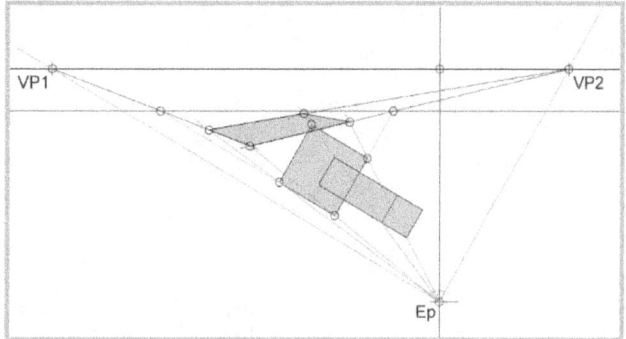

3. And now we draw the base areas for the other objects. There is a secondary body lying on the large box. Its base area also has to be drawn on the floor.

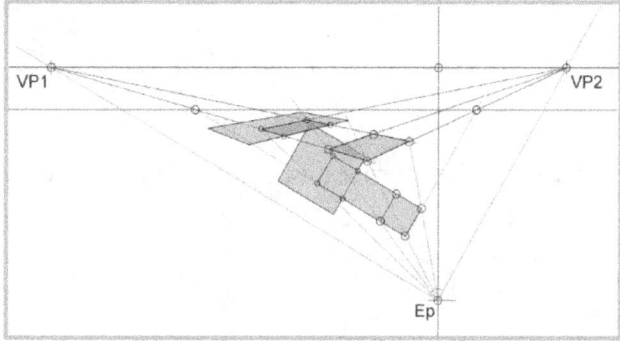

4. In the next step we extend the two-dimensional faces upward into space. In order to establish the height, we use the usual side view of the object. This happens initially in the first step.

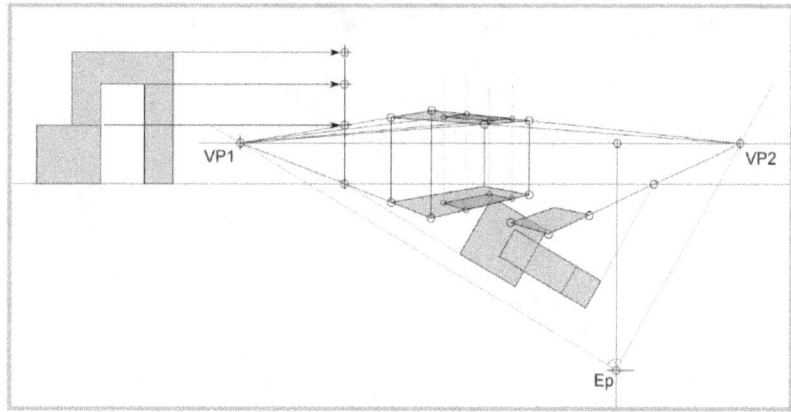

5. Then the remaining parts of the object follow – situated higher.

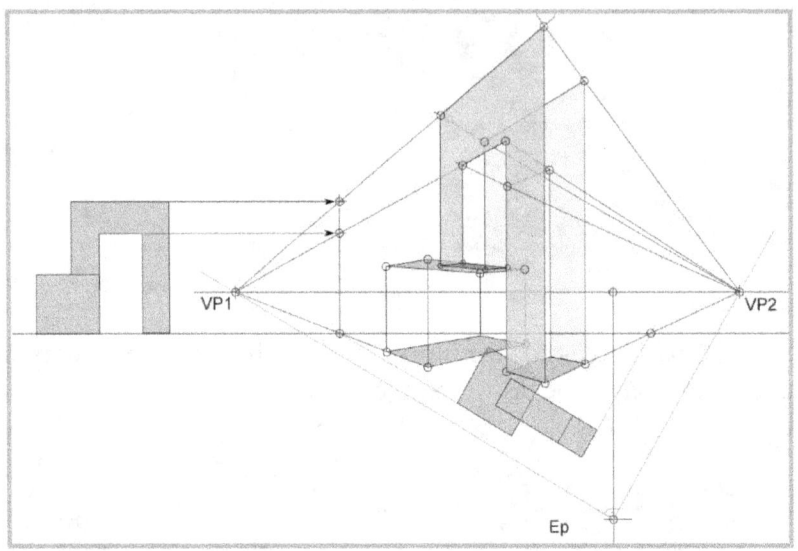

6. When we now connect the remaining corner points together, the overall object is completed.

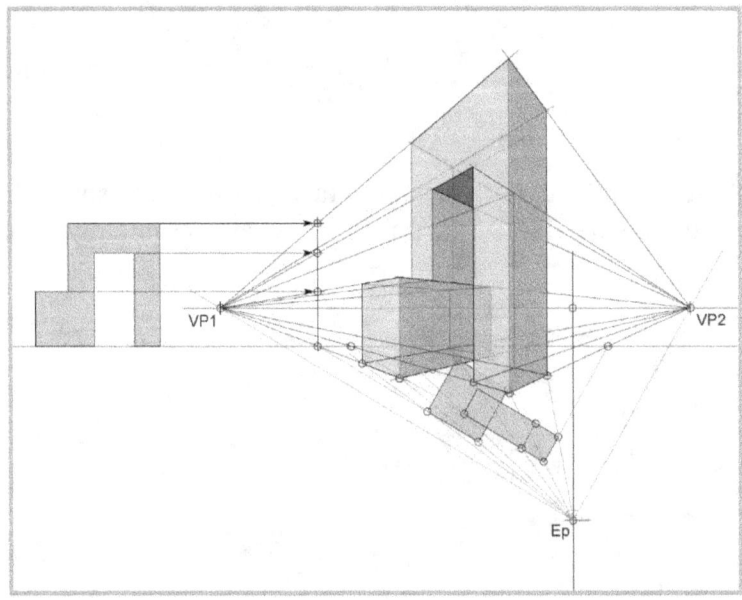

Without the construction lines and without the hidden edges, the figure then looks like this.

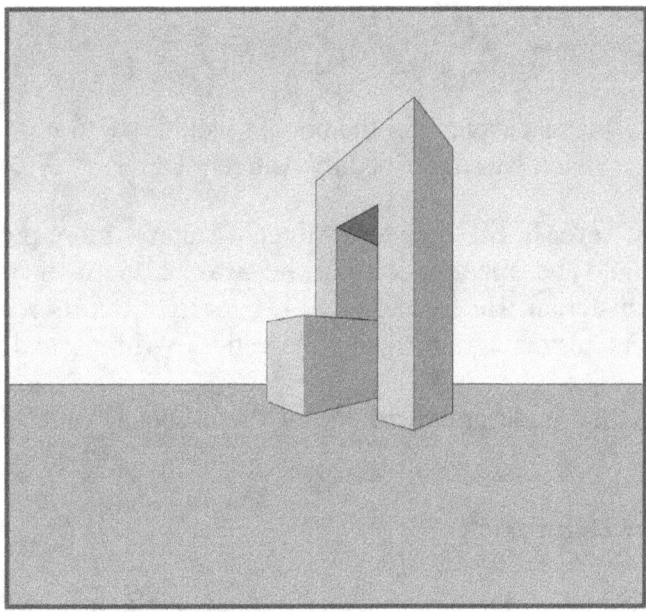

Completed drawing in perspective

This slightly more complex example of perspective drawing represents the last image in this book. You have become acquainted here with many examples of various situations and should now have useful tools at your disposal to be able to draw complicated perspective motifs as well.

But we are still not quite finished! I have added one more short chapter here that will most likely spark your interest. Here you will also find an absorbing glimpse into the historical origins of perspective drawing.

10 A Supplementary Observation: Perspective According to Dürer

In the context of a small 'bonus chapter' for the book, I would like to introduce one more method of drawing in perspective which was described by Albrecht Dürer.

For all of you who have never heard the name Albrecht Dürer – more precisely, Albrecht Dürer the Younger – it should be mentioned that he was a German painter, graphic artist, mathematician and art historian. He lived from 1471 to 1528 and is recognized as one of the most renowned artists in history. Also, many theoretical writings and reference books were penned by him.

The aforementioned method is described in one of these books, which I would like to briefly introduce here.

Reproduction using the Dürer trick

The goal of Dürer's Technique was to reproduce an object realistically. The method enables the draftsman to represent even complicated perspectives with precision. However, this method is not suitable for landscape paintings or architectural drawings; rather, it is only appropriate for objects that have sufficient space within a room.

The reason for this: use of this method requires that the picture motif is transferred onto paper with the aid of a cord.

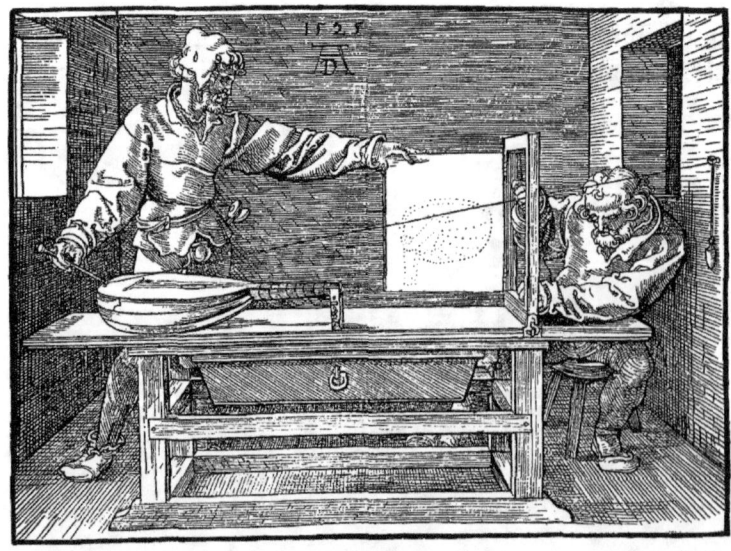

Albrecht Dürer: Artist Drawing a Lute ("Der Zeichner der Laute") (1525)
Woodcut of a method for transferring reality onto a drawing

The cord is pulled up through the eye of a needle fixed to the wall behind the artist. At this end of the cord, a small weight is attached so that the cord can be pulled taut, while still remaining moveable (extendable).
The attachment point of the cord corresponds to the point of view – i.e. the eye point, or eye – of an (imaginary) observer. At the other end of the cord, a stick is attached.

The second half of Dürer's contraption is a framework that is attached to the table. On the side of the framework, a small door is hinged that can be opened and snapped shut. The drawing surface (paper, canvas, etc) is fixed to the door. Further, two cords are needed that correspond to the height and width, respectively, of the framework.

Procedure:

In order to understand the procedure better, take a look at the picture above, which was also created by Dürer in the form of a woodcut.

1. The door, upon which the drawing surface is fixed, is opened at first.

2. The first person touches a point on the drawing object (model) with the point of the stick, to which the long cord is attached. The cord is pulled taut in the process by the weight at the other end.

3. A second person now manipulates the two (short) cords. The two cords are attached, respectively horizontally and vertically, to the framework so that they intersect at that point where the long cord passes through the framework.
So, he has now symbolized – by means of the intersection of the two short cords – that point at which the pointer stick cord would intersect with the picture plane (i.e. drawing surface).

4. The long cord can now be loosened, while the two short cords remain attached to the framework.

5. Now the door with the drawing surface is closed.

6. Using the crossing point of the two short cords that are still fixed to the framework, the point of intersection can now be transferred to the drawing surface.

7. This procedure is repeated for many points on the surface of the model.

8. With the aid of these points, the contours of the drawing object can be drawn quite precisely.

Source:

Albrecht Dürer's book: <u>Instruction in Measurement with Compass and Ruler</u> ("Underweysung der Messung mit dem Zirckel und Richtscheyt") from the year 1525.

Closing Statement

And now we are at the end of the book. I hope that all of the information and knowledge that I have packed into this book have aided you in your study of perspective.

Parallel to all of our theoretical efforts, the most important thing for drawing is, of course, practice. Experiment on your own with various perspective drawings. You don't have to start immediately with complex geometry; rather, it is better to try to represent simple objects. Put this book to good use whenever you arrive at a point where you have difficulties with drawing. The exercises that you have worked with here should cover most cases involving perspective representation.
Break complicated objects down to simple subsections. This will work for almost all objects. The individual subsections are then relatively simple to draw in perspective.

And if you have enjoyed the book, I would really appreciate it if you would recommend it to friends and colleagues, or write a positive evaluation for me online.

Visit one of my websites! You can find further instructions regarding the topic of learning to draw and paint, as well as many of my own works:

www.art-class.net
www.kunstkurs-online.de
zeichnen-lernen.markus-agerer.de
www.markus-agerer.de

For suggestions for improvement, critique and feedback: markus-agerer@web.de

Many thanks and kind regards to all my readers and all of those individuals who have supported me in the production of my book!

Markus Agerer

11 Sources

Books:

"Underweysung der Messung mit dem Zirckel und Richtscheyt"
Albrecht Dürer der Jüngere; Nürnberg 1525

„Perspektivisch Zeichnen"
Grundlagen zur Darstellung des dreidimensionalen Raums
Autor: Gernot Störzbach; Verlag: Christophorus Verlag GmbH & Co. KG., Freiburg

Internet:

http://www.kunstkurs-online.de

http://zeichnen-lernen.markus-agerer.de

http://www.wikipedia.org

http://www.pharmawiki.ch/perspektive

www.ingramcontent.com/pod-product-compliance
Lightning Source LLC
Chambersburg PA
CBHW081148180526
45170CB00006B/1983